ROME

IN FLIGHT OVER THE ETERNAL CITY AND LATIUM

WHITE STAR PUBLISHERS

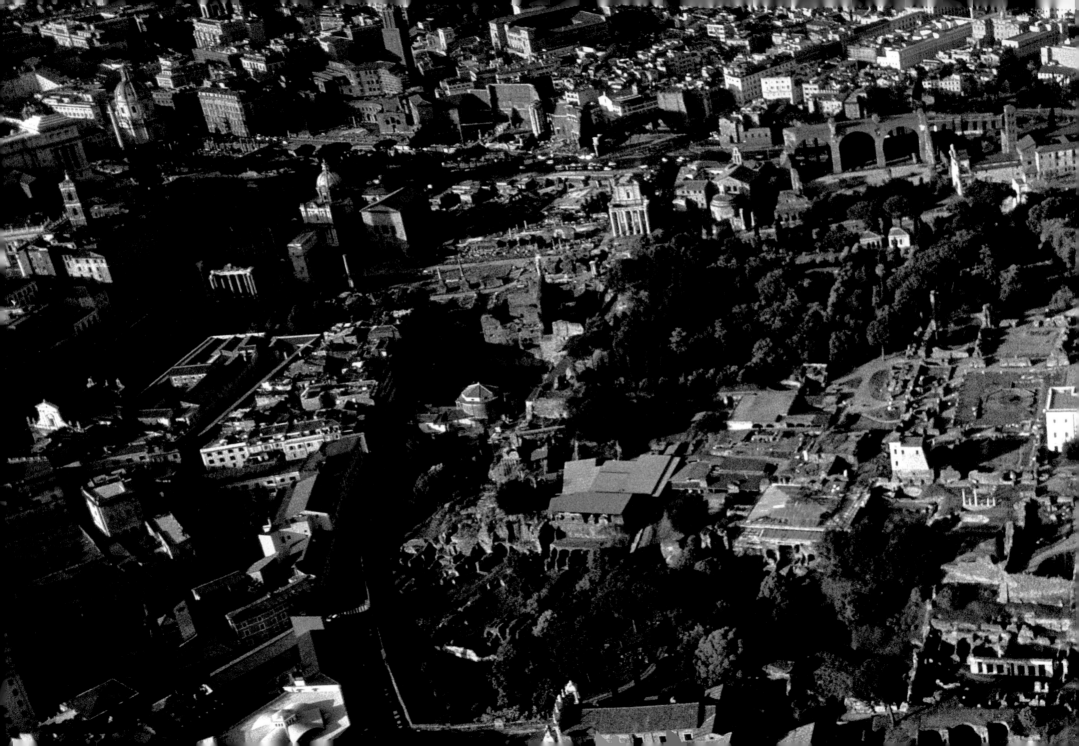

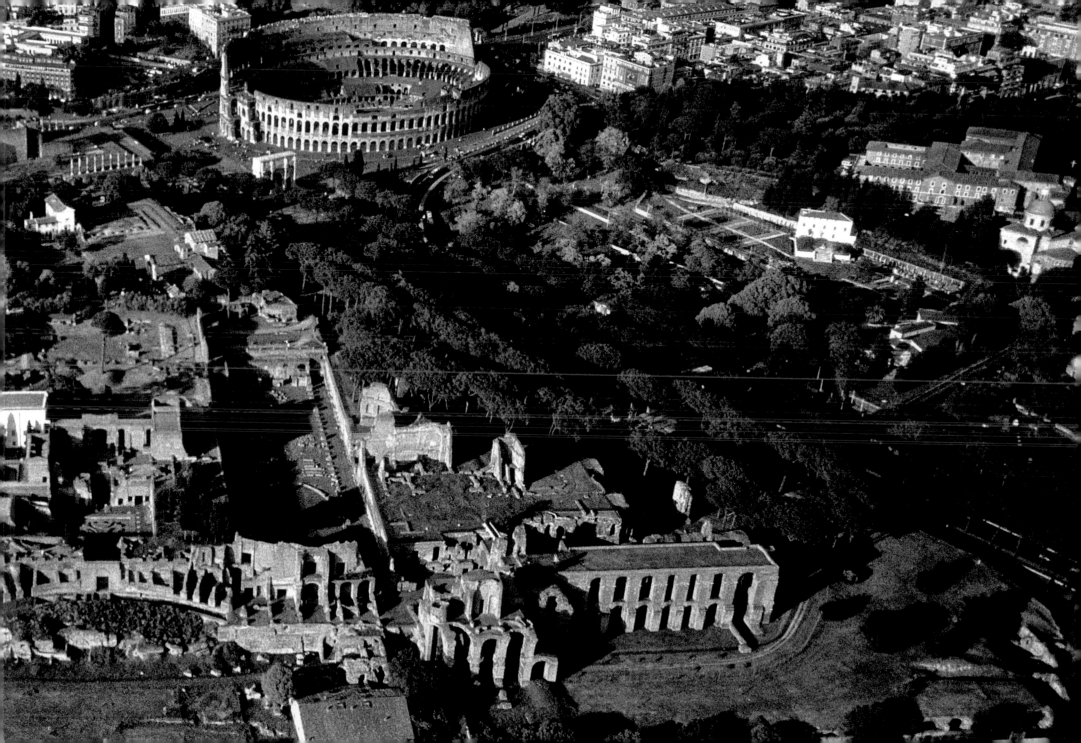

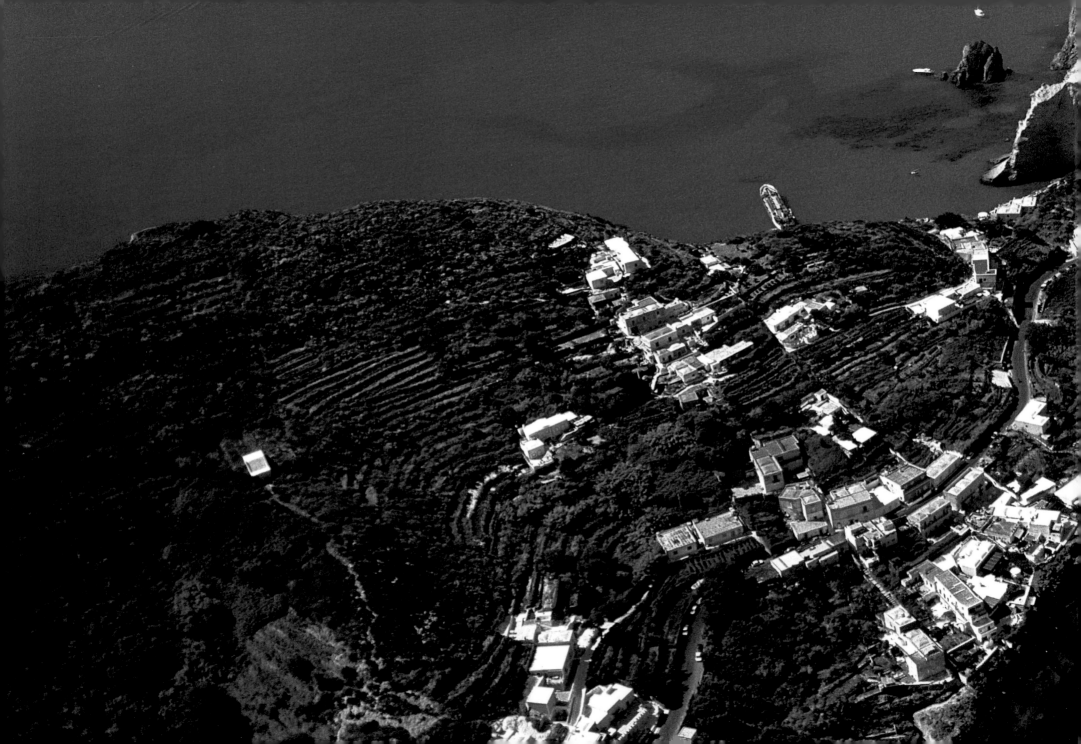

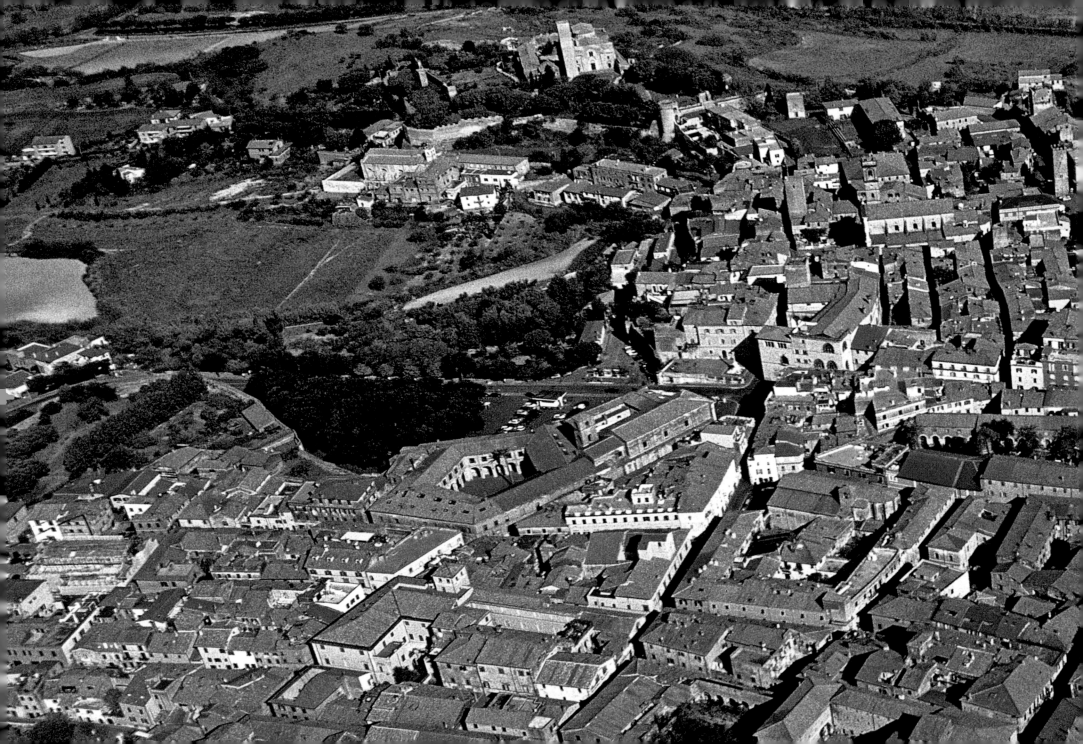

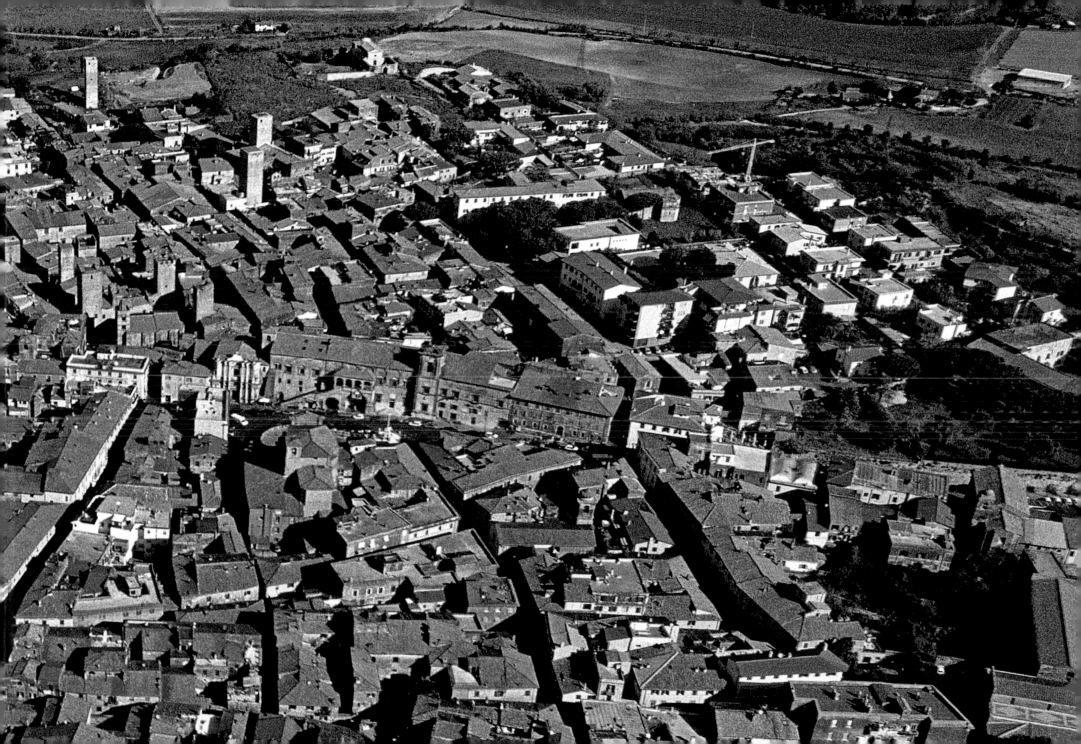

ROME

IN FLIGHT OVER THE ETERNAL CITY AND LATIUM

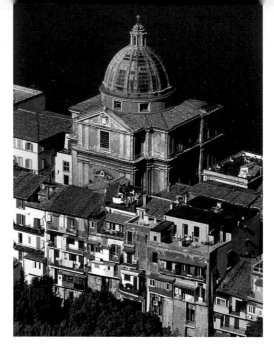

PHOTOGRAPHS
Antonio Attini
Marcello Bertinetti

TEXT
Stefano Ardito

Contents

2-3 The extraordinary archaeological park at the heart of Rome includes the Palatine (in the foreground), the Forums and the Colosseum.

4-5 The landscape of Ponza, Lazio's largest island, is a mosaic of crystal-clear waters, tuff cliffs and narrow cultivated terraces.

6-7 Tarquinia (Viterbo) is famous for its Etruscan necropolises and also boasts an elegant historic district protected by medieval walls and towers. [NB: (Viterbo) and other names in parentheses indicate the province in which a named place is located].

8 The church of Castelgandolfo (Rome), dedicated to St. Thomas of Villanova, was commissioned by Pope Alexander VII from Gian Lorenzo Bernini, who built it on a Greek cross plan because of the limited available space.

9 The straight streets of Corso Vittorio Emanuele II (center) and Via Giulia cut through the center of Rome toward Piazza Venezia and the Capitoline.

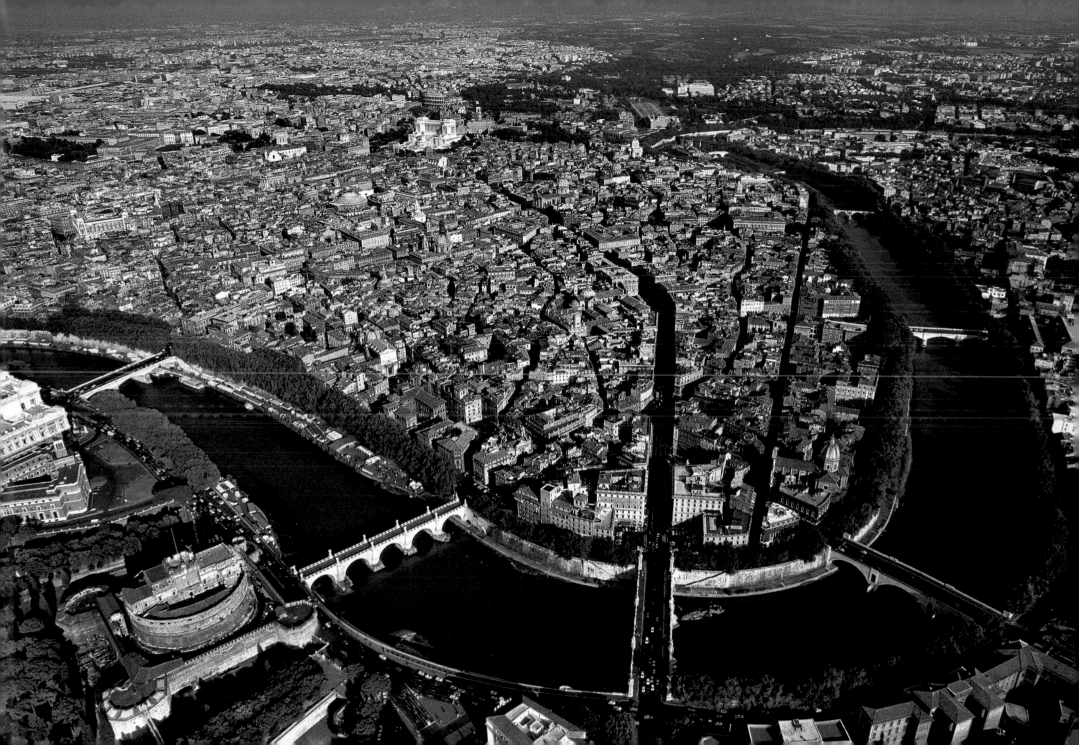

Welcome to the heart of Italy and the world! Many images of Rome, from the ground or from above, have become part of our collective memory. From Kansas, Tokyo and Buenos Aires to Bombay, Reykjavik and Cape Town, anyone who has access to printed matter or television has at least once in their life seen the Tiber snaking through the city, the arches of the Colosseum, the columns of the Forums, the Fountain of Trevi and the fountains of Piazza Navona, the dome of St. Peter's and Bernini's colonnade reaching out toward Via della Conciliazione and the Tiber, as if to embrace Rome and the world.

You don't have to be a Catholic to know that Rome has been one of the world's main spiritual centers for 2000 years, and everyone has seen pictures of the Pope speaking to a square brimming with people. Similarly, you don't need to have studied art history to know that Rome's basilicas, squares and palaces were designed by great artists such as Michelangelo and Bernini, and that the Capitoline and Vatican Museums (plus many others erroneously described as "minor") are home to extraordinary treasures. Many of the romantic landscapes of Latium (Lazio in Italian) – Rome's historic Forums, the Campagna Romana, the Tivoli waterfalls, the coast and the Pontine Marshes – have been painted by artists from the times of the Grand Tour until the present day.

However, Italians – and also foreigners – often see other pictures of a different, more everyday city, which is the exact opposite of, but just as real as, the other: traffic jams on the Tiber Embankment, the Ring Road and the city streets; the coming and going of politicians and their blue cars traveling between Palazzo Montecitorio, Palazzo Madama and Palazzo Chigi; trade union and political demonstrations that often paralyze the already chaotic city center traffic; the Termini Station; Fiumicino Airport; soccer matches at the Olympic Stadium; and the Rome Marathon, which crosses the city and its archaeological sites. On Sundays and holidays, Rome is packed with pilgrims and tourists, who throng its basilicas, squares, ice-cream parlors and restaurants.

The city's extraordinary beauty and great evocative power overshadow and sometimes completely obscure the rest of Lazio. However, this mistake deserves to be rectified. In terms of area and population, the land around Rome (the other provincial capitals are Viterbo, Rieti, Frosinone and Latina), which borders on Tuscany, Umbria, Marche, Abruzzo, Campania and

11 The Colosseum (Rome), the ancient world's most famous amphitheater, was built by the emperors Vespasian, Titus and Domitian from AD 72.

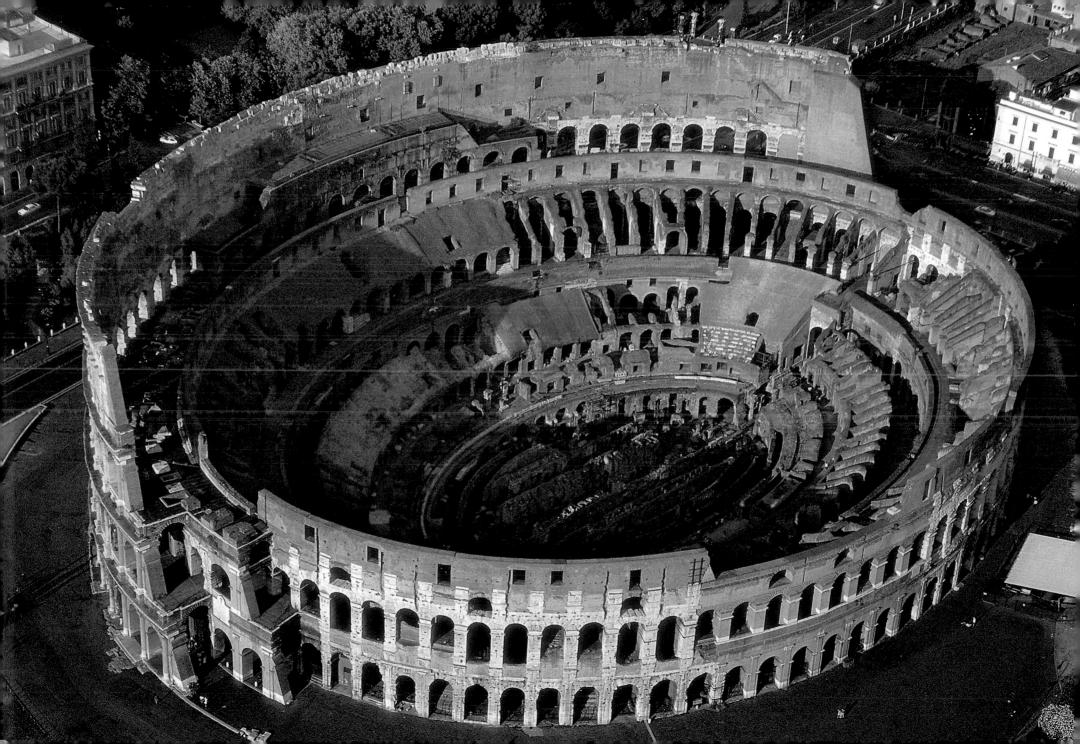

Molise, is one of the most varied and interesting of all the Italian regions and the entire Mediterranean.

The cities of the Etruscans, Latins and Italics and the ancient roads that still crisscross the countryside are flanked by medieval fortresses and castles, abbeys, monasteries and hermitages, villages and Baroque palaces, magnificent parks like Villa Lante and Villa d'Este, modern architecture such as the Foro Italico sports complex, the buildings of the EUR district (the initials stand for Esposizione Universale di Roma/ Universal Exposition of Rome) and the towns founded following the draining of the Pontine Marshes, commencing with Latina and Sabaudia. "A Tuscan air is already discernible in the Viterbo area, the Circeo brings to mind the magic of Capri and Ischia, while Tivoli has the flavor of Abruzzo," wrote the writer and art critic Mario Praz in 1967, when introducing his book Lazio (1967).

Nature also plays an important role. From the beech groves, waterfalls and rocks of the Apennine massifs that mark the border with Abruzzo (Laga, Mt. Terminillo, the long Simbruini-Ernici range, Mainarde and the mountains of the Abruzzo National Park), you need only descend a few miles to admire the lazy meanders of the Tiber among the hills of the Sabina, the coastal lakes and marshes of the Roman coast and the Circeo, the volcanic lakes of the Alban Hills, and the impressive limestone cliffs of Gaeta.

 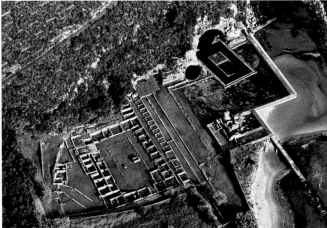 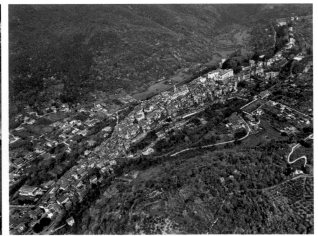

12 left The Tiber Island separates the Ghetto and central Rome from the Trastevere district.

A long ribbon of beaches edges the Tyrrhenian Sea, while the tuff gorges and plateaus of the Tuscia, between Rome and the Tuscan Maremma, were shaped by the eruptions of ancient volcanoes for over half a million years. Their craters were long ago filled with the blue lakes of Bolsena, Bracciano and Vico. Off the Pontine coast lie the mainly volcanic islands of Ponza, Palmarola, Zannone, Ventotene and Santo Stefano.

A bird's-eye view reveals the variety and beauty of the landscapes. However, nature is very much alive in Lazio. The woods are dominated by holm oak, chestnut, turkey oak or beech, depending on altitude. The list of spring flowers (which appear in March on the coast, and between May and June in the mountains) includes alpine varieties, such as the Turk's cap lily, poet's narcissus, and fire lily, dozens of species of wild orchids, and desert plants such as the Hottentot fig, which colors the dunes of Castelporziano and Sabaudia. In autumn the forests of the Tuscia don a red carpet of cyclamens.

The Apennine wolf, chamois, Marsican brown bear and griffon vulture inhabit the Lazio mountains, while the hills are home to crested porcupine, badger and roe deer, and the Fiora River to the otter. Birds of prey include the red kite, eagle owl and short-toed eagle; and the peregrine falcon, gray heron and cormorant allow themselves to be photographed even in the center of Rome. Wild ducks and coots frequent the volcanic lakes and the lagoons of the Circeo for many months of the year. While flocks of sheep still abound in the Apennine pastures, Maremma cows graze on the Tolfa Mountains and around Tarquinia, followed by the butteri (mounted cowherds).

It is no coincidence that Lazio's landscapes and natural treasures have long been guarded by a system of protected areas, which now number over 50. The Abruzzo National Park, founded in 1923 in the Ciociaria, which became the Abruzzo, Lazio and Molise Park in 2002, was joined by the Circeo National Park in 1934, and the Gran Sasso and Laga Mountains National Park – which also comprises part of Marche and Abruzzo – in 1995. Over 30 regional parks and reserves have been founded since the establishment of the first in 1979. These are flanked by several state reserves, two protected marine areas and a dozen conservation areas founded by the World Wildlife Fund and the Italian League for the Protection of Birds. Even the Municipality of Rome contains a surprising number of protected areas.

12 center A natural cavity at the foot of Mount Ciannito in Sperlonga (Latina) is home to the Grotto of Tiberius, the nymphaeum of one of the imperial villas that was abandoned when Tiberius moved to Capri in AD 26.

12 right The medieval village of Genazzano (Rome) extends along on a hilltop on the eastern edge of the Campagna Romana.

However, the beauties of Lazio – seen from the ground or the sky – are not only natural. Like the other regions of Italy (which is now one the most densely inhabited countries in Europe), this ancient land overlooking the Tyrrhenian Sea has an extensive network of roads, industrial areas, power stations, railways and airports. The evocative geometric patterns formed by the Renaissance and medieval towns are flanked by the far less charming ones of the business districts and built-up modern areas, which have often been developed without planning or regulation of any kind. The ministries and state agencies are flanked by a private sector that all the statistics indicate as one of the most active and dynamic in Italy, bringing an ever-increasing flow of Italians and foreigners to Rome and Lazio, and consequently the landscape is undergoing rapid change. You need only cross the region on a highway or expressway, or look out of the window of an airplane descending toward the runways of Fiumicino Airport, to see that the open spaces of the Campagna Romana, Ciociaria, Pontine Marshes and the region's other flat or hilly areas are rapidly filling up.

Vast stretches of the mountains are still solitary and wild, and many small towns on their slopes have suffered rapid depopulation. However, even on the "roofs" of Lazio, from the Mainarde to the Laga, the lumber tracks, residential areas, ski runs and other manmade features have left visible traces, even at high altitudes. The local governments, which often pretended not to see in the past, have now largely changed their attitude. However, although most of the dumps have disappeared and the protected areas have multiplied almost everywhere, it is not easy to manage a territory as subject to great human pressure as Lazio is.

Visitors to Rome and Lazio are invited to keep their eyes wide open in order discover the thousand facets of the territory and the works that humankind has built there over the centuries, for the region conceals many secret gems, located just a stone's throw from famous places. It is important to realize that the appearance of Lazio is constantly changing, although not always for the better. However, this has been the case for 30 centuries and will continue to be so in the future.

15 Gaeta (Latina), for centuries a stronghold of the Kingdom of Naples, offers a safe landing place guarded by the medieval cathedral and the Bourbon fortress.

18-19 The Spanish Steps (partially hidden in this photograph) lead down from the Trinità dei Monti Church to Piazza di Spagna in Rome.

20-21 The rocky walls and dense Mediterranean scrub of Mt. Circeo descend toward the Tyrrhenian Sea.

22-23 Man's presence has helped to create precious tapestries on the hillsides of Latina.

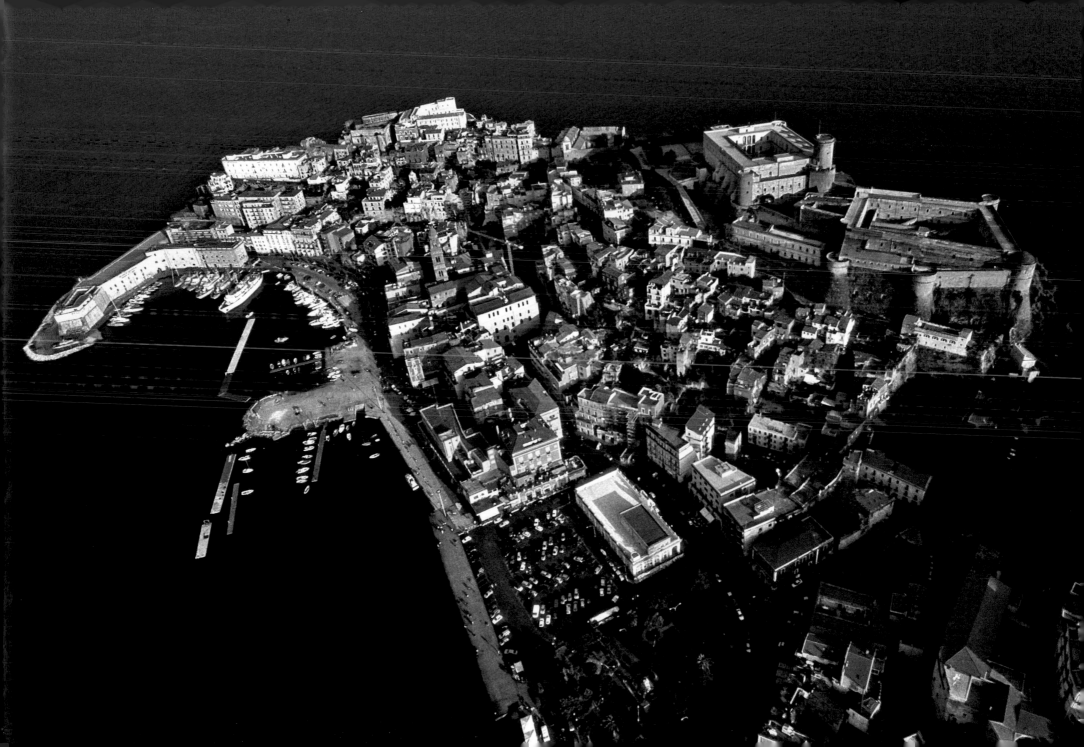

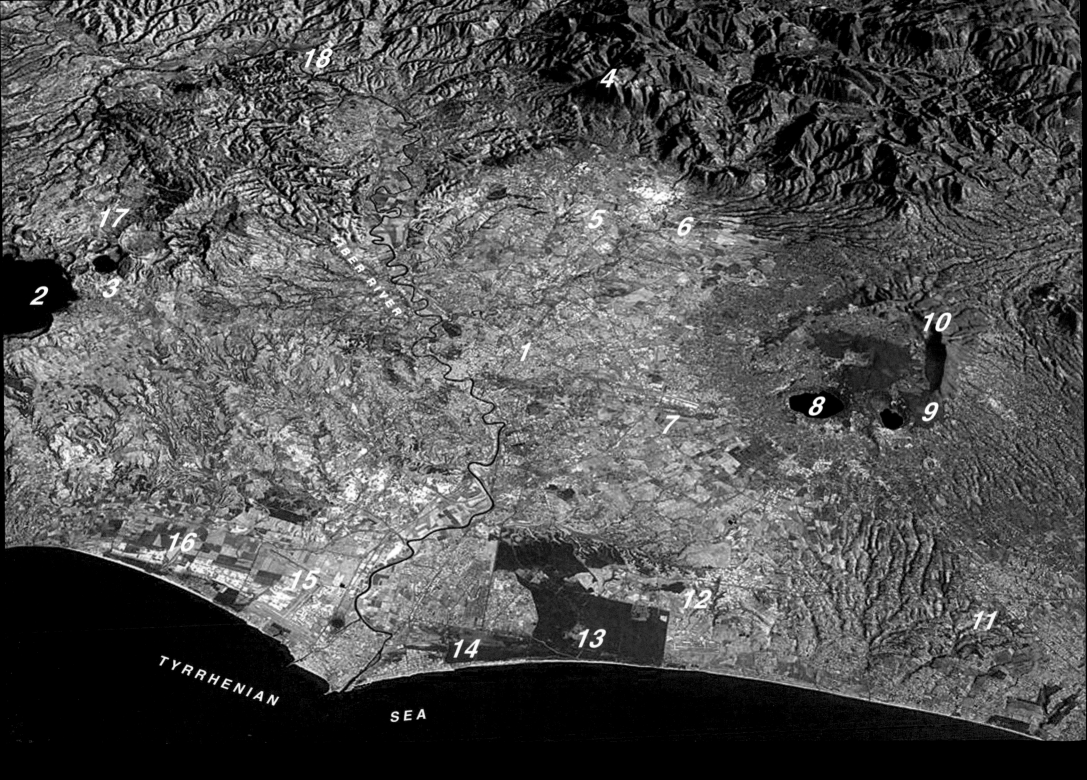

TIBER RIVER

TYRRHENIAN

SEA

Facts and figures on Rome and its region

- Area: 6642 sq. miles (17,203 sq. km)
- Population: 5,145,805 (last census)
- Regional capital: Rome (3,807,992 inhabitants)
- Provincial capitals: Frosinone (48,466), Latina (108,968), Rieti (44,453), and Viterbo (59,354)
- The territory is prevalently hilly (53.9%); the rest of the region is mountainous (26.1%) or flat (20%)
- Main rivers: Tiber (252 miles/405 km), Liri-Garigliano (98 miles/158 km), Aniene (62 miles/100 km), Velino (56 miles/90 km), and Sacco (54 miles/86 km)
- Main lakes: Lake Bolsena (44.2 sq. miles/115 sq. km), Lake Bracciano (22.2 sq. miles/ 57.5 sq. km), Lake Vico (4.7 sq miles/12.1 sq. km), Lake Albano (2.3 sq miles/5.9 sq. km), Lake Fondi (1.7 sq. miles/4.4 sq. km), Lake Fogliano (1.6 sq. miles/ 4.1 sq. km), and Lake Sabaudia (1.5 sq miles/3.8 sq. km)

- The coastline (mainland and islands) stretches for 224.6 miles (361.4 km)
- Islands: Ponza (3.8 sq. miles/9.8 q. km); Ventotene (0.6 sq. miles/1.5 sq. km), Palmarola (0.4 sq. miles/1 sq. km), Zannone (0.35 sq. miles/0.9 sq. km), Santo Stefano (0.19 sq. miles/0.49 sq. km), and Gavi (0.15 sq. miles/0.38 sq. km)
- Highest peak: Mount Gorzano (8058 ft/2456 m)
- Lazio comprises 378 municipalities, 259 of which have fewer than 5000 inhabitants
- Population density: 116 inhabitants per sq. mile (306 per sq. km)
- National parks in Lazio:
 - Circeo National Park
 - Gran Sasso and Laga Mountains
 - Abruzzo National Park, Lazio, Molise

16 Rome is not only a splendid art city, the capital of the ancient world and the cradle of modern Mediterranean civilization, but also the center of a region brimming with places of historical and natural interest, as revealed by this satellite photograph, which shows:

1	Rome	7	Fiumicino	13	Torvaianica Plain
2	Lake Bracciano	8	Lake Albano	14	Lido di Ostia
3	Lake Martignano	9	Lake Nemi	15	Ostia
4	Sabine Hills	10	Alban Hills	16	Cerveteri Plain
5	Guidonia	11	Aprilia	17	Sabatini Mountains
6	Tivoli	12	Pomezia	18	Sabina

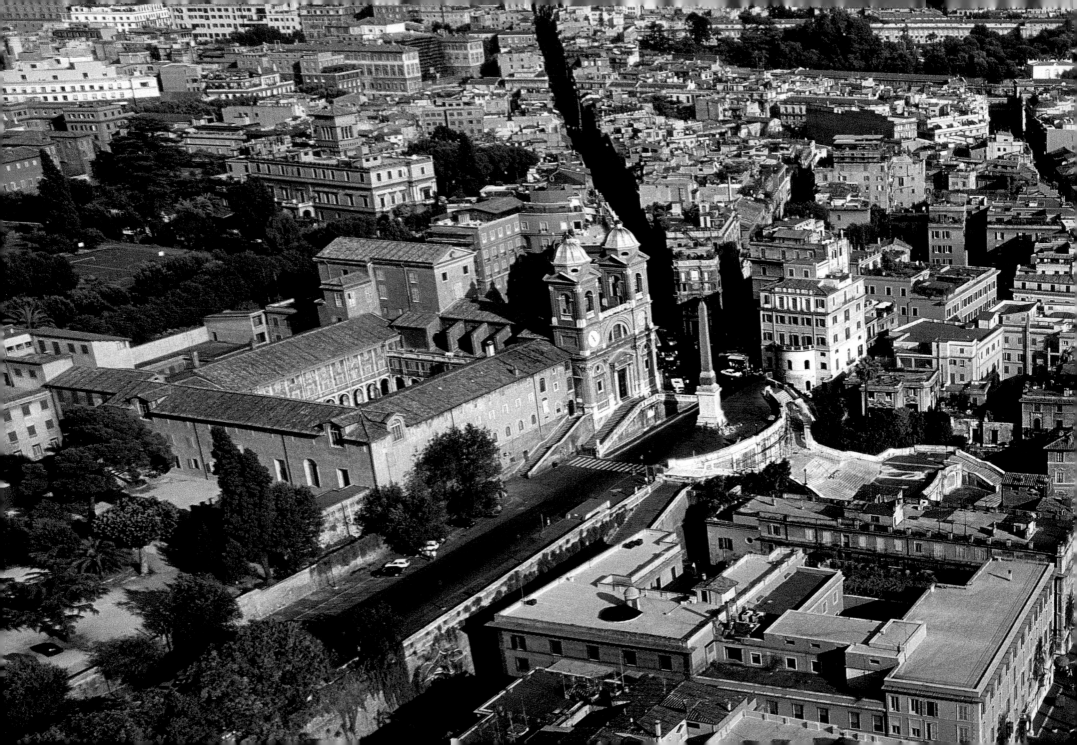

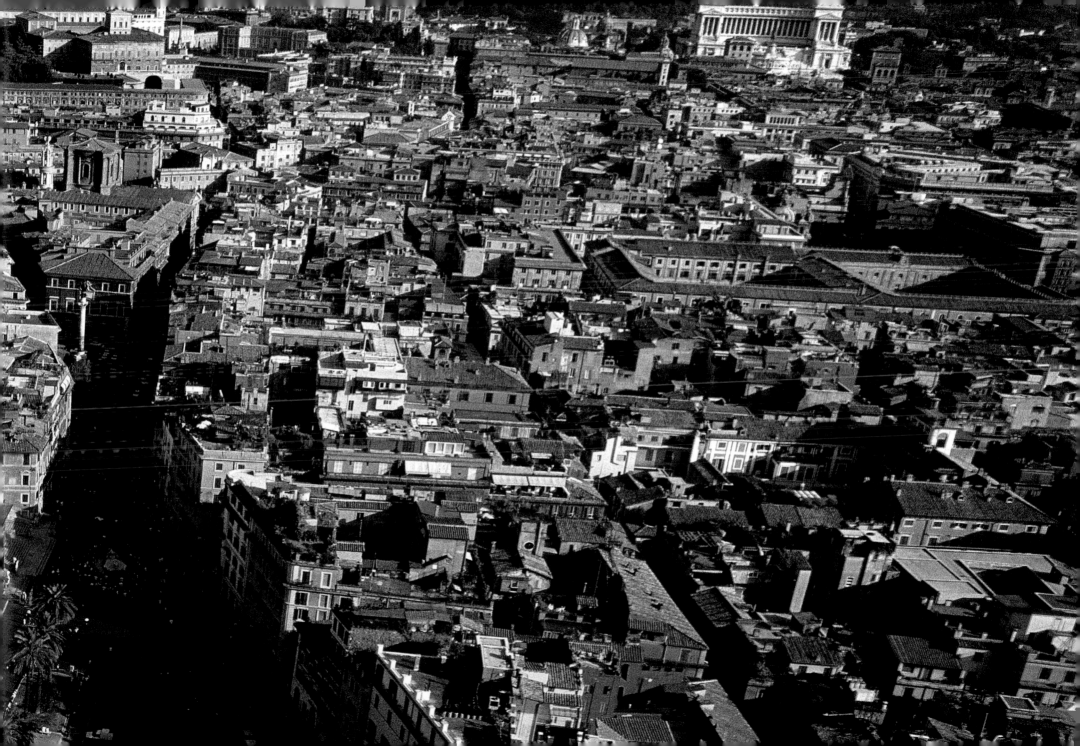

 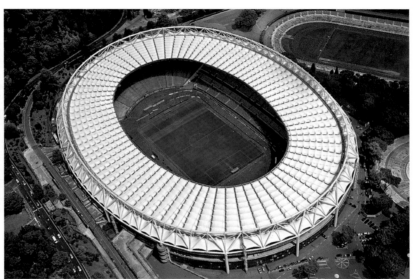

ROME

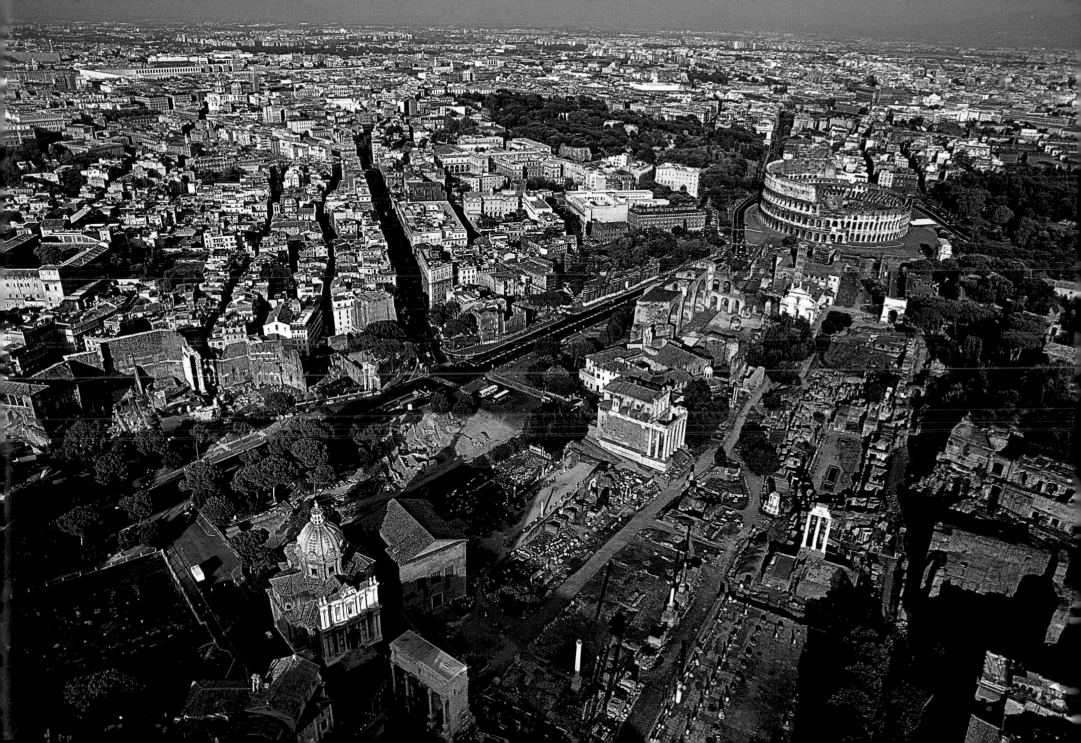

First of all, there's the Tiber. Viewed from high above, or even from an airplane descending toward Fiumicino or Ciampino, the loops of Italy's third-largest river mark the landscape, history and modern themes of the city. The bend of Tiber Island, between the Trastevere district and the Ghetto, is the site of Rome's oldest bridges and memories. Indeed, the very earliest city was built on this spot, next to the river (*Rumon* or *Ruma* means "water" in the Etruscan language), where a ford linked the lands of the Etruscans to the north to those of the Latins to the south. The Cloaca Maxima flows into the river opposite the island. The sewer was built under the Tarquins, who drained the marshes between the Palatine and the Capitoline hills, allowing the transformation of the early villages into a true city.

The Romans spanned the turbulent waters of the Tiber with eight bridges. The Fabricio and the Cestio, on the two sides of the island, date back to 62 and 46 BC. The only surviving span of the Pons Aemilius over the rapids, just downstream of the island, was built in 179 BC and restored in 142 BC. The bridge collapsed many times, even after having been rebuilt by Michelangelo between 1548 and 1549. Indeed, for centuries the witty Romans have called it the "Ponte Rotto" (Broken Bridge).

Just over half a mile upstream of the island, the opposition of the two powers that have coexisted in Rome for one and a half centuries is clearly visible in the loop of the Vatican and the city center. The dome of St. Peter's, the walls of the Vatican City, and the mausoleum of Emperor Hadrian – transformed into Castel Sant'Angelo, the fortress of the popes – rise on the right bank of the river, while the left bank, beyond Piazza Navona and the river port of Ripetta, is home to the palaces of worldly power, built or rebuilt following the breach of Porta Pia, through which Italian troops entered the city in 1870, and the subsequent transfer of Parliament and the Government from Florence. Although Palazzo Montecitorio, Palazzo Madama and Palazzo Chigi (home to the Chamber of Deputies, the Senate and the Prime Minister) commenced their functions following the birth of modern Italy, Palazzo Quirinale was originally the residence of the popes, passing to the kings of the Savoy dynasty in 1871 and subsequently to the presidents of the Italian Republic.

24 left Joined to the banks of the river by the Fabricio and Sestio bridges, Tiber Island played an important role in the settlement of the surrounding hills. It was the place of worship of many deities, but was chiefly dedicated to Aesculapius, the god of medicine.

24 right The Olympic Stadium was built during the 1930s and extended to seat 54,000 spectators on occasion of the 1960 Rome Olympic Games. Further renovation for the 1990 World Soccer Championship brought seating capacity up to 85,000.

25 The Forum extends toward the Colosseum and is separated by Via dei Fori Imperiali, the Monti quarter (ancient Suburra) and the districts built in the late 19th-century. The holm oaks, gardens, walls and old palaces of the Palatine can be seen on the right.

27 Rome grew up alongside Tiber Island, where a ford allowed easy crossing of the river. Today the island separates the Trastevere quarter (left of the photograph) from the historic district, where the Synagogue, Altar of the Nation and Piazza del Campidoglio can be seen. The Circus Maximus is visible at the bottom.

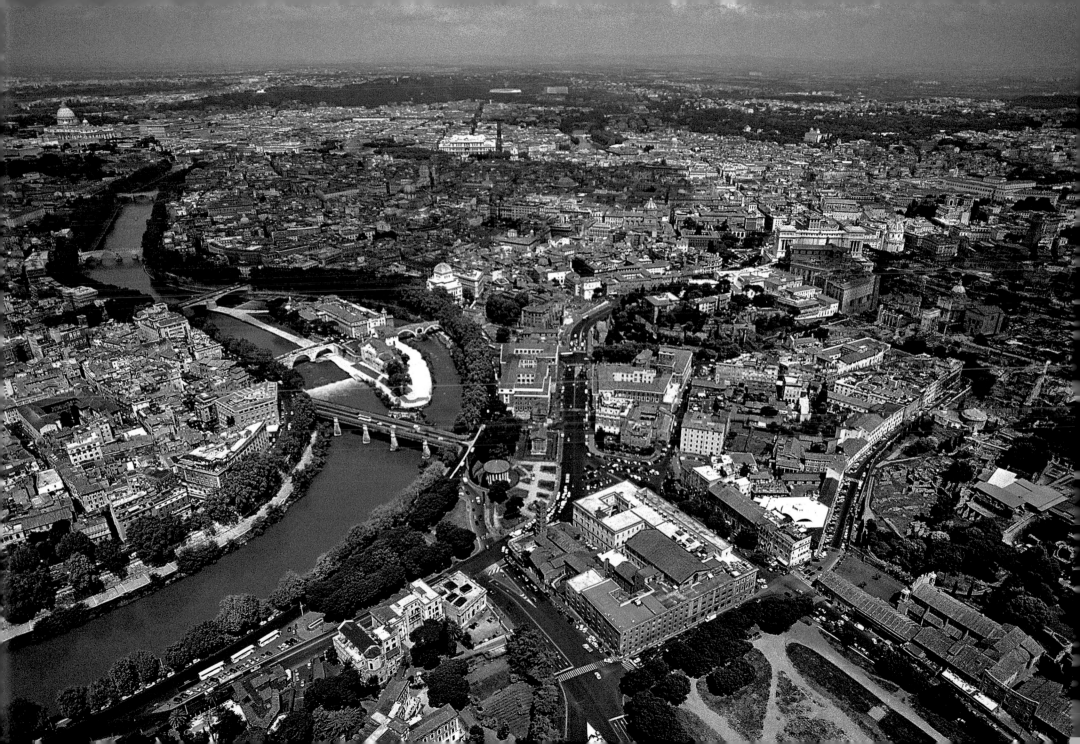

Today the right bank of the river is home to the Olympic Stadium, the RAI (Italian broadcasting corporation), the "Palazzaccio" and other law courts, and the restaurants of the Trastevere district. However, in the world of politics, the expression "across the Tiber" is used to refer to the Vatican.

Each bend in the river tells a different story. The first, for visitors arriving from the north, marks the spot where the Aniene flows into the Tiber and bears testimony to the recent expansion of the city with the tower blocks of the Nuovo Salario district, the viaducts of Via Olimpica, the mosque at the foot of Mt. Antenne, the little Urbe Airport and the parks crossed by the cycle track that connects Castel Giubileo and the Foro Italico.

Further downstream, the elegant Milvian Bridge, built in 109 BC, witnessed Constantine's victory over Maxentius, and the subsequent conversion of the pagan metropolis into the capital of the Christian world. For many centuries it was crossed by pilgrims from Northern Europe arriving in Rome at the end of a long journey along the Via Francigena. The next bend, overlooked by the pine trees and observatory of Mt. Mario, testifies to the building of the period of Fascist rule and the sporting life of the city. The Olympic Stadium, built for the 1960 Games, is surrounded by the Fascist architecture of the Foro Italico. This spot marks the starting point of a series of modern bridges and the travertine embankments, which prevent the Tiber from flooding the city as in the past.

28 left Built between 1889 and 1910, the imposing law courts (which Romans refer to as "the Palazzaccio") separate Piazza Cavour and the Prati district from the horse chestnut trees that line the embankment. The historic district can be seen behind, on the left bank of the Tiber.

Modern history has also left its mark south of the city center in the form of the metal arches of Ponte dell'Industria, the heart of 19th-century industrial Rome, and the white travertine buildings of the EUR district, begun in 1936 and housing the Palasport and other facilities created for the 1960 Olympic Games. After leaving the city behind, the river continues its sinuous journey toward the coast at Fiumicino and Ostia.

A lower flight altitude is needed to pick out the hundreds of squares set between the churches and palaces, which are home to more Egyptian obelisks than Cairo and offer visitors to Rome the most famous views of the city. The most famous of all is St. Peter's Square, which spreads out from the basilica and the Vatican toward the world. Bernini's 17th century colonnade opens up like a great embrace, echoing the Urbi et Orbi ("to the City and the World") blessing pronounced by the pope on New Year's Eve.

It is necessary to cross the Tiber to reach the squares of political power (Piazza di Montecitorio and Piazza Colonna) and the gem-piazzas that leave tourists gaping, from the oblong Piazza Navona to the perfect settings of the Pantheon, Piazza Farnese and the Trevi Fountain. Piazza del Campidoglio, designed by Michelangelo, watches over the city center from above, while the right bank of the river is home to Piazza Santa Maria in Trastevere, overlooked by Rome's oldest basilica, which is still in use today.

However, those who know and love the city are well aware that its heart and contradictions are best experienced in the more popular and well-trodden squares, where the monuments of the past encounter bustling modern life. The list includes Piazza San Giovanni, where faith lives alongside trade union demonstrations and rock concerts; Campo de' Fiori, which has been transformed from a place of execution to a fruit and vegetable market and night spot; and Piazza Vittorio Emanuele, with its esoteric garden and crowded market.

Other symbols of the thousand faces of Rome include Piazza Venezia, with its traffic jams, the view of the Forums, the steps of Santa Maria di Aracoeli and the Campidoglio, the travertine stone blocks of the Vittoriano and the balcony from which Mussolini made his speeches. Piazza dei Cinquecento is the end of the railway and bus lines and a meeting point for immigrants from Asia, Eastern Europe and Africa, while nearby Piazza Esedra was transformed into Piazza della Repubblica with the addition of arcades and a fountain. Piazza di Porta San Paolo is the site of the Pyramid of Cestius, the ancient city walls and another crowded station. However, the perfect combination is represented by the Baroque scenery of Piazza del

28 center Trajan's Column, built to celebrate the emperor's victories over the Dacians, separates Piazza Venezia from the Imperial Forums. It is flanked by the 16th-century dome of Santa Maria di Loreto (bottom) and the 18th-century one of the Santissimo Nome di Maria church.

28 right The church of Santa Maria in Cosmedin, on the edge of the Roman Forum, was built in the 6th century, making it one of the oldest in the city. It was a place of worship for Greeks fleeing the iconoclastic persecutions. It has been remodeled several times and is flanked by a fine Romanesque bell tower.

Popolo and the chaos of Piazzale Flaminio that opens up just beyond the walls. The boutiques, fashionable bars, steps of the Villa Borghese and churches of 17th-century Rome on one side contrast sharply with the traffic jams, urban railways and trams that carry thousands of commuters to the city center each day on the other.

Rome has had many faces over the centuries. The same perimeter has witnessed the successive foundation of the medieval, papal and Baroque cities, the new "Piedmontese" Rome, and today's modern metropolis. However, from the ground the visitor discovers that the ancient city still occupies a large portion of Rome. Indeed, the Forums, Colosseum, Palatine and Circus Maximus in the city center form the largest urban archaeological area in the world.

To the southeast, beyond the Pyramid of Cestius and the Baths of Caracalla, lies the ancient Appian Way, which continues another 9 miles (14.5 km) into the countryside, the Caffarella Valley and the arches of the Aqua Claudius and Aqua Felix aqueducts. The ruins of the ancient Roman port of Ostia and the hexagonal basin of Trajan's harbor at Portus can be seen toward the sea. The length and excellent state of preservation of the Aurelian Walls can only fully be appreciated from the sky. These fortifications were built between AD 271 and 275 and extended for almost 11.8 miles (19 km) around the largest city of the ancient world.

Finally, a bird's-eye vantage point reveals that Rome is a city of green spaces. The center is surrounded by maritime pines, the buildings and avenues of Villa Borghese and Villa Doria Pamphilj laid out by the great families of the papal city; Villa Torlonia, built during the early 19th century for a family of merchants of French origin; and Villa Ada remodeled from 1872 for the Savoy kings. Precious fragments of old parks also survive at Villa Celimontana, just a stone's throw from the Colosseum; Villa Sciarra on the Gianicolo Hill; Mt. Mario and in other places. Farther out lie the meadows, fields, cork oak forests, and gorges of the 17 parks and nature reserves that cover 217,500 acres (88,020 hectares) of the city's municipal territory.

The scientific value of these areas is constituted by the 1200 species of plants, 5000 species of insects, and 152 species of mammals, birds, amphibians and reptiles (including roe deer, barn owls and porcupines) documented by botanists and zoologists. However, the green areas of the Ancient Appian Way, Veio, Roman Coast and Decima-Malafede parks and the other protected areas around Rome also constitute a priceless heritage. History buffs can discover the landscape of the Campagna Romana as it was in bygone days, complete with butteri and flocks of grazing sheep, while the city's inhabitants and tourists can enjoy a precious area in which to experience and explore the world of nature.

31 The huge monument to Victor Emmanuel II (known as the Vittoriano) houses the Altar of the Nation and – since 1921 – the Tomb of the Unknown Soldier, dedicated to the unidentified fallen soldiers of the Great War. The steps lead down to Piazza Venezia.

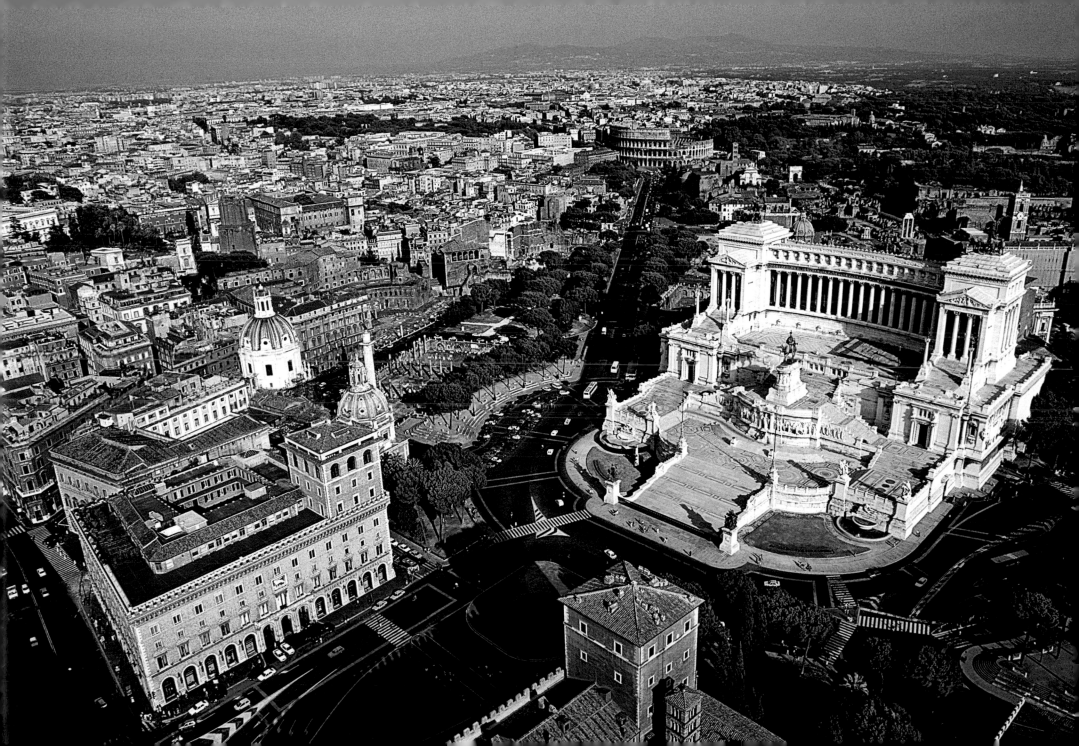

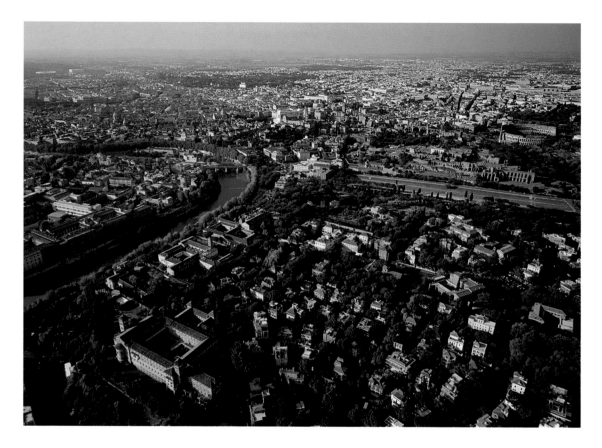

32 Houses, churches and monasteries alternate with the elegant green spaces of the Giardino degli Aranci and Roseto Comunale on top of the Aventine Hill, which overlooks the Tiber south of the Forums and the Capitoline. The valley occupied by the Circus Maximus separates the hill from the Palatine, Forums and the Colosseum.

33 The large, tree-lined Piazza Mazzini at the meeting place of eight streets is the center of the Prati district, built during the early decades of the 20th century between the Tiber, Vatican City and Mt. Mario. The Tiber and the green grounds of Villa Borghese can be seen on the right, with the churches of the city center in the background.

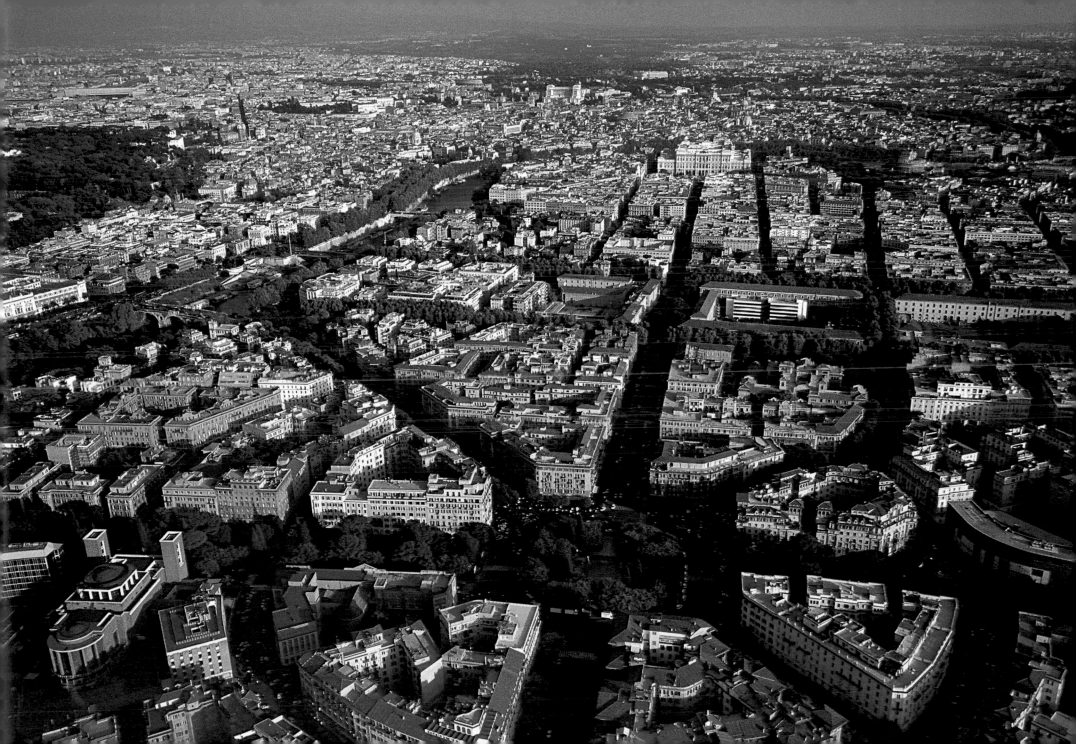

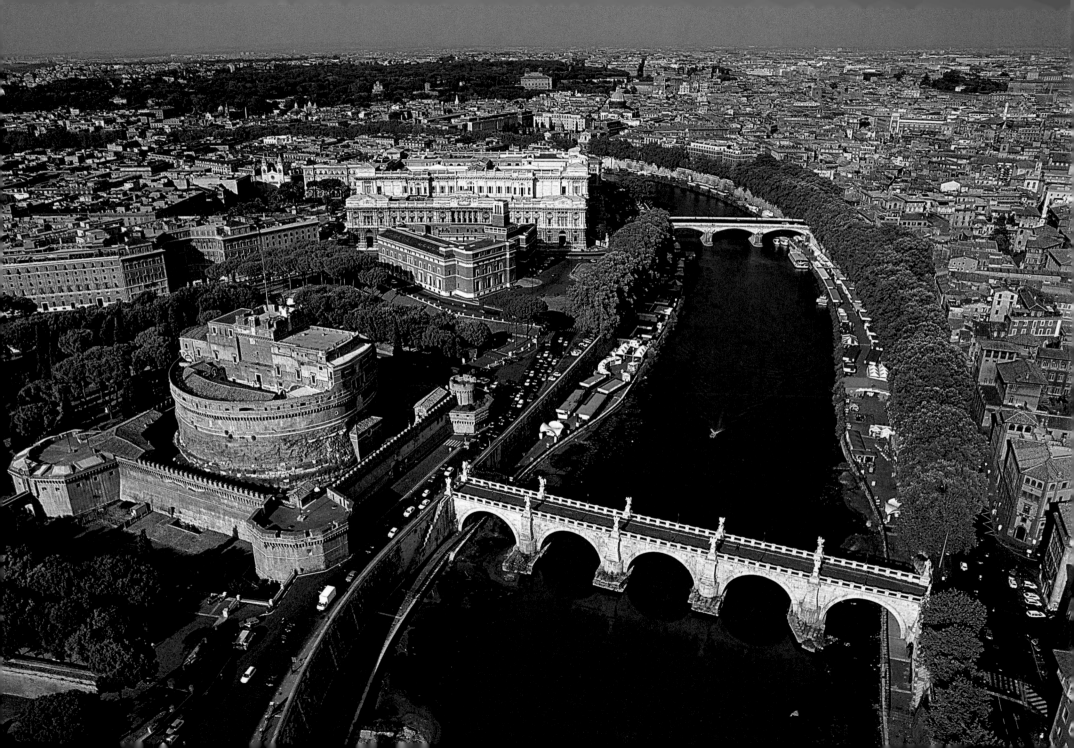

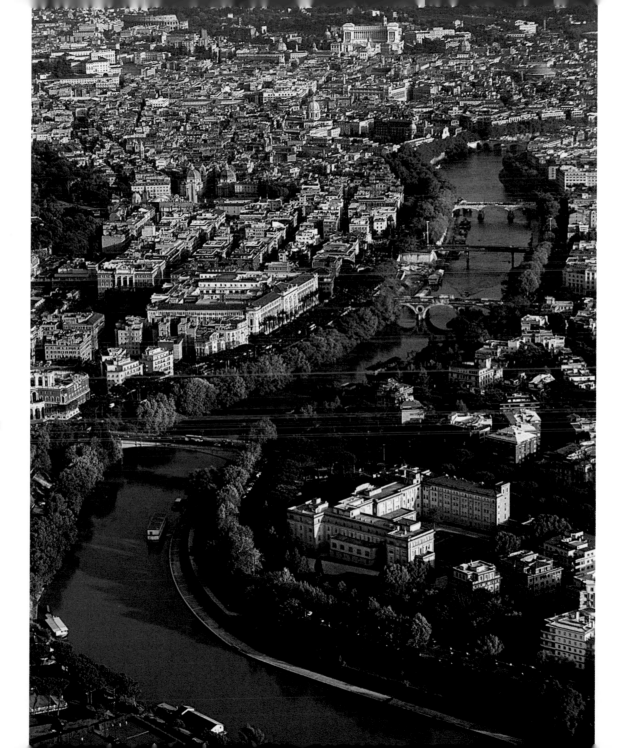

34 Castel Sant'Angelo, commenced in AD 130 as Emperor Hadrian's mausoleum and during the Middle Ages transformed into an imposing papal fortress, overlooks the Tiber and Ponte Sant'Angelo, decorated with statues of angels by Bernini's pupils.

35 North of the historic district, the Tiber separates the Flaminio quarter (on the left of the photograph), dominated by the imposing Ministry of the Navy, from the Prati district. The barges moored along the banks are home to sporting clubs (canoeing is very popular on the river) and restaurants.

36 A view from the sky, or from a boat on the Tiber, reveals the ancient origins of Ponte Sant'Angelo, built between AD 133 and 134 to connect Hadrian's Mausoleum (now Castel Sant'Angelo) with the center of Rome. The three central spans of the ancient bridge still survive.

37 The ten great statues of angels bearing the symbols of Christ's passion make Ponte Sant'Angelo both elegant and unmistakable. The statues were designed by Gian Lorenzo Bernini (1598-1690), one of the leading figures of Baroque-era Rome, and created by the artists of his school.

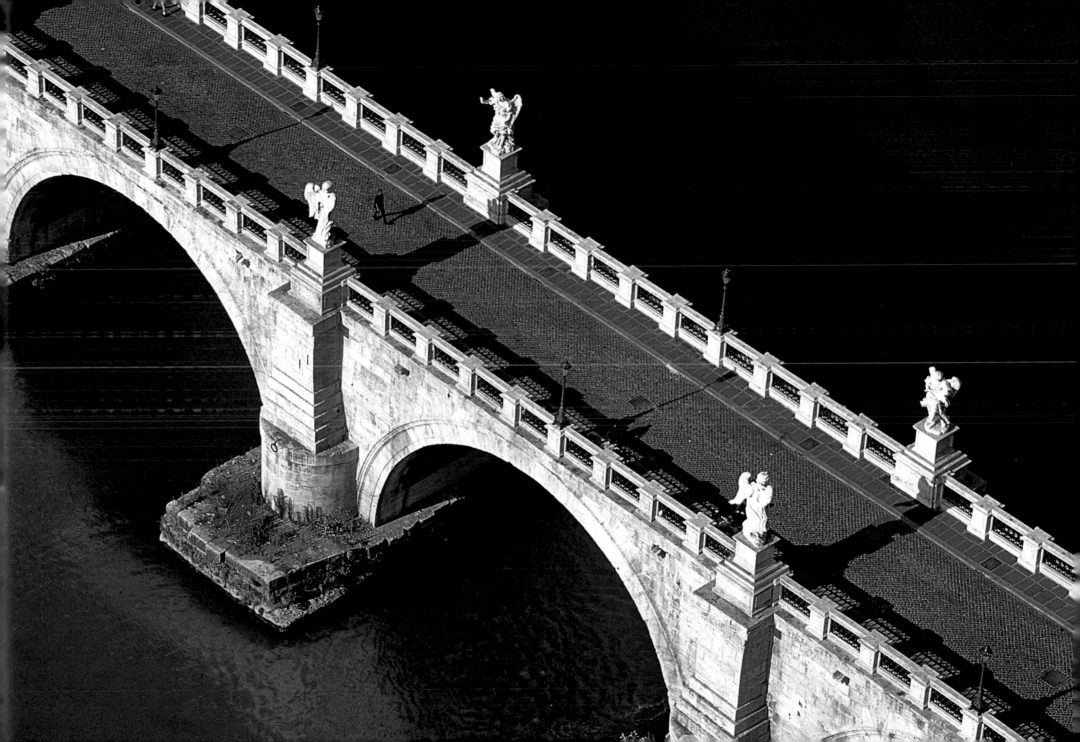

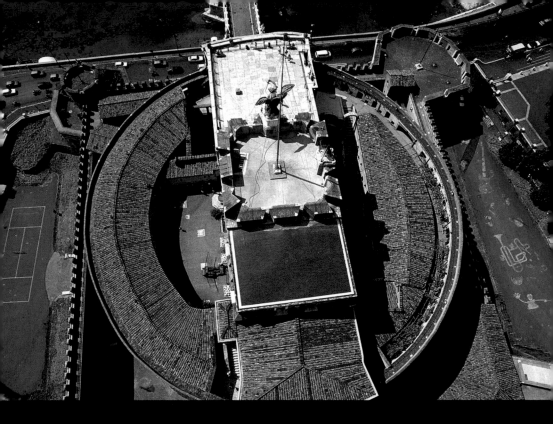

38 Castel Sant'Angelo is one of Rome's best-known monuments and owes its name to Pope Gregory the Great, who had a vision of an angel sheathing a sword during the plague outbreak of 590. The great bronze statue on top of the monument recalls the episode.

39 A close-up image allows the various construction phases of Castel Sant'Angelo to be identified. The cylindrical base is that of Hadrian's Mausoleum, while the walls and upper part were added for the popes during the Middle Ages, and the garden was laid out in the 20th century.

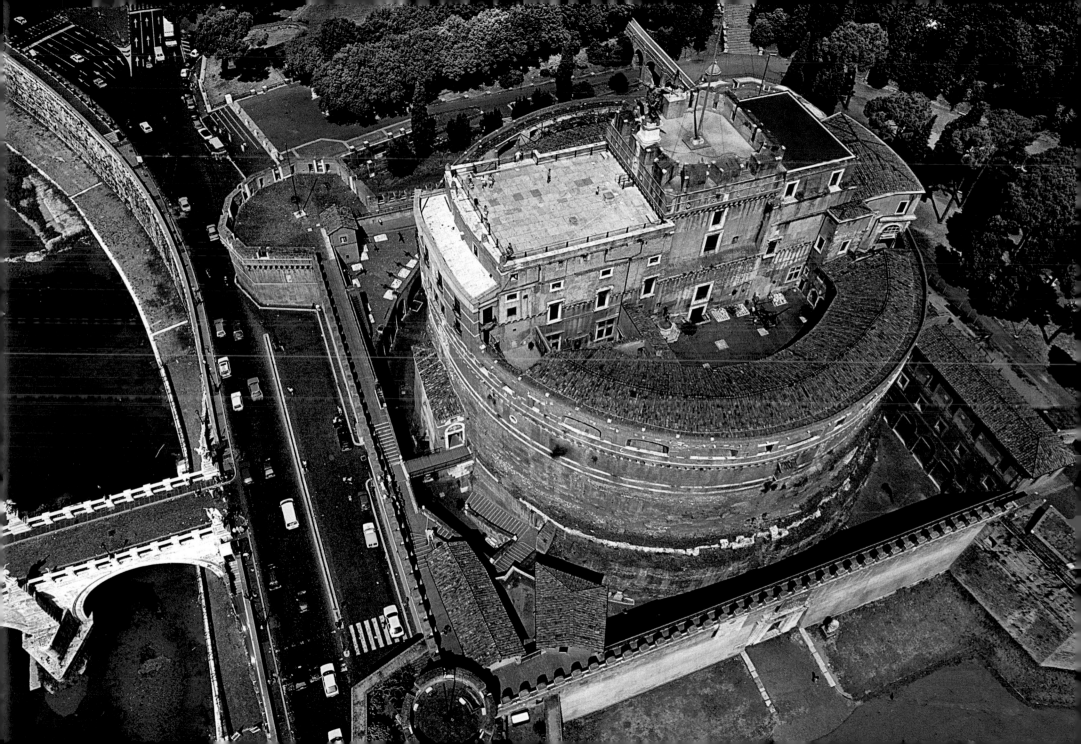

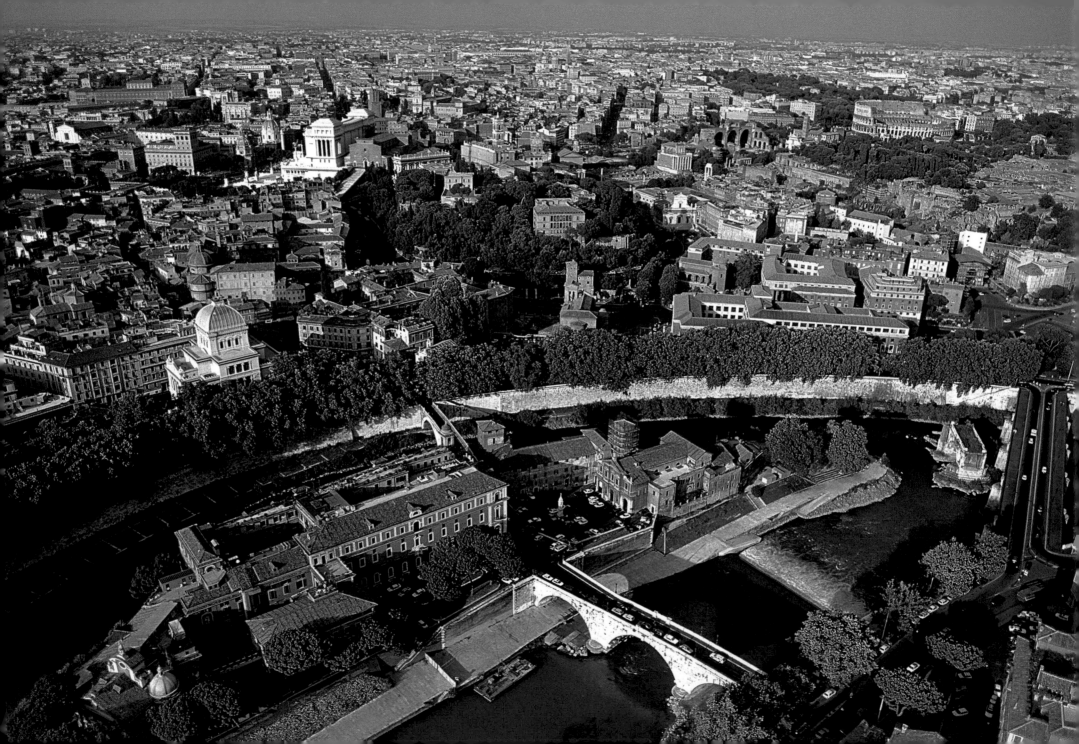

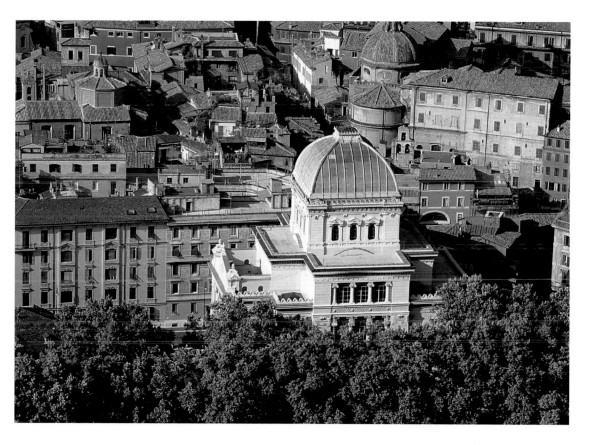

40 Tiber Island is home to the imposing Fatebenefratelli (or San Giovanni di Dio) Hospital and the church of San Bartolomeo all'Isola. Ponte Cestio connects the island to the Trastevere quarter, while Ponte Fabricio joins it to the historic district and the Ghetto. The ruins of the Pons Aemilius can be seen on the right.

41 The dome of the New Synagogue, built between 1899 and 1904, dominates the Ghetto, as Rome's Jewish quarter is still known. In addition to the ancient monuments (the most famous of which is the Portico of Octavia), the district is also home to the memory of the Roman Jewish community, which was damaged but not wiped out by the deportations of 1943 and 1944.

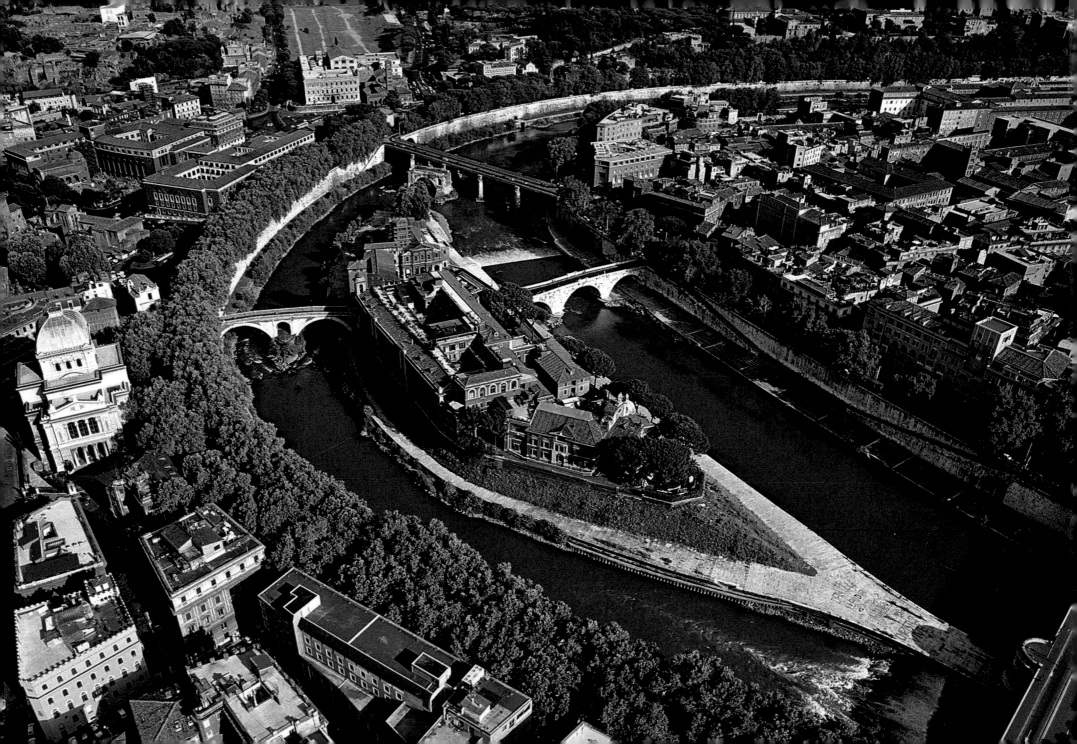

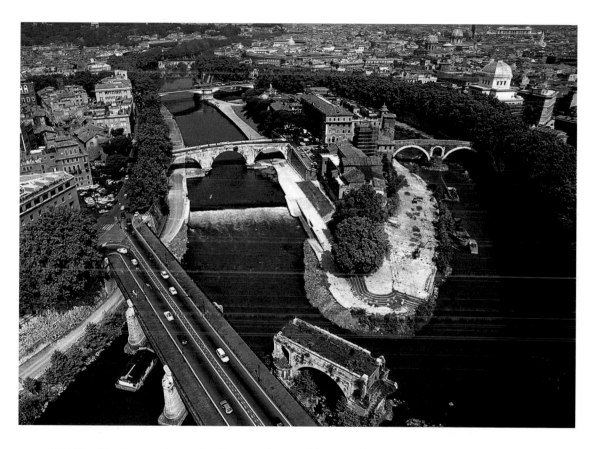

42 The Tiber's travertine embankments, designed by Raffaele Canevari and built between 1876 and 1900, prevent the river from periodically flooding the city. On the right bank, upstream of Ponte Cestio and the rapids, lie the quays of one of the city's many landing places.

43 The modern structure of Ponte Palatino, built in 1886, stands alongside the only surviving arch of the Pons Aemilius, the first stone bridge of ancient Rome. Destroyed several times by the waters, the Romans have nicknamed the construction "Ponte Rotto" (Broken Bridge).

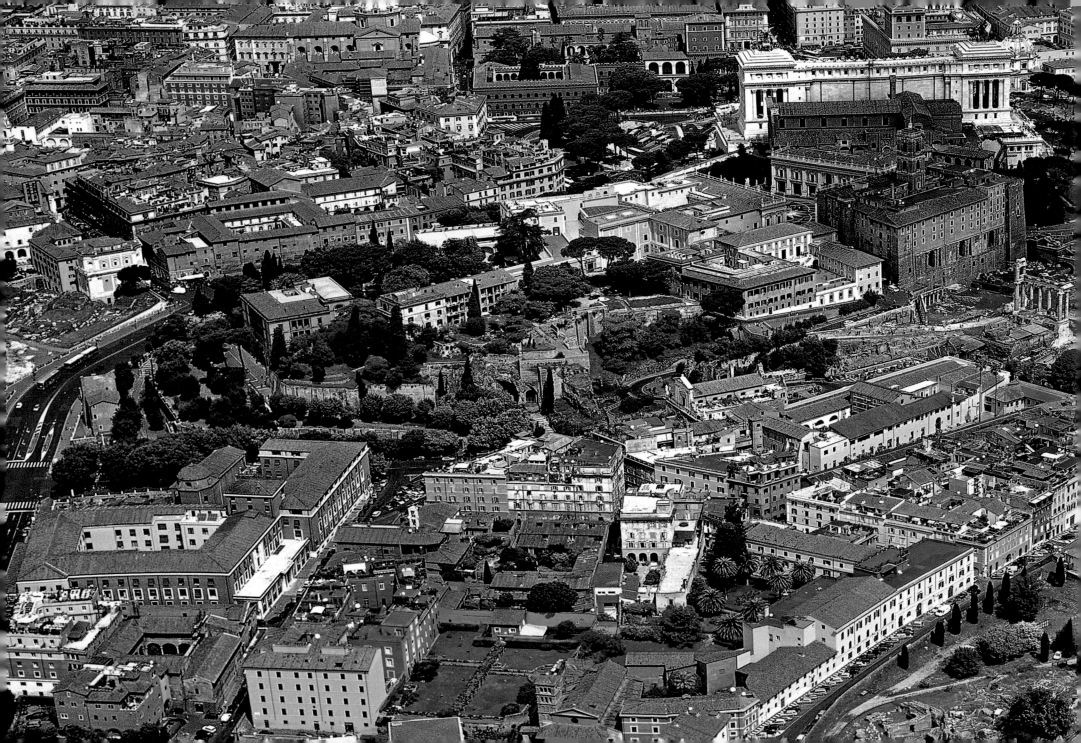

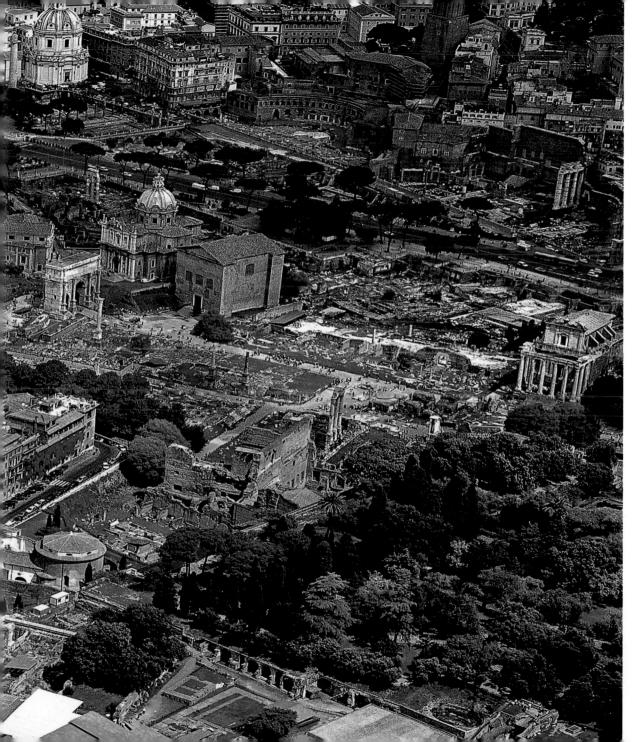

44-45 The Capitoline is the geographic and administrative heart of Rome (and the site of the city hall), which started to assume its current form in 1563, when Michelangelo designed the Piazza del Campidoglio and the surrounding palaces for Pope Paul III. The hill dominates the valley and the ancient monuments of the Roman Forum.

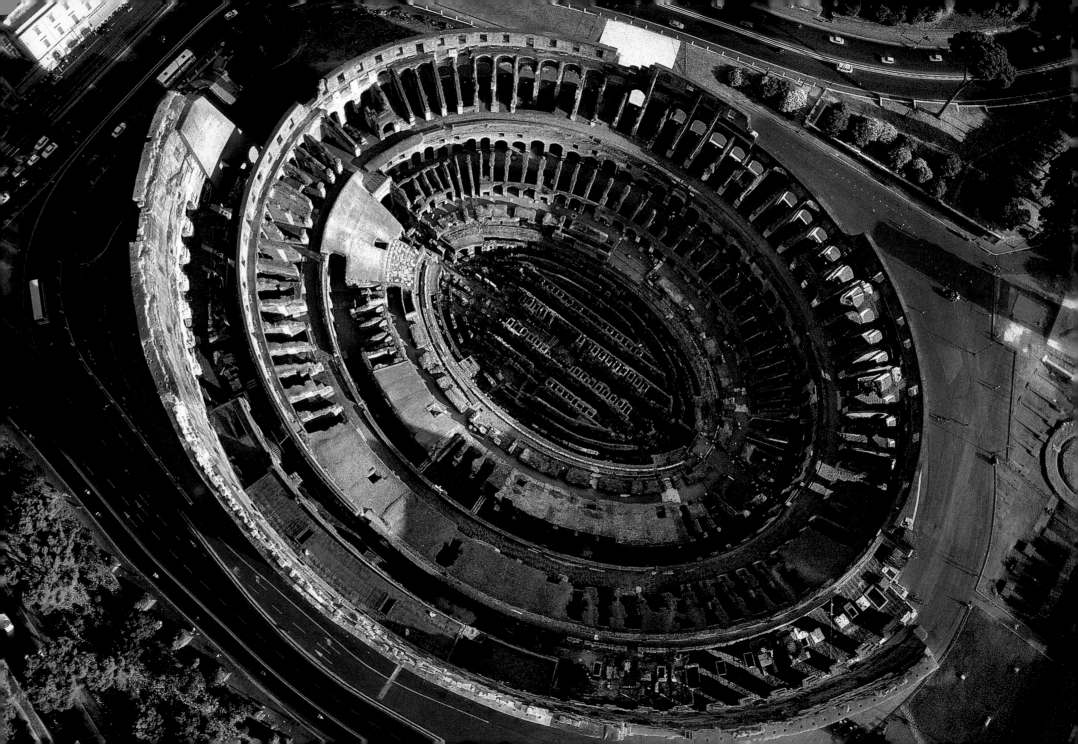

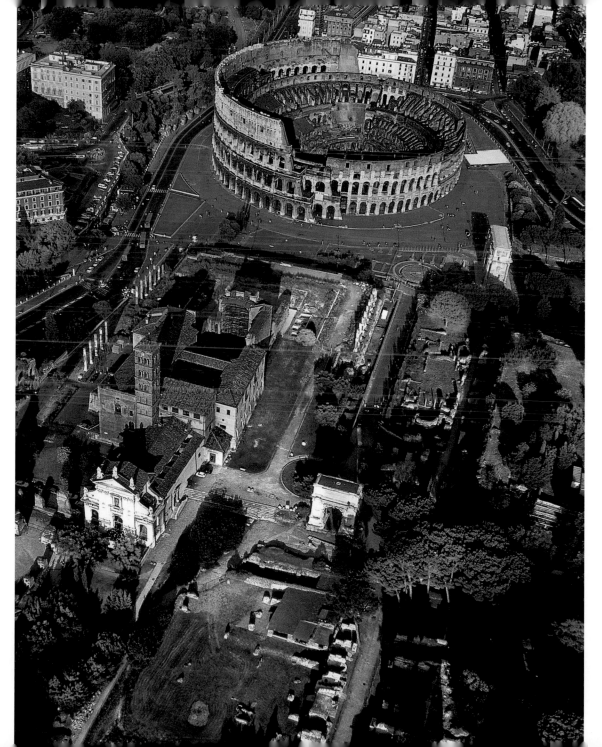

46 A bird's-eye view reveals the inner structure of the Colosseum, the huge amphitheater that was able to accommodate some 50,000 spectators. Today the arena and many of the terraces have collapsed, revealing the corridors, cells and other underground areas.

47 The church of Santa Francesca Romana (or Santa Maria Nova), built during the 9th century and adorned with a handsome travertine façade in 1615, and the elegant Arch of Titus, erected during Domitian's rule to celebrate the victories of Vespasian and Titus over the Jews, stand between the Colosseum and the Roman Forum.

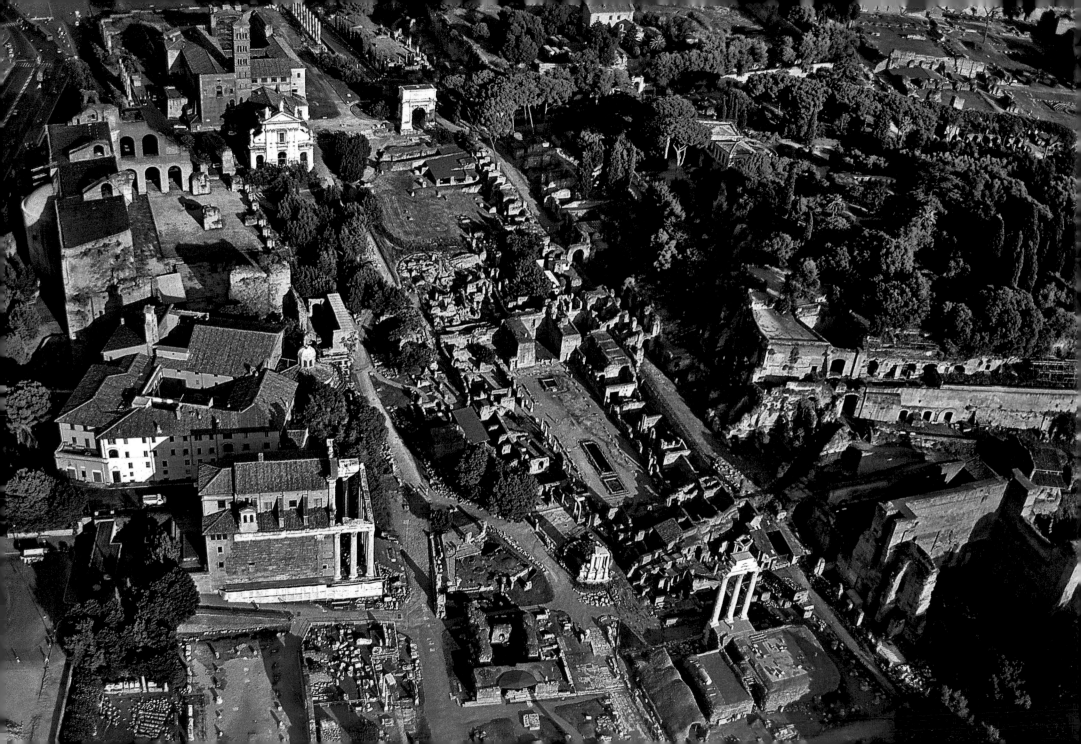

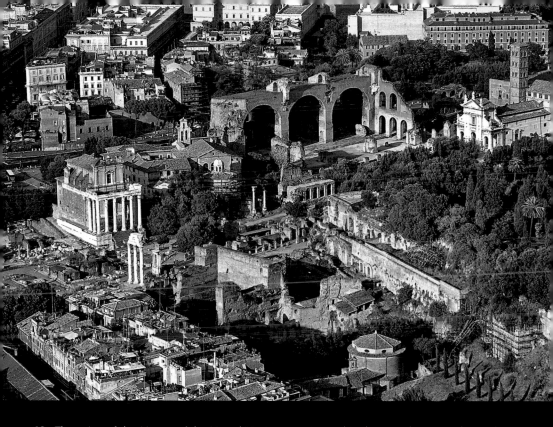

48 The ruins of the House of the Vestal Virgins are situated in the area between the Arch of Titus and the three surviving columns of the Temple of Vesta, in the narrowest part of the Roman Forum. The Temple of Antoninus and Faustina, now the church of San Lorenzo in Miranda, is visible on the left and the gardens of the Palatine on the right.

49 An aerial view from the south shows the gardens on the top of the Palatine Hill (the Orti Farnesiani, laid out during the 17th century) and the huge arches of the Basilica of Maxentius, commenced in AD 308 and completed by Constantine following his victory at the Milvian Bridge

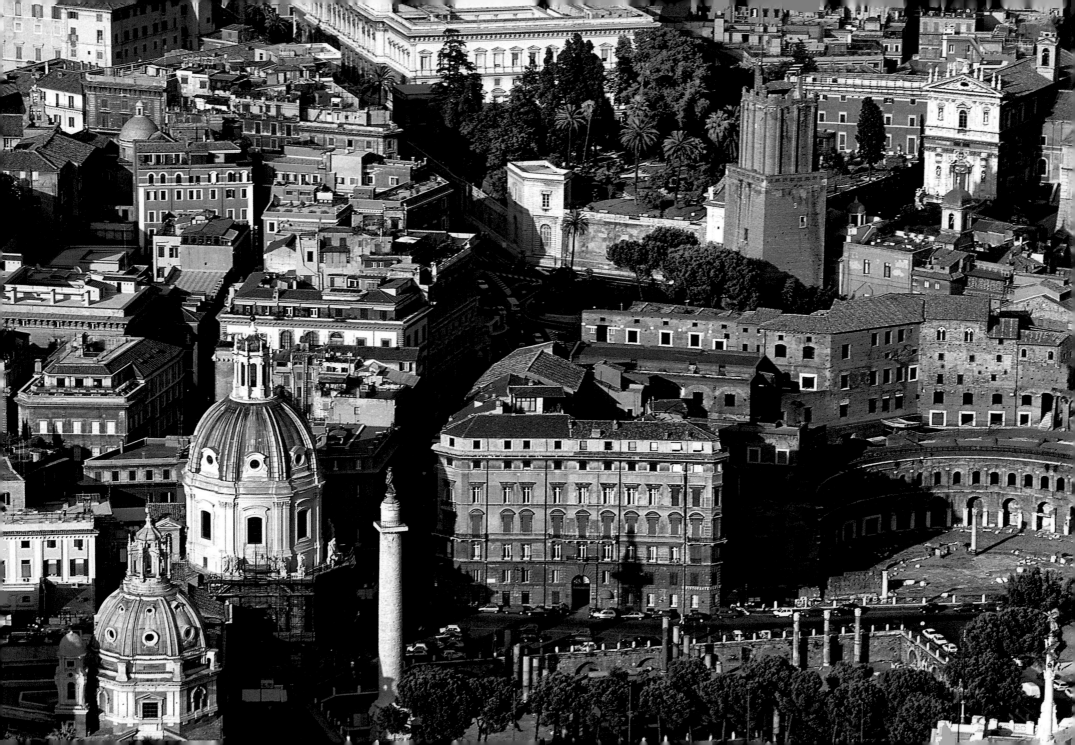

50 The Militia Tower, built during the first few decades of the 13th century, dominates Trajan's Markets and Trajan's Forum, the last and most splendid of the Imperial Forums that flank the Roman Forum. Trajan's Column and the churches of Santa Maria di Loreto and Santissimo Nome di Maria can be seen on the left.

51 The Arch of Constantine, the largest of ancient Rome's triumphal arches, stands just a few feet away from the Colosseum. It was solemnly inaugurated in AD 315 and decorated with bas-reliefs depicting the emperor's triumphs and his victories over the Dacians and at the Battle of the Milvian Bridge.

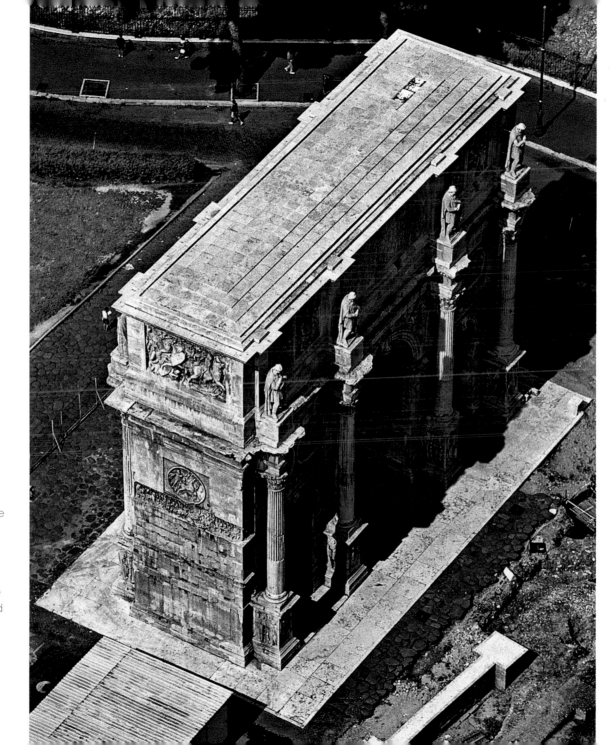

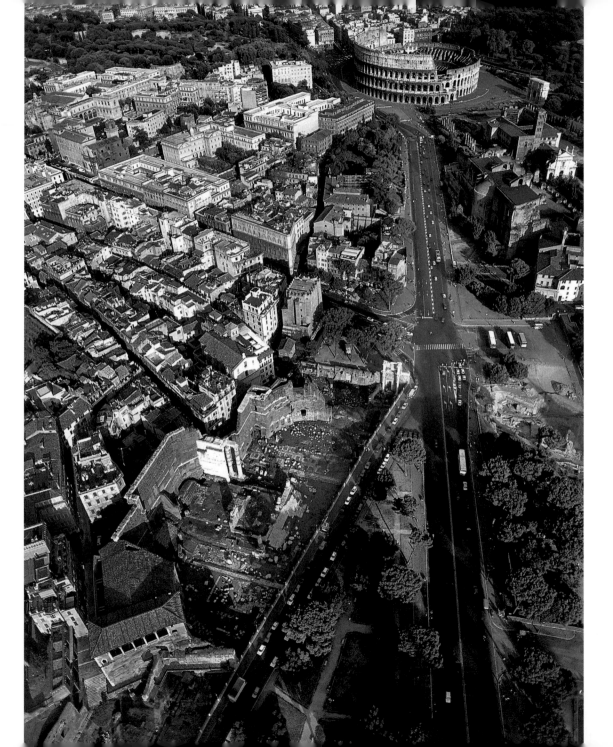

52 The Forums of Caesar, Augustus, Nerva and Trajan (known as the Imperial Forums), commenced in 54 BC and subsequently buried beneath a medieval quarter, were unearthed in 1924 and later partially hidden again by Via dell'Impero, now known as Via dei Fori Imperiali.

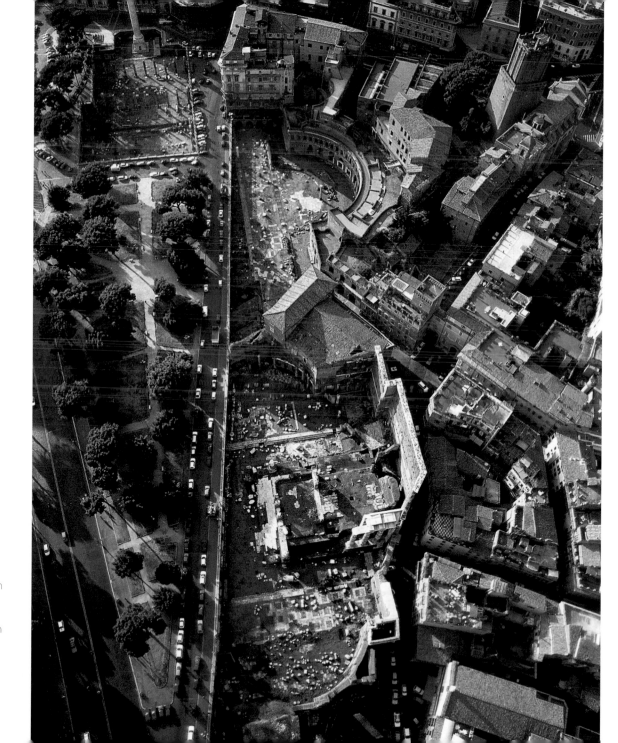

53 The Forums of Trajan (top) and Augustus are the best preserved of the Imperial Forums complex. A high boundary wall separates the Forum of Augustus, with the podium of the temple dedicated to Mars Ultor, from the medieval and modern buildings of the Monti district.

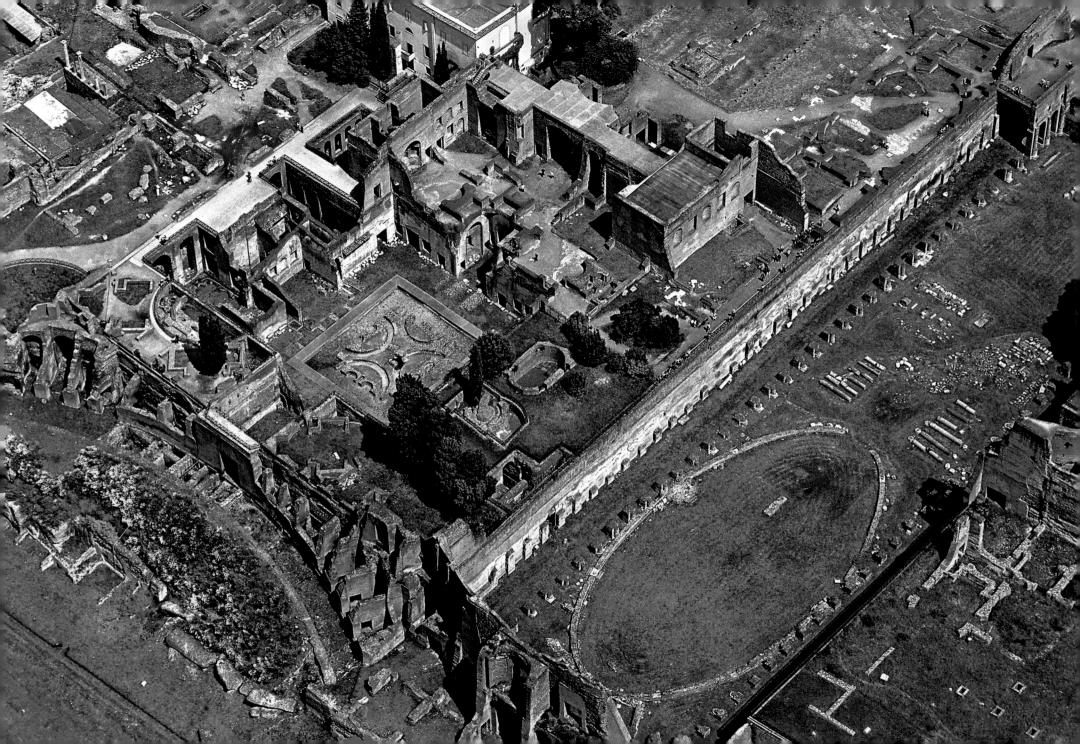

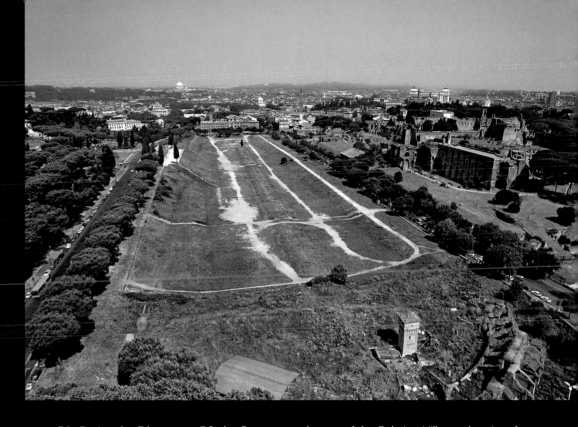

54 During the 7th century BC, the flat area on the top of the Palatine Hill was the site of one of the villages that later grew into Rome, and is still home to the ruins of imperial palaces such as the Domus Flavia, Domus Augustana and Domus Severiana. The amphitheater visible in the photo is Theodoric's oval enceinte of the Palatine Stadium.

55 The Circus Maximus, between the Palatine and Aventine hills, was ancient Rome's great hippodrome. Founded during the reign of Tarquinius Priscus, it was remodeled many times (the last ones under Trajan, Caracalla and Constantine), and although no monumental remains have survived, it is nonetheless an evocative venue for concerts and events.

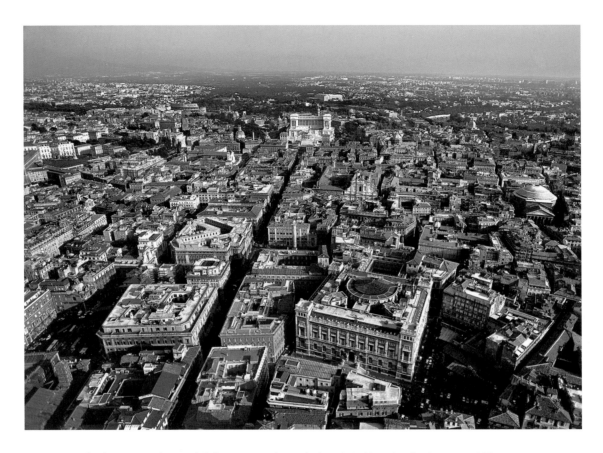

56 The long straight Via del Corso cuts through the city's historic district toward Piazza Venezia and the monument to Victor Emmanuel II. On its right stands Palazzo di Montecitorio, built in 1650 and converted to house the Chamber of Deputies in 1871.

57 The Pantheon's great dome with its oculus makes it an unmistakable landmark. The temple was commenced in 27 BC by Marcus Vipsanius Agrippa and was rebuilt by Hadrian, before being converted to a Christian church in AD 609. Today the monument houses the tombs of Raphael and the Savoy kings.

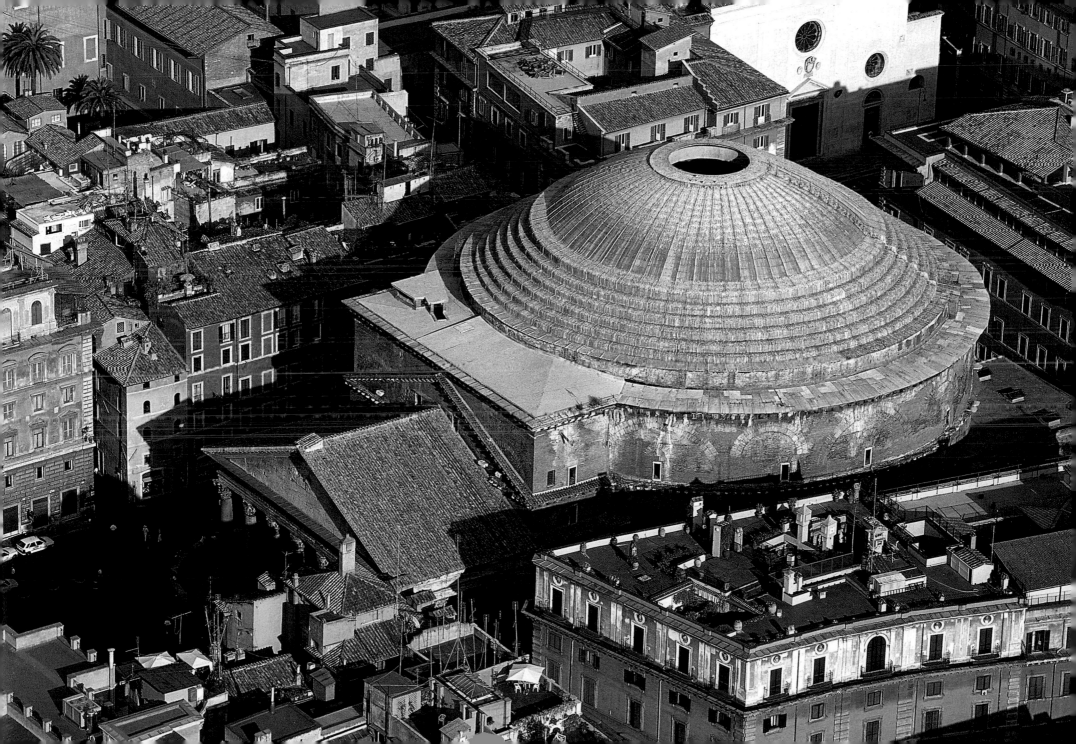

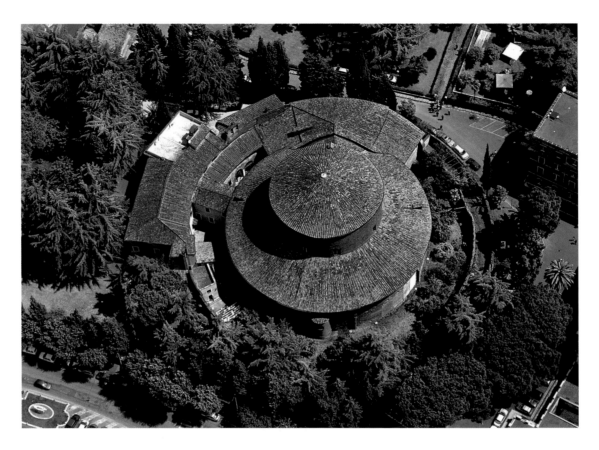

58 The Church of Santo Stefano Rotondo, on the Caelian Hill, is one of the oldest in Rome (it was consecrated by Pope Simplicius between 470 and 480) and has the same circular plan as the Early Christian basilicas of Ravenna.

59 The roofs and domes of what has rightly been called the "Renaissance city" extend from the Pantheon toward the Vittoriano and the Capitoline. The façades of the churches of Santa Maria Sopra Minerva (to the right of the Pantheon) and Sant'Ignazio can be discerned.

60-61 A single photograph reveals some of the most important urban projects implemented following the unity of Italy; they include the embankments of the Tiber and Corso Vittorio Emanuele II that crosses the city center toward the Vittoriano. The Law Courts, on the left of the photograph, date back to the same period.

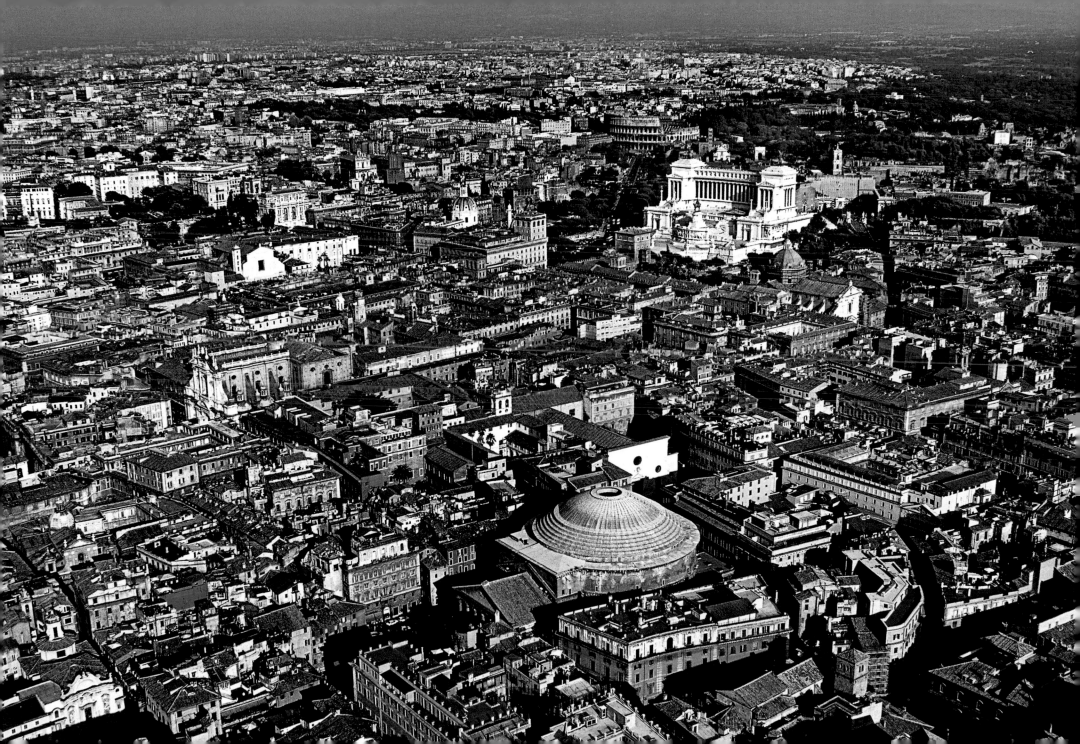

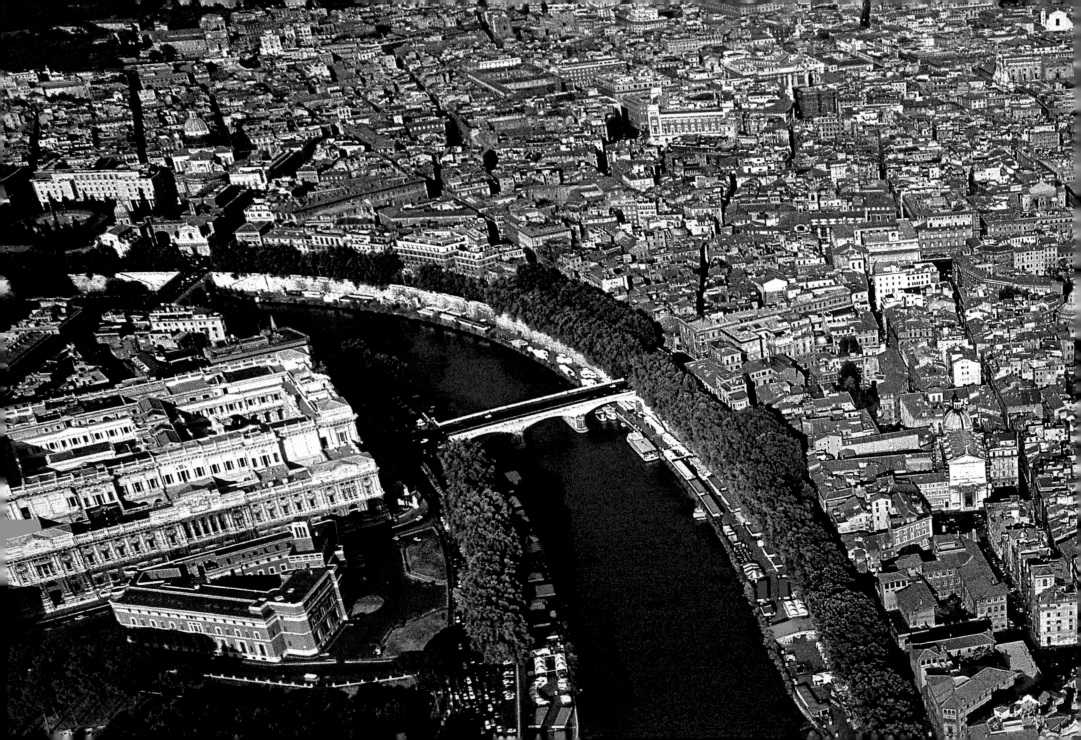

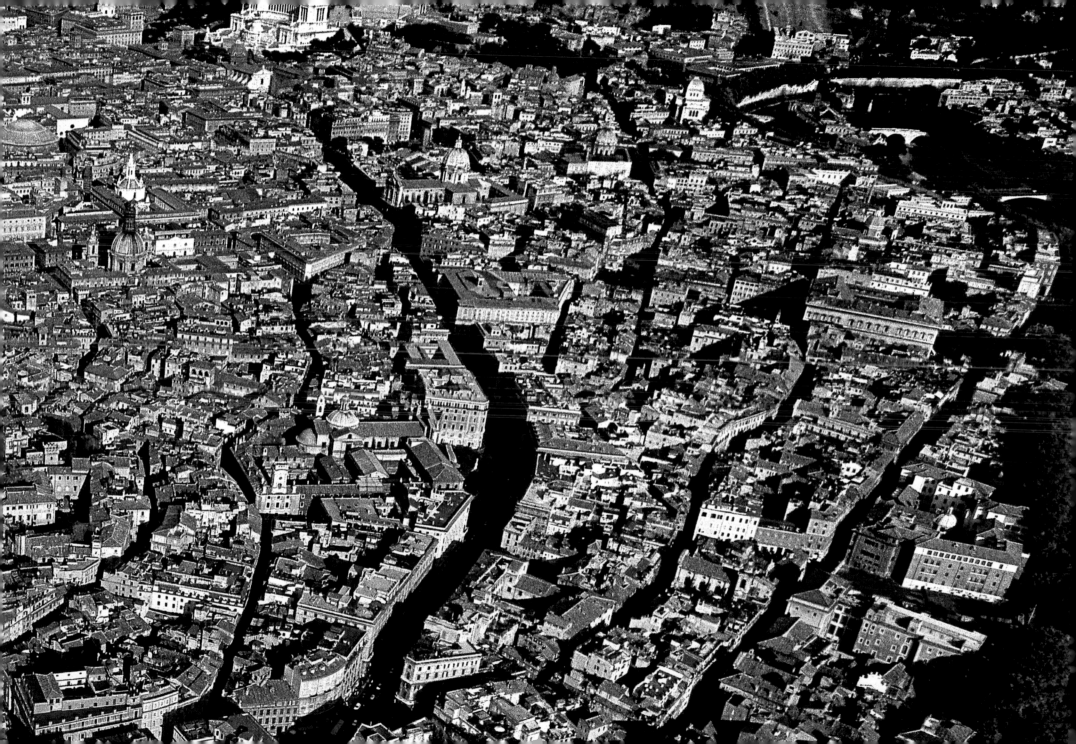

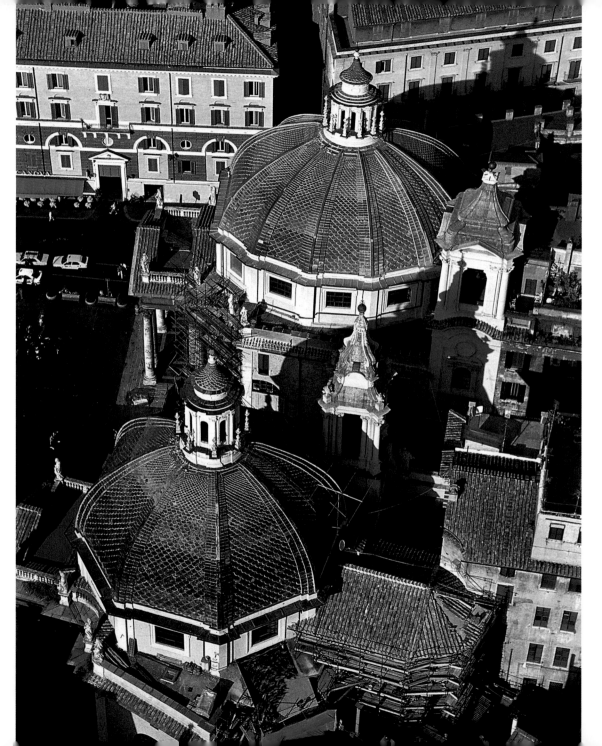

62 On the far side of Piazza del Popolo, the twin churches of Santa Maria di Montesanto (top) and Santa Maria dei Miracoli separate the junctions with Via del Babuino, Via del Corso and Via di Ripetta. Both were designed by Bernini and built between 1662 and 1679.

63 Piazza del Popolo, laid out by Giuseppe Valadier between 1816 and 1824, is one of the largest and most spectacular of the city's squares. It is closed to the north (bottom in the photo) by the Porta del Popolo, from which the old consular road led to Umbria and Marche, and an Egyptian obelisk from Heliopolis stands in its center.

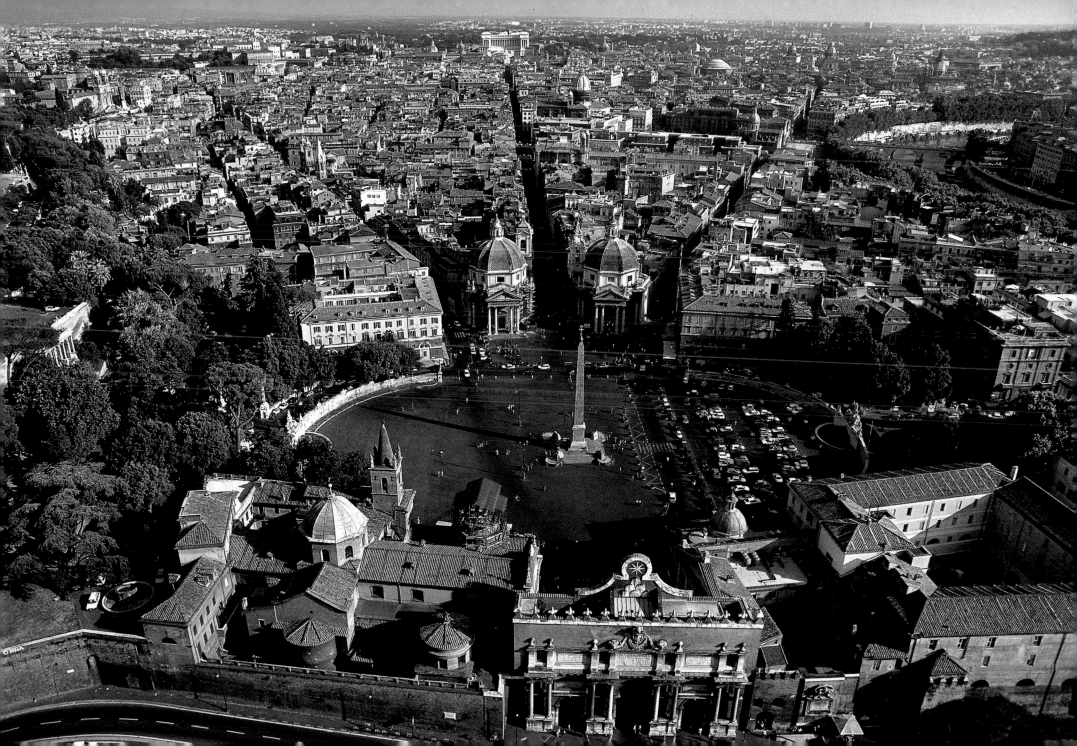

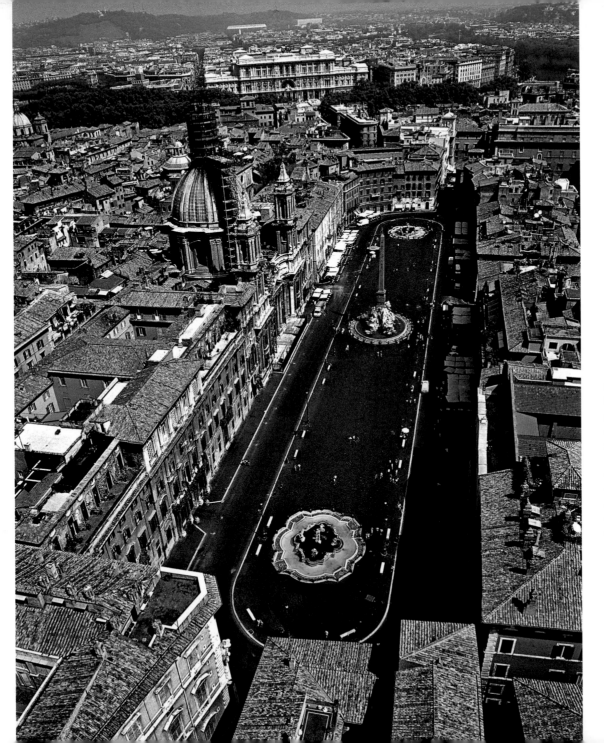

64 Piazza Navona, laid out during the 17th century on the site of the ancient Stadium of Domitian, is one of the most beautiful and famous squares of the Renaissance and baroque city. Measuring 787 by 213 ft (240 by 65 m), it is embellished with the Fountain of the Four Rivers (center), the Fountain of Neptune, and the Moor's Fountain, and guarded by the church of Sant'Agnese in Agone.

65 The straight Corso Rinascimento separates Piazza Navona, with its fountains and church, from Palazzo Madama, the home of the Senate, and the dome of the Pantheon. The church of Santa Maria dell'Anima stands on the opposite side of the square (bottom of the photograph).

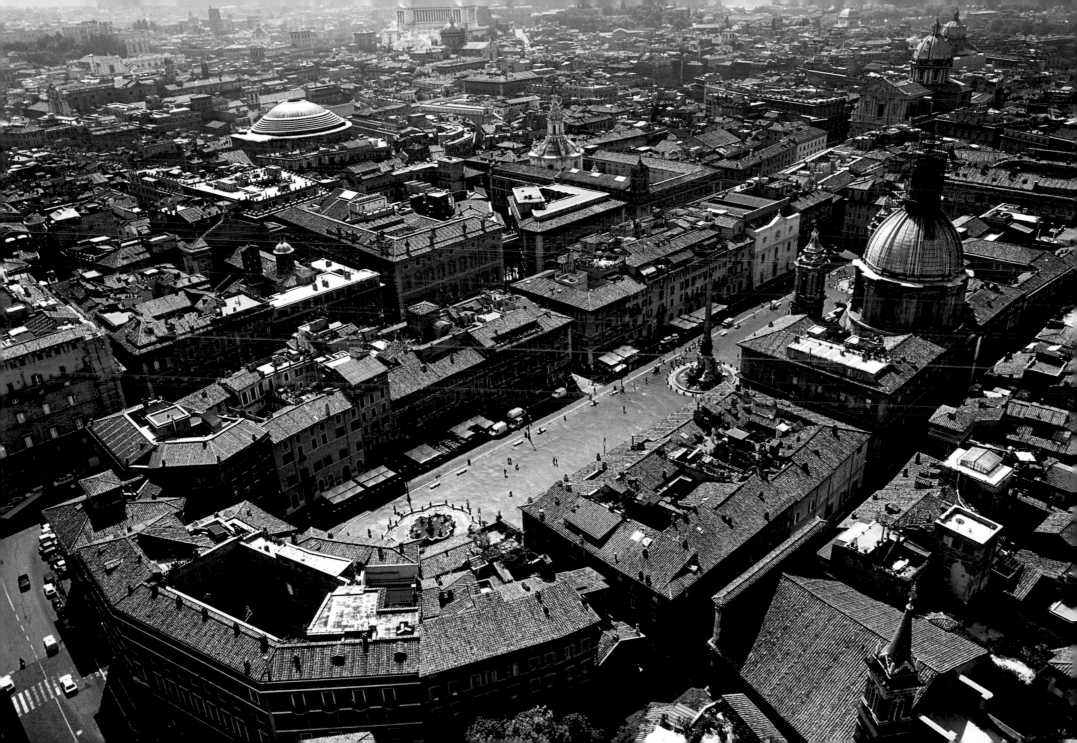

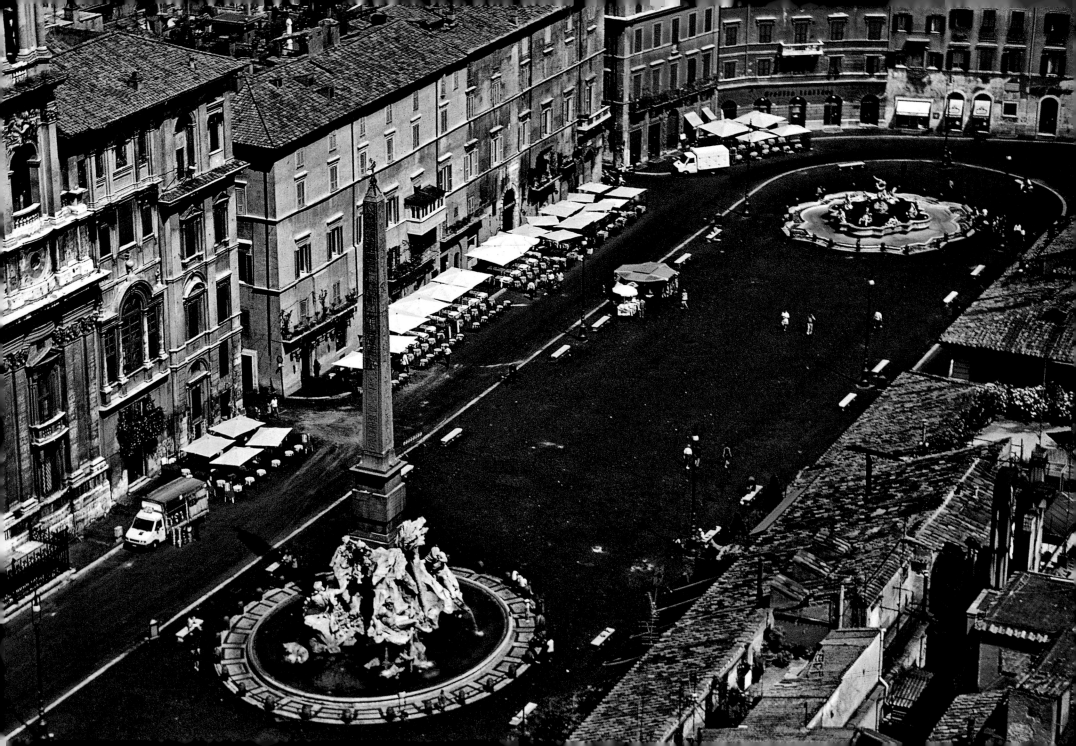

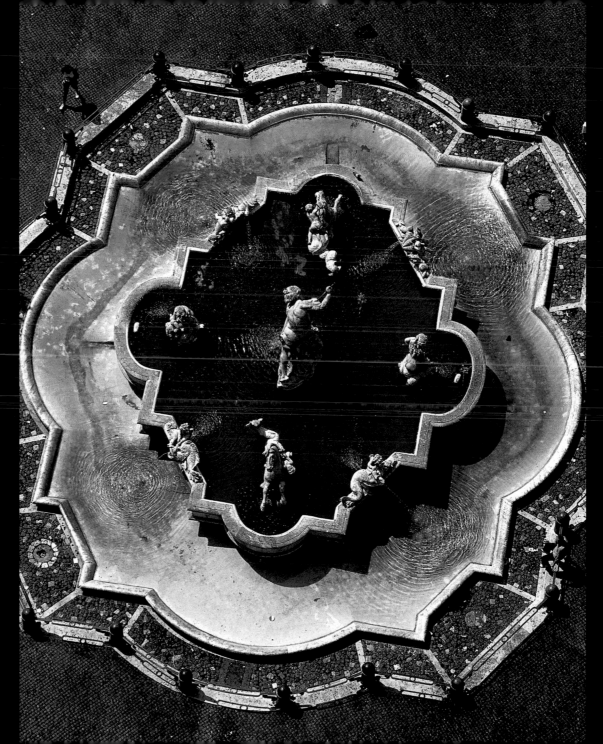

66 The Fountain of the Four Rivers, installed in 1651 in the center of Piazza Navona, is one of Bernini's best-known works. An Egyptian obelisk, taken from its former site in the Circus of Maxentius, stands in the center, its base surrounded by statues symbolizing the Nile, Ganges, Rio de la Plata and Danube.

67 The Fountain of Neptune, at the northern end of Piazza Navona, combines a huge 16th-century basin by Giacomo della Porta with statues created three centuries later by Antonio della Bitta (Neptune fighting an octopus, center) and Gregorio Zappalà.

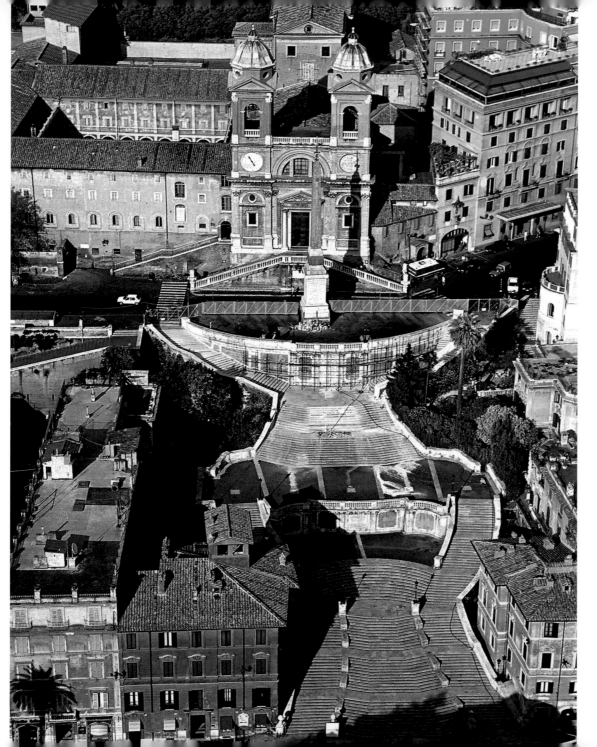

68 The spectacular Spanish Steps, built in travertine between 1723 and 1726 by Francesco De Sanctis, lead up to the Trinità dei Monti Church, which belongs to the French complex of Villa Medici. The steps are bedecked with azaleas in May.

69 Piazza di Spagna stands at the foot of the Spanish Steps, in the shadow in the photograph. Above, the sun illuminates the 16th-century Villa Medici, the home of the French Academy, with its magnificent garden that borders the grounds of Villa Borghese.

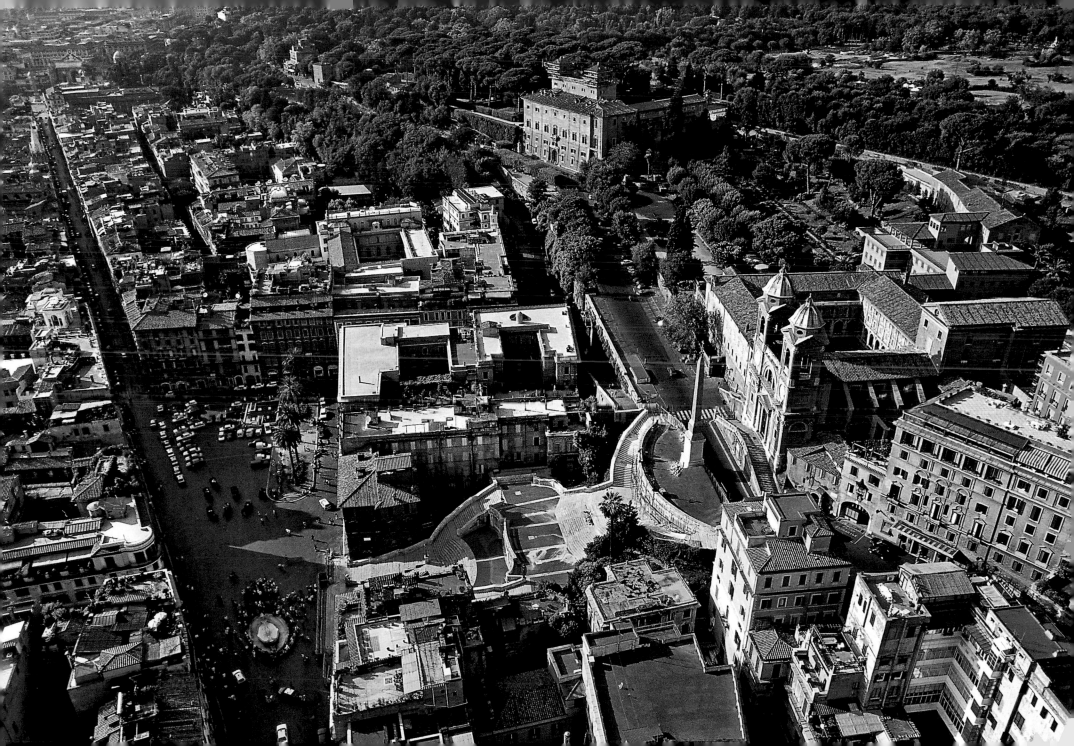

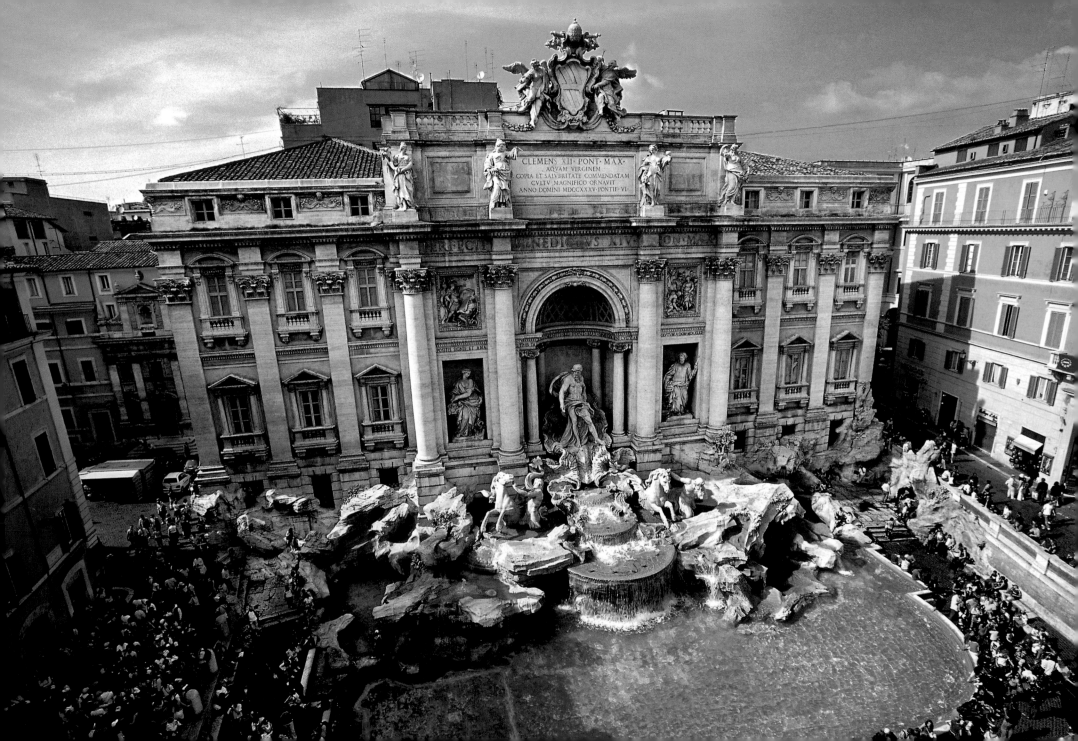

70 Each day the Fountain of Trevi attracts thousands of tourists from all over the world and marks the entry in the city of the Aqua Virgo Roman aqueduct. It was commenced by Bernini in 1640 and completed by Nicola Salvi between 1732 and 1761.

71 The narrow square housing the Trevi Fountain lies at the foot of the Quirinal Hill. Behind, the façade of the church of Santi Vincenzo e Anastasio, designed by Martino Longhi the Younger in 1650, is known as "Martino's Reed Thicket" due to its numerous columns.

72-73 In the middle of the fountain, on a stepped base, two large sea horses draw the shell chariot ridden by Neptune, while water gushes out from beneath the sea god's feet.

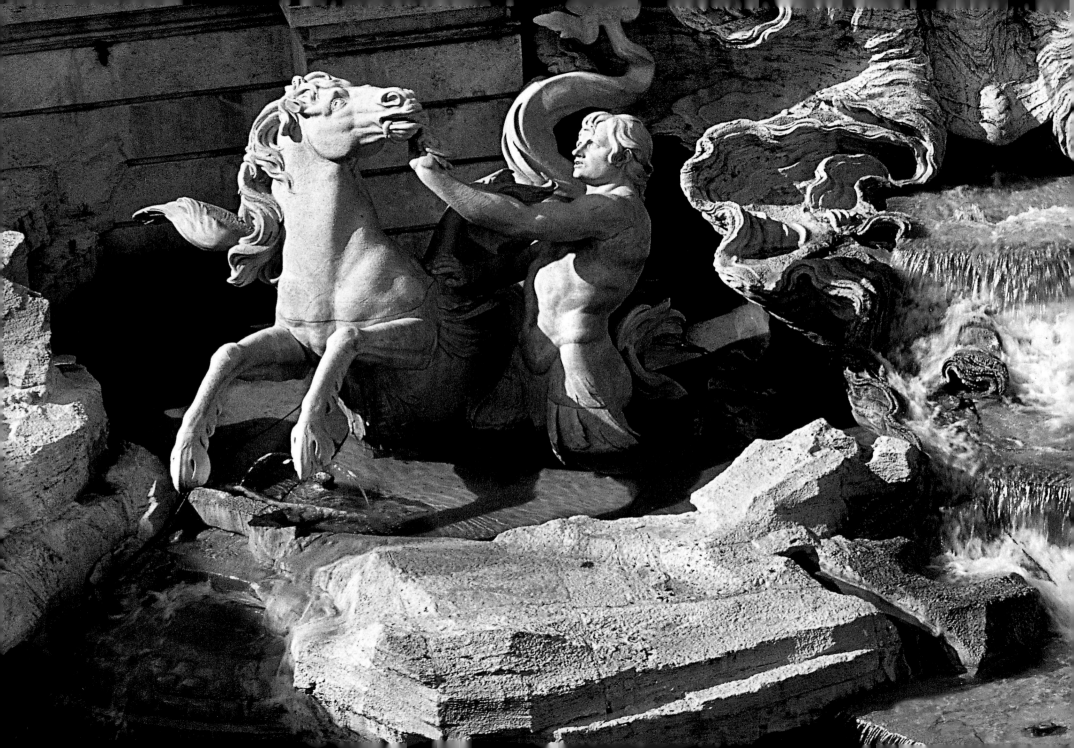

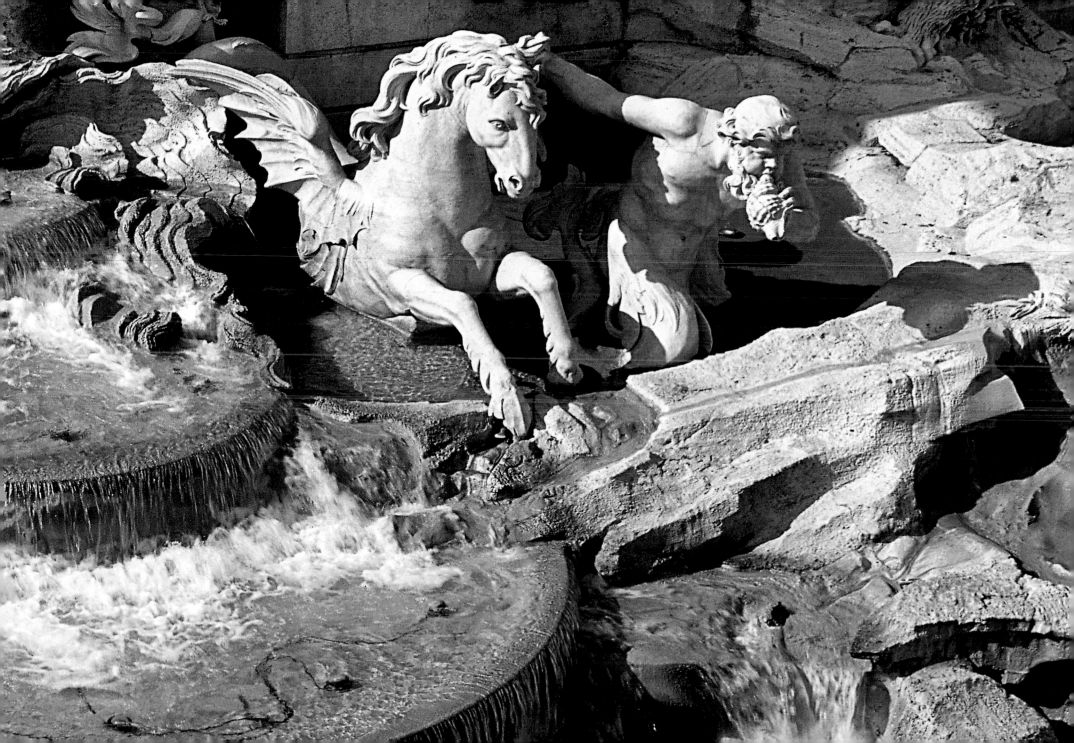

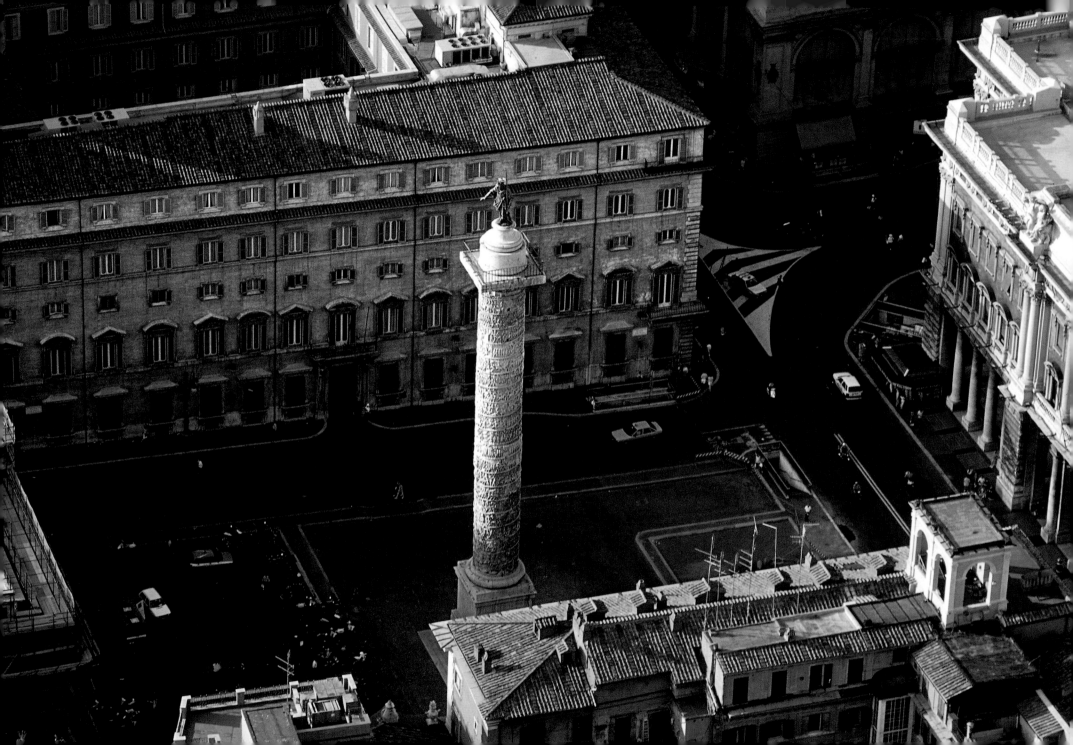

74 The Column of Marcus Aurelius, erected between AD 180 and 196 and topped with a statue of Saint Paul in 1588, stands in Piazza Colonna, which is the heart of Roman and Italian political life. Behind the column is Palazzo Chigi, the residence of the Italian Prime Minister.

75 Palazzo Farnese, overlooking the square of the same name, is one of the city's finest Renaissance palaces and is home to the French Embassy. It was commenced in 1514 by Antonio da Sangallo, continued by Michelangelo and completed by Giacomo della Porta. The interior is dedicated with frescoes by Annibale Carracci.

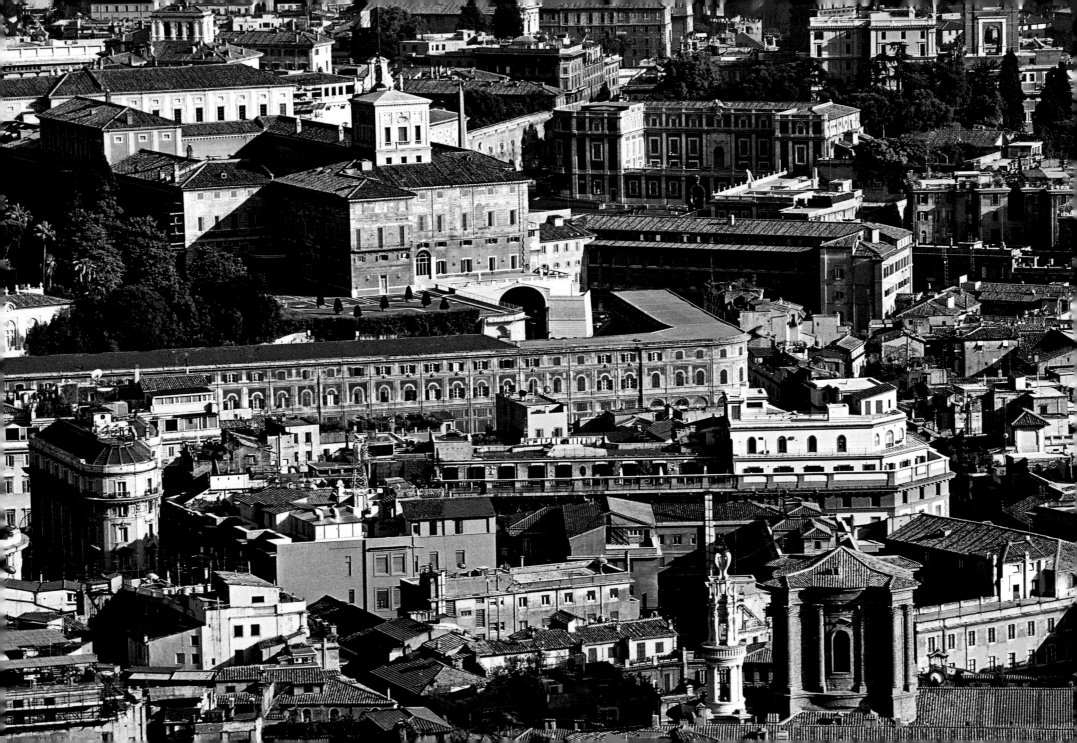

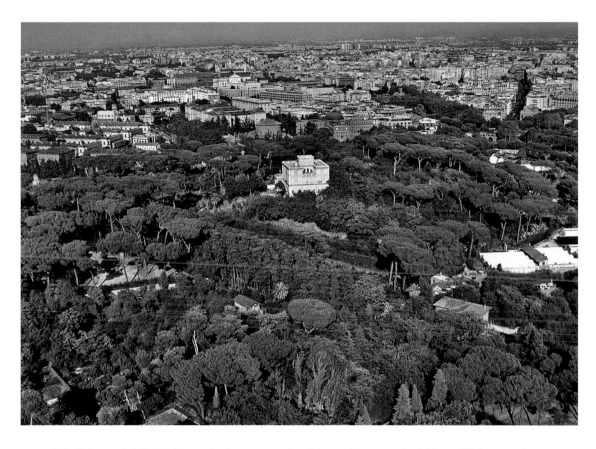

76 Palazzo del Quirinale was built as a papal residence between the 16th and 17th centuries, although Clement VIII had already lived there from 1592. It became the residence of the Italian kings in 1870 and subsequently home to the country's presidents. The palace is closed to the public, but the nearby Stables host important exhibitions.

77 Villa Celimontana, on the Caelian Hill, separates the Colosseum from the Baths of Caracalla. One of the buildings of the villa, in the center of the photograph, is home to the Italian Geographic Society. The greenhouses on the right belong to the San Sisto Seed Nursery and are used by the municipal gardening service.

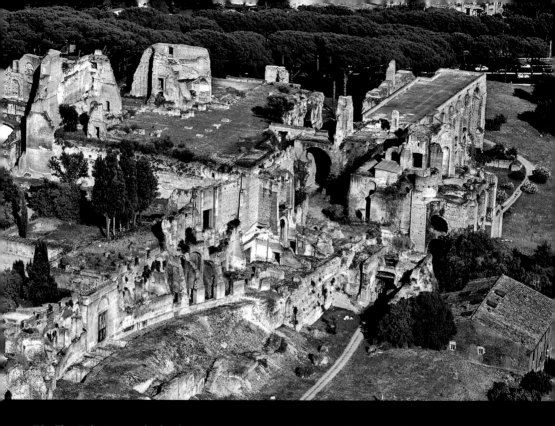

78 The Palatine overlooks the Circus Maximus with the mighty Imperial arches that supported the Domus Severiana, an extension of the imperial residences built during the rule of Septimius Severus. The buildings on the upper terrace are the Domus Augustana.

79 The imposing Baths of Caracalla, built between AD 212 and 217, remained in use until the 6th century, when the interruption of the aqueducts made them unserviceable. Several magnificent sculptures were found inside the baths, including the Farnese Bull, now housed in the National Museum of Naples.

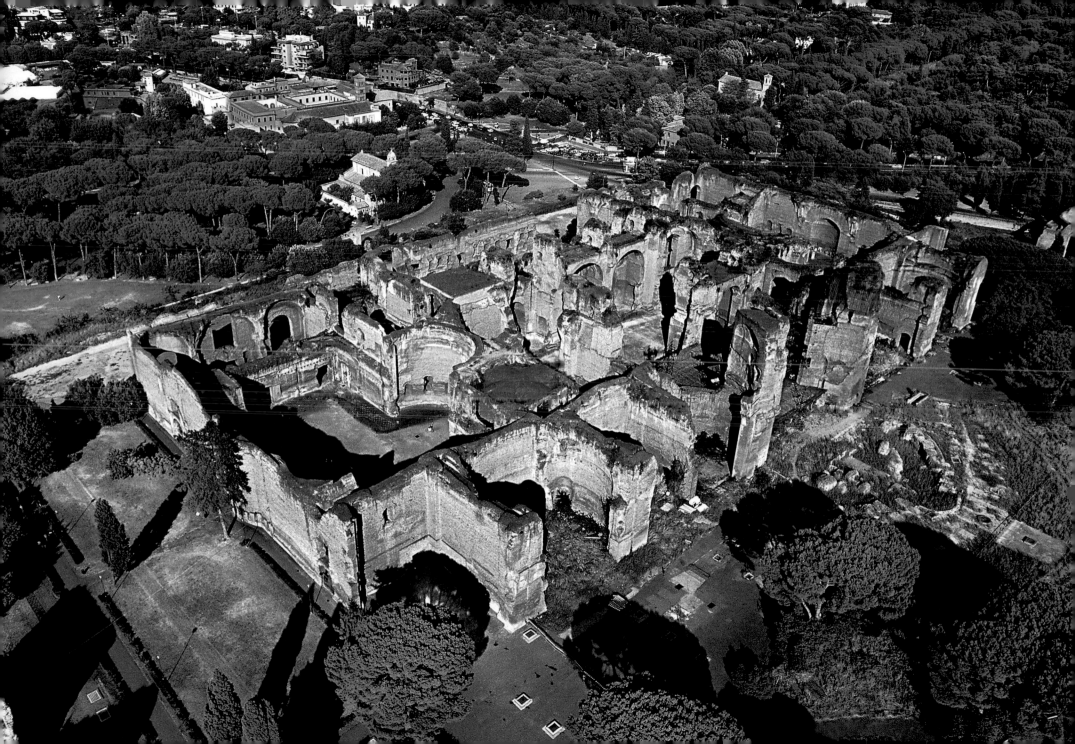

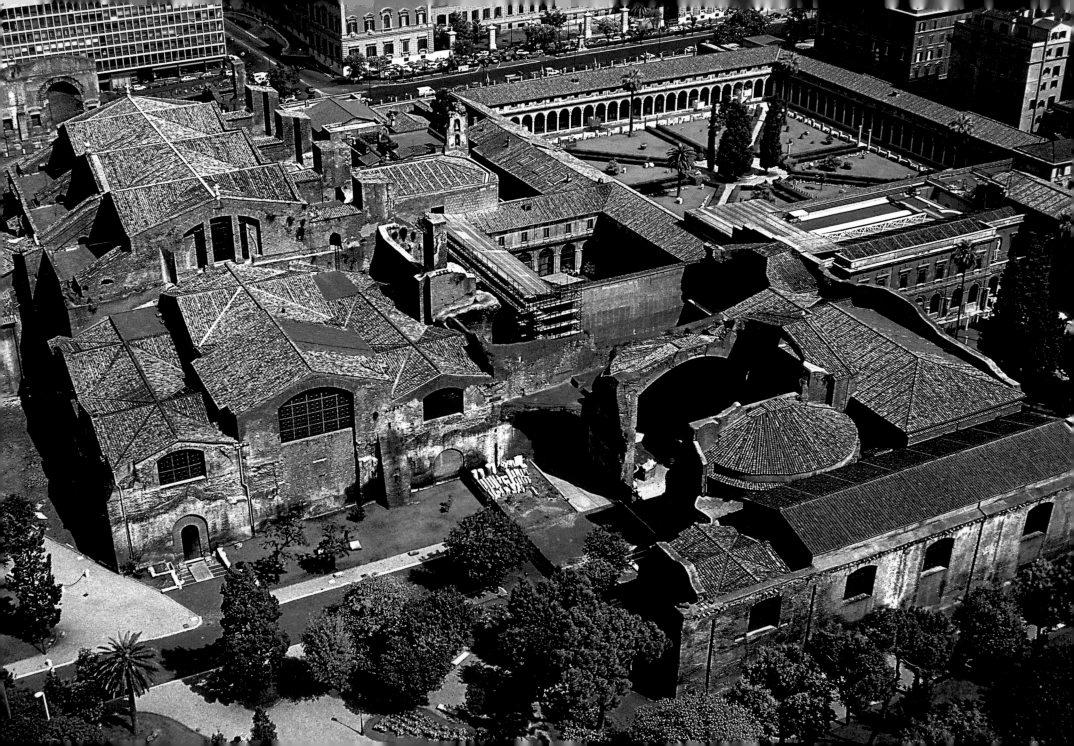

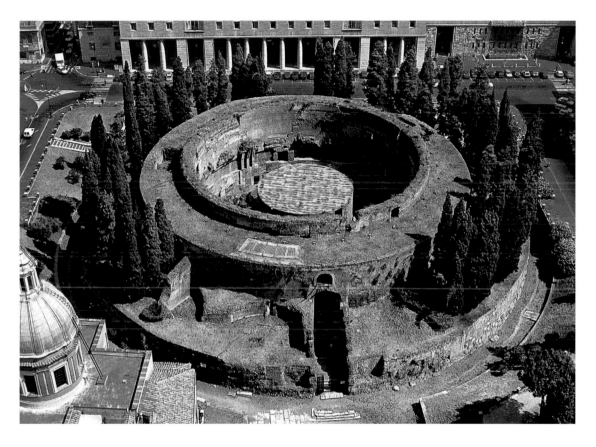

80 The Baths of Diocletian, just a stone's throw from Termini Station, were built between AD 298 and 306 and transformed into a Carthusian monastery during the 16th century. They now house the collections and restoration workshops of the National Roman Museum.

81 The Mausoleum of Augustus, which also houses the tombs of the emperor's family, stands between Via del Corso and the Tiber, surrounded by cypresses. It is flanked by the Ara Pacis, the church of San Rocco and other colonnaded buildings dating from the Fascist period.

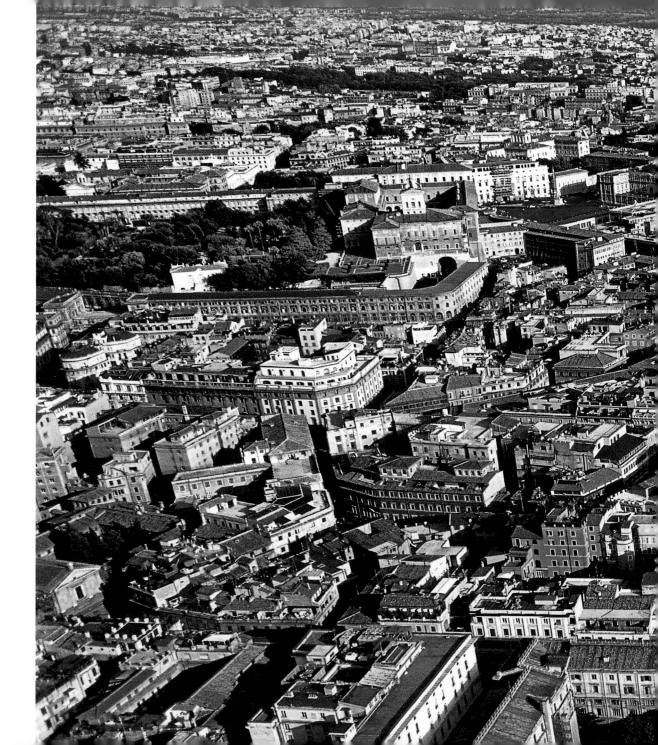

82

82-83 The area of Rome between the Quirinal (left) and Via del Corso features an alternating series of Baroque and other 19th-century and modern buildings, such as the Post Office Building in Piazza San Silvestro, at the bottom of the photograph. Palazzo Montecitorio is partially visible on the right.

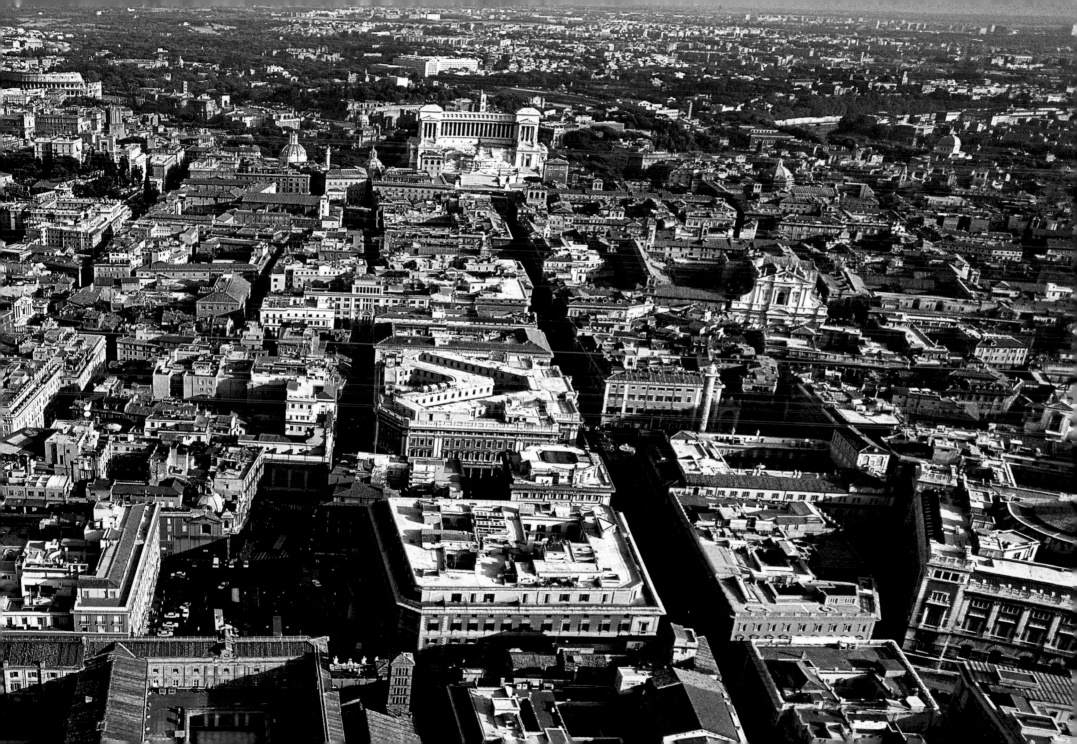

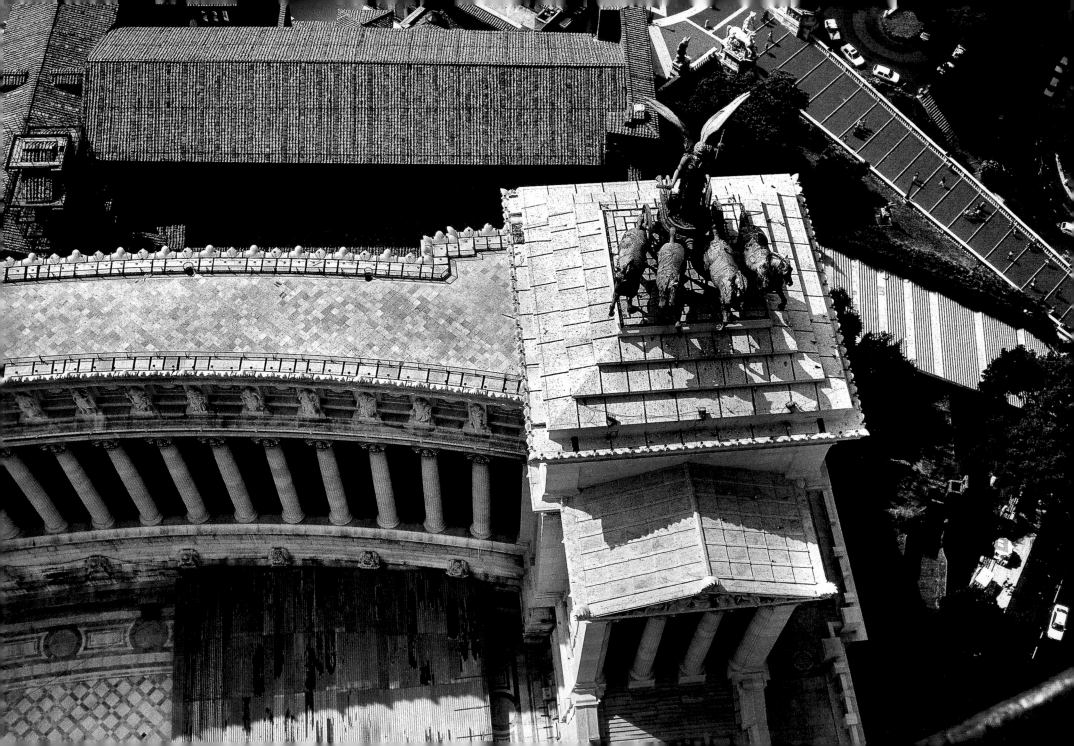

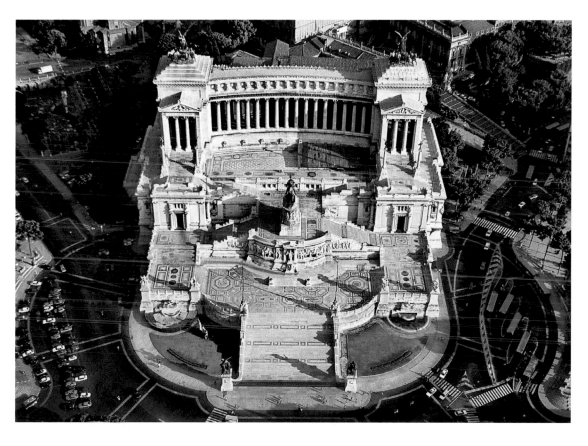

84 Two imposing bronze quadrigae crown the monument to Victor Emmanuel II (known as the Vittoriano), which overlooks Piazza Venezia. Behind are the old church of Santa Maria di Aracoeli and the Piazza del Campidoglio, connected to Piazza Venezia by two separate flights of steps.

85 The front view of the Vittoriano, built entirely from Botticino marble quarried near Brescia, reveals why locals call it the "typewriter." The sheer size of the complex made it difficult to insert among the city's finest antique and Renaissance monuments.

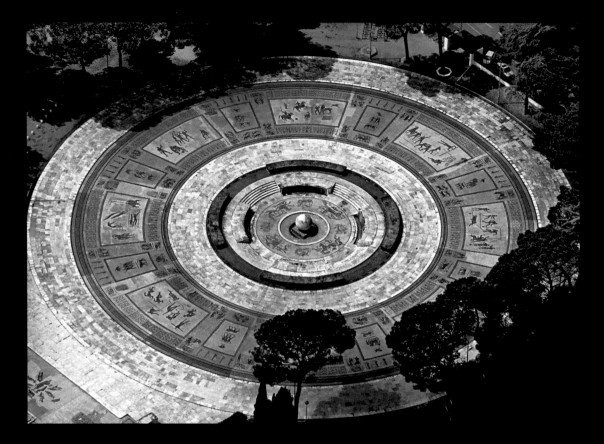

86 The mosaic paving of the Foro Italico was laid between 1928 and 1937 and, like the avenue that leads to the square, commemorates the most important dates of the empire and the Italian Republic.

87 The new Auditorium (or Città della Musica), designed by Renzo Piano and inaugurated in 2002, is one of Rome's few works of modern architecture. The building stands alongside the Flaminio Stadium and the Olympic Village built for the 1960 Games.

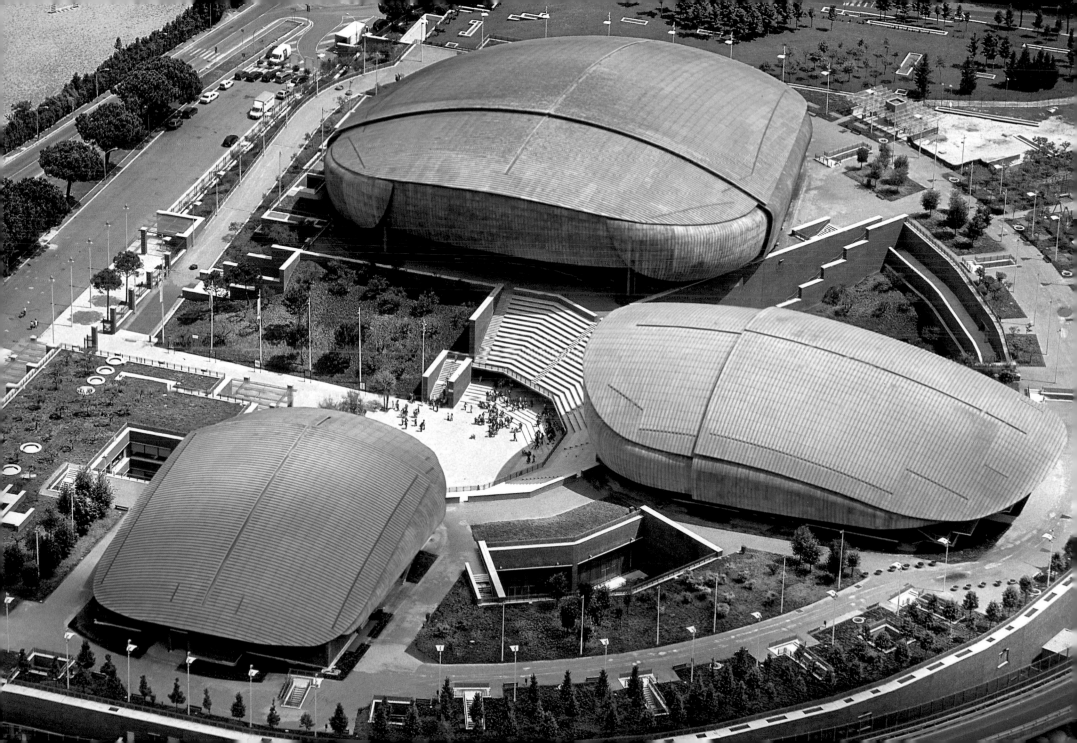

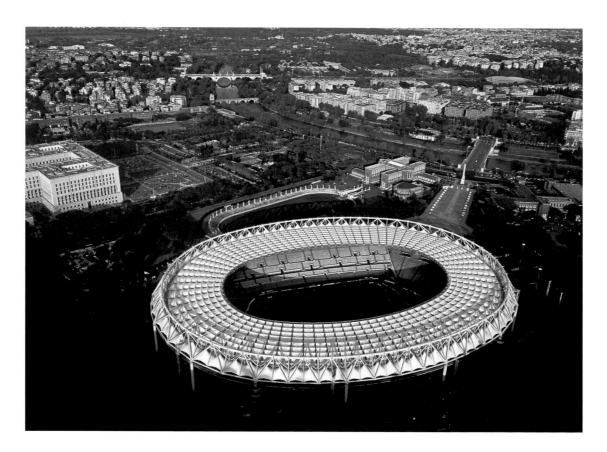

88 The Olympic Stadium, at the foot of the wooded slopes of Mt. Mario, was built during the Fascist period, adapted for the 1960 Olympic Games and given an elegant roof for the 1990 World Soccer Championships. The Ministry of Foreign Affairs can be seen on the left of the photograph.

89 The travertine terraces and statues of the Marmi Stadium can be seen behind the terraces and the roof of the Olympic Stadium. The Foro Italico complex also features two swimming pools, tennis courts that host the Italian Open, and other buildings.

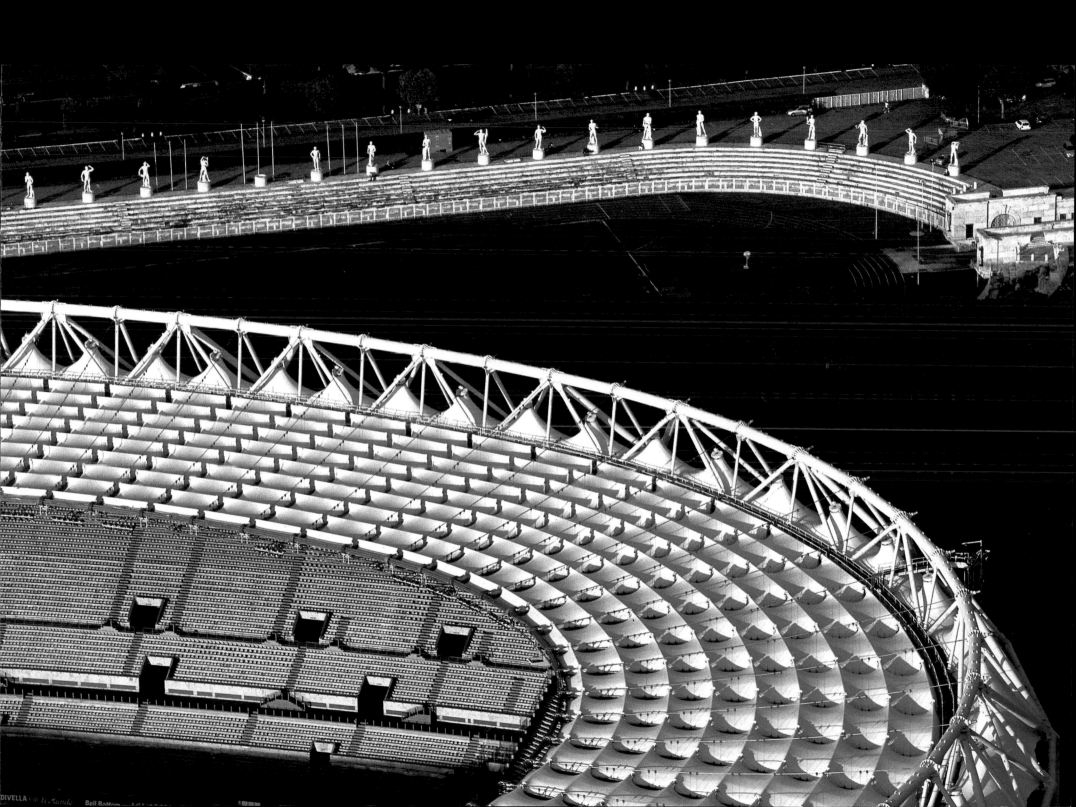

90 The imposing modern architecture of the 20th-century Buon Pastore complex on Via di Bravetta overlooks the Casali Valley, which is still dotted with vegetable gardens and fields and protected by a Regional Nature Reserve that covers an area of 1159 acres (469 hectares).

91 Upstream from Tiber Island lies the San Michele complex, now a popular conference venue, and the quays of Ripa Grande, where for many centuries boats from Ostia and the Mediterranean moored. The churches and piazzas of Trastevere can be seen behind San Michele.

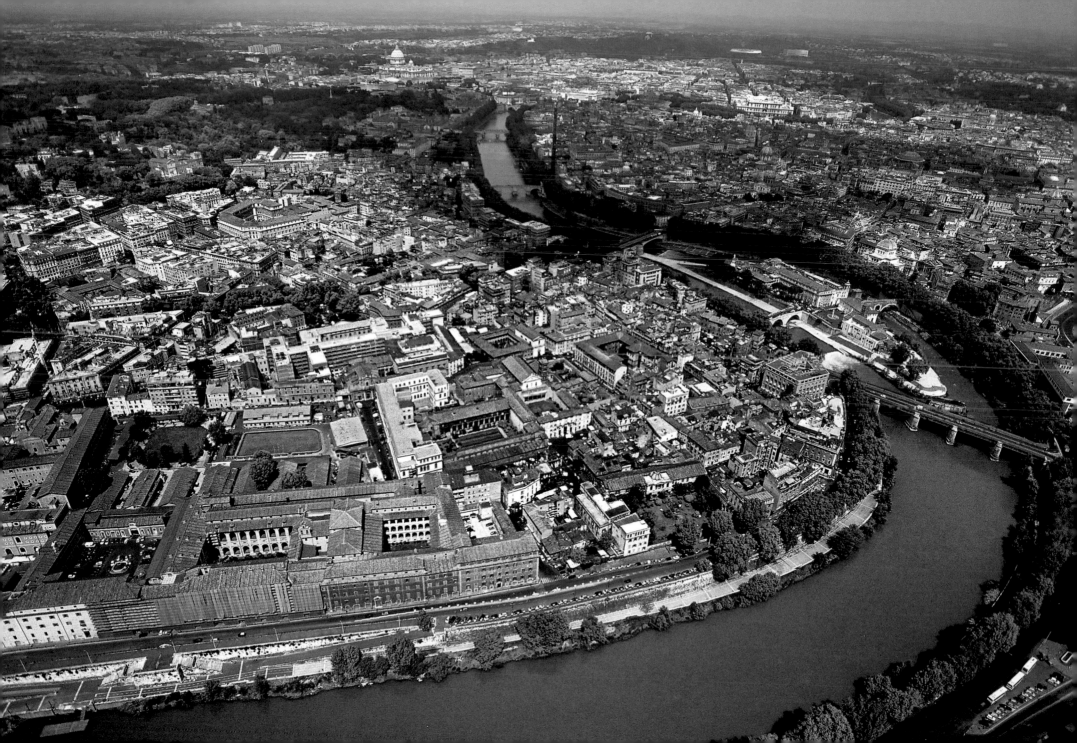

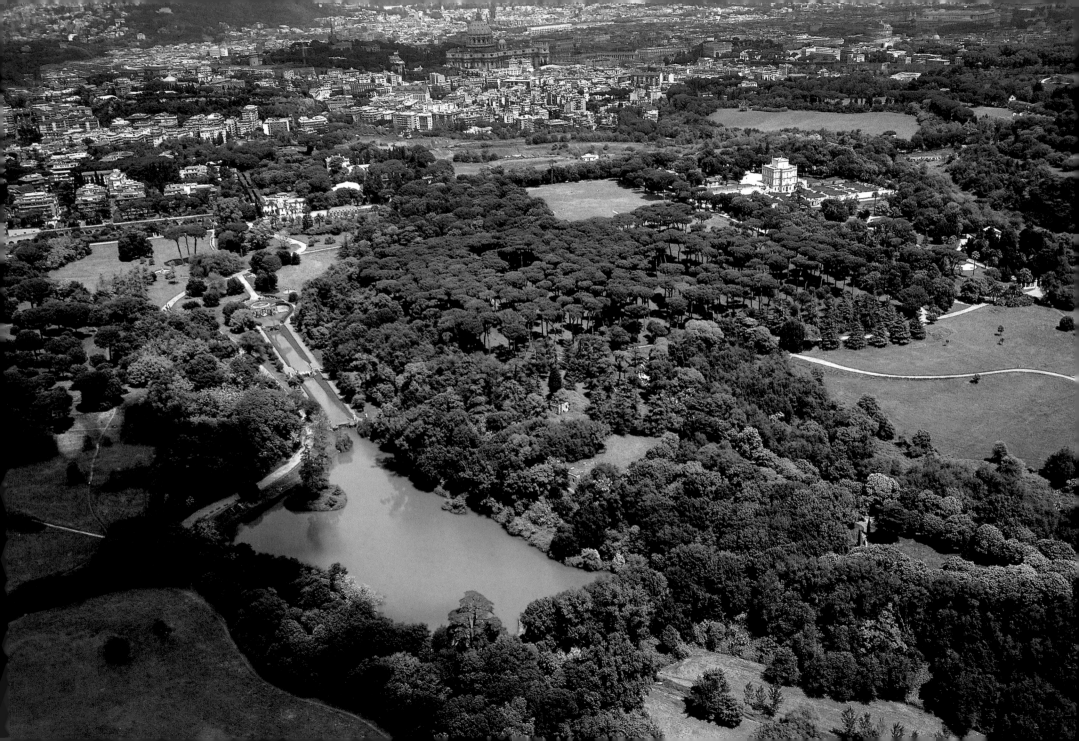

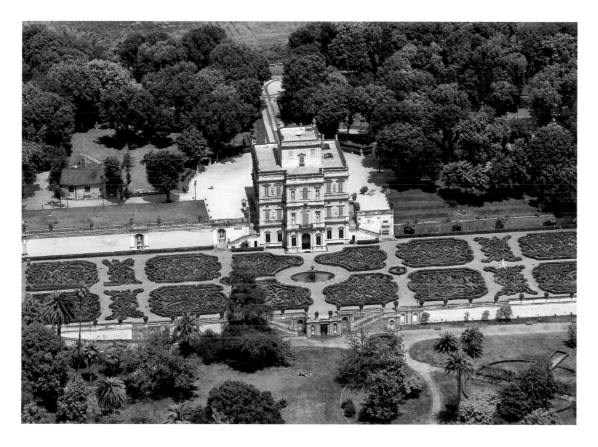

92 Villa Doria Pamphilj, whose grounds form the largest park in Rome, lies between the Gianicolo Hill, the Monteverde district and the ancient Aurelian Way. The villa was remodeled from 1644, when Giovanni Battista Pamphilj became Pope Innocent X, and bought by the Municipality of Rome between 1968 and 1971.

93 The elegant Casino del Buon Respiro (or Villa Algardi) in the grounds of Villa Doria Pamphilj was completed in 1652. Unlike the rest of the park, which belongs to the Municipality of Rome, it is now the property of the Prime Minister and is closed to the public.

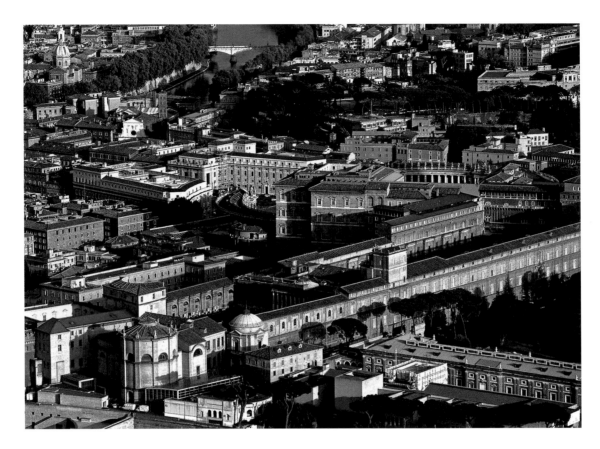

94 St. Peter's Basilica, the Paul VI Hall and the Vatican Museums complex – which includes the Sistine Chapel and extraordinary collections of art and archaeology – constitute the parts of the Vatican City normally accessible to the public.

95 The Vatican Gardens, behind St. Peter's Basilica, are the most secret part of the Vatican City. The small state (0.17 sq. miles/0.44 sq. km) recognized by the Lateran Treaty on February 11, 1929 also includes the basilicas of St. John Lateran, Santa Maria Maggiore and San Paolo Fuori le Mura.

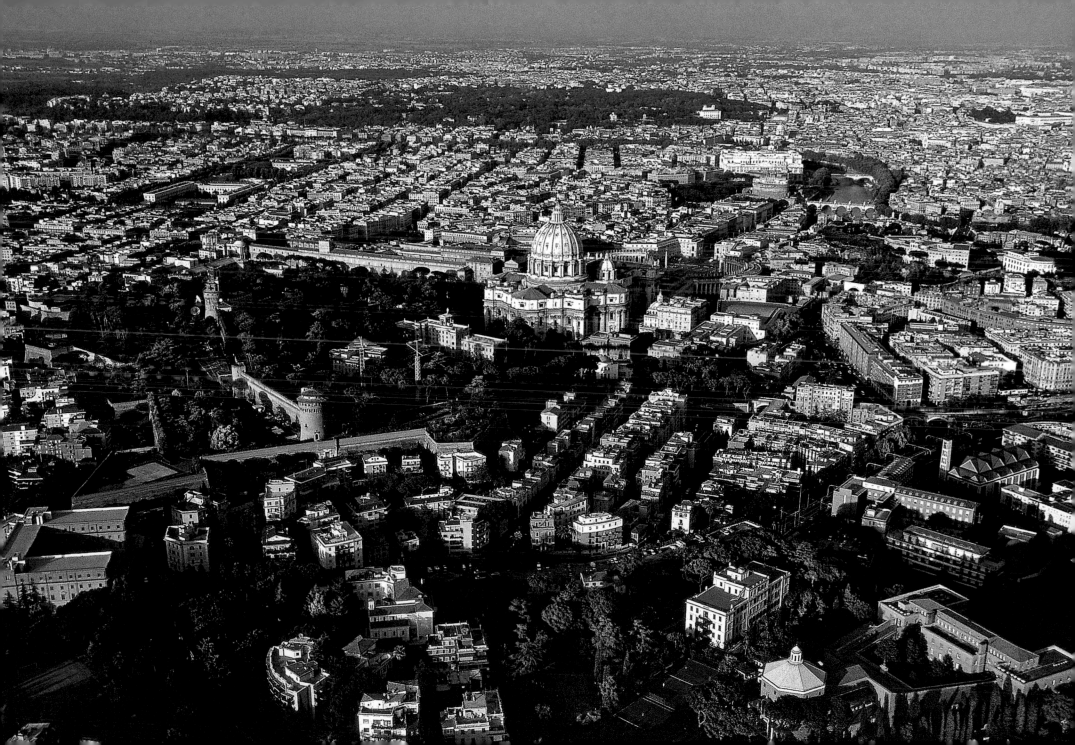

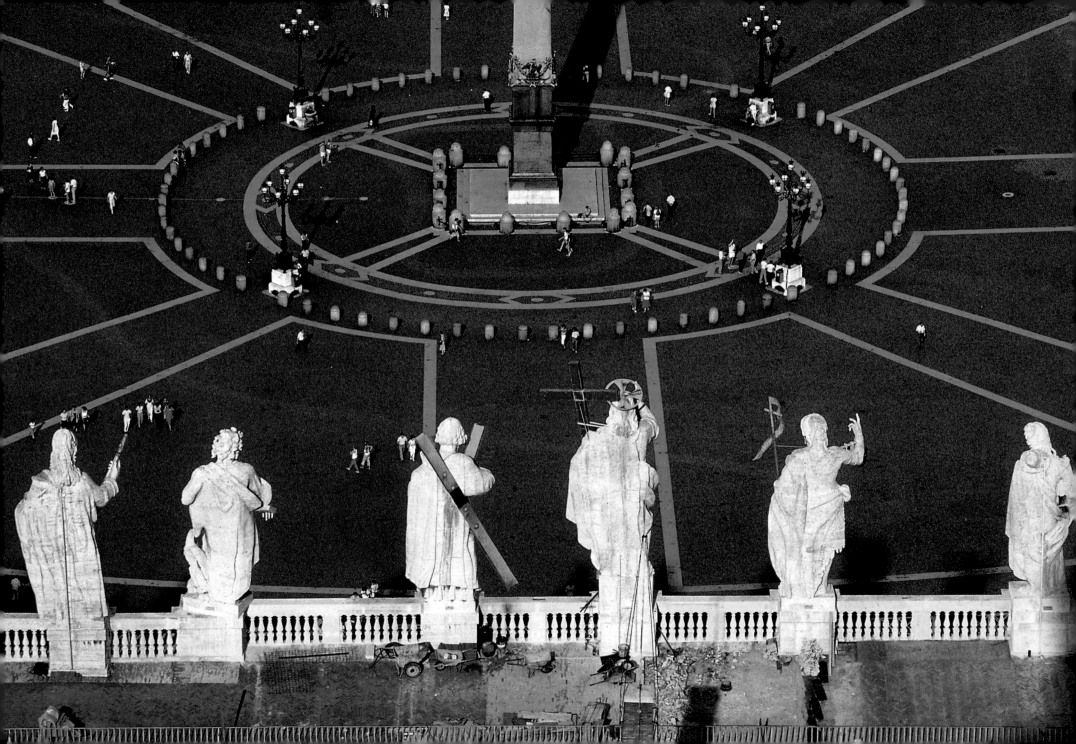

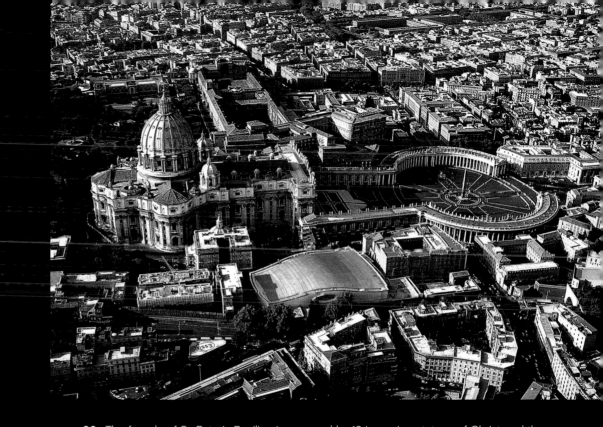

96 The façade of St. Peter's Basilica is crowned by 13 imposing statues of Christ and the Apostles, 18.7 ft (5.7 m) tall, which seem to look out over the square of the same name, which is packed with the faithful from all over the Catholic world on Sundays and the main religious holidays.

97 Bernini's colonnade, built between 1656 and 1667, seems to reach out from St. Peter's Basilica to embrace Rome and the world. The structure comprises 284 columns and 88 pillars and is crowned by 140 statues of saints. An Egyptian obelisk, brought to Rome on the orders of Emperor Caligula, stands in the center.

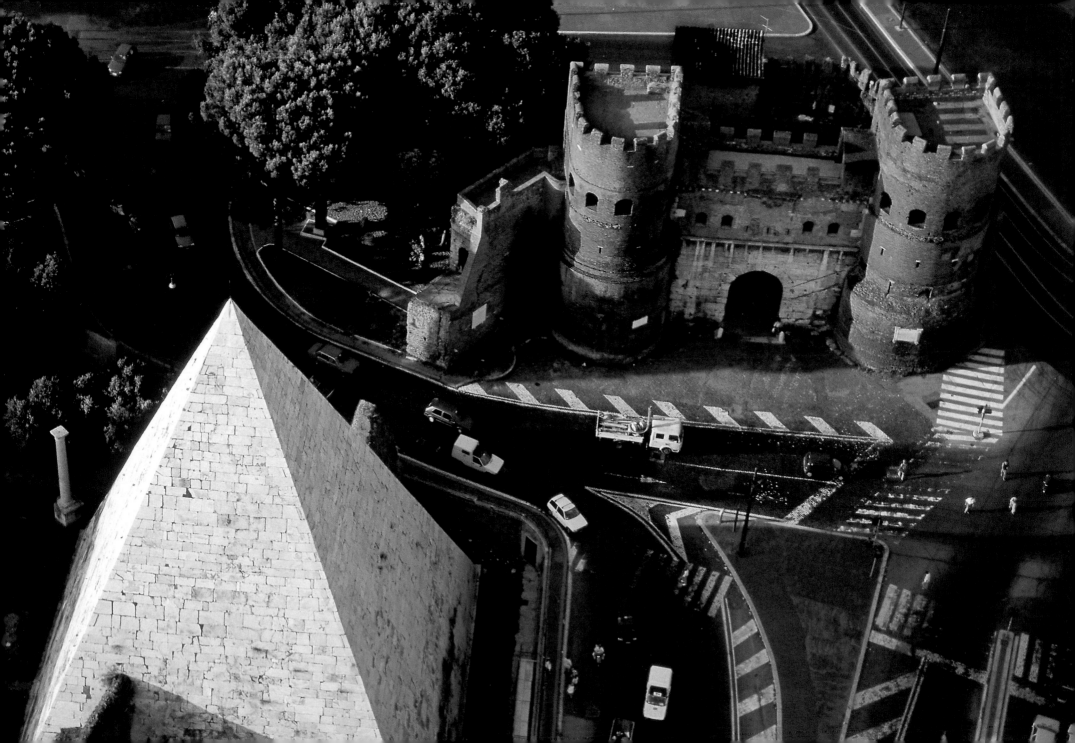

98 Porta San Paolo, at the beginning of the ancient Ostian Way, rises above the surprising Pyramid of Cestius, built in 12 BC as the tomb of Caius Cestius. The fighting between soldiers and civilians of Rome and German troops that took place in the square in 1943 marked the beginning of the Resistance.

99 In the northern part of the city, the Tiber separates the Flaminio (on the left of the photograph) and Prati districts.

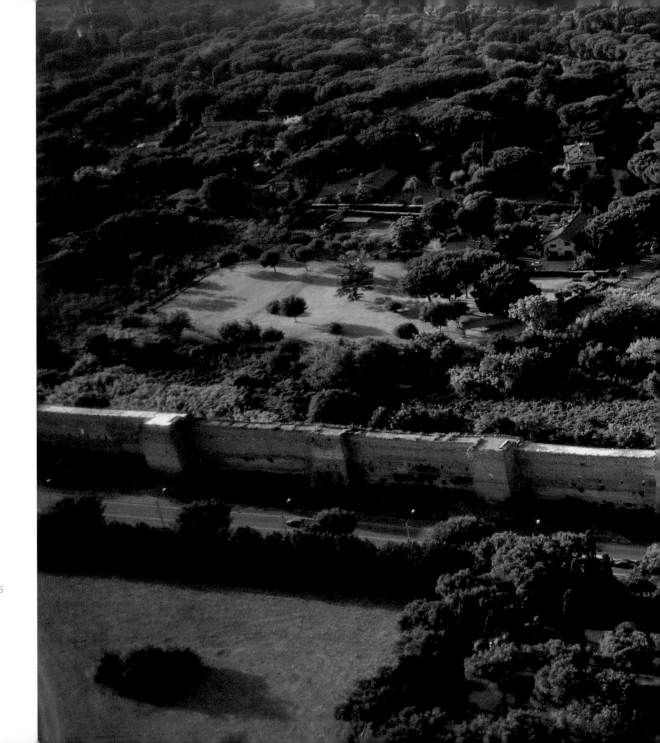

100-101 Porta San Sebastiano, which houses the little Museum of the Walls, is the gate in the Aurelian Walls that marks the beginning of the ancient Appian Way, which led to the Castelli Romani, Terracina, Capua and the Apulian ports of Brindisi and Taranto.

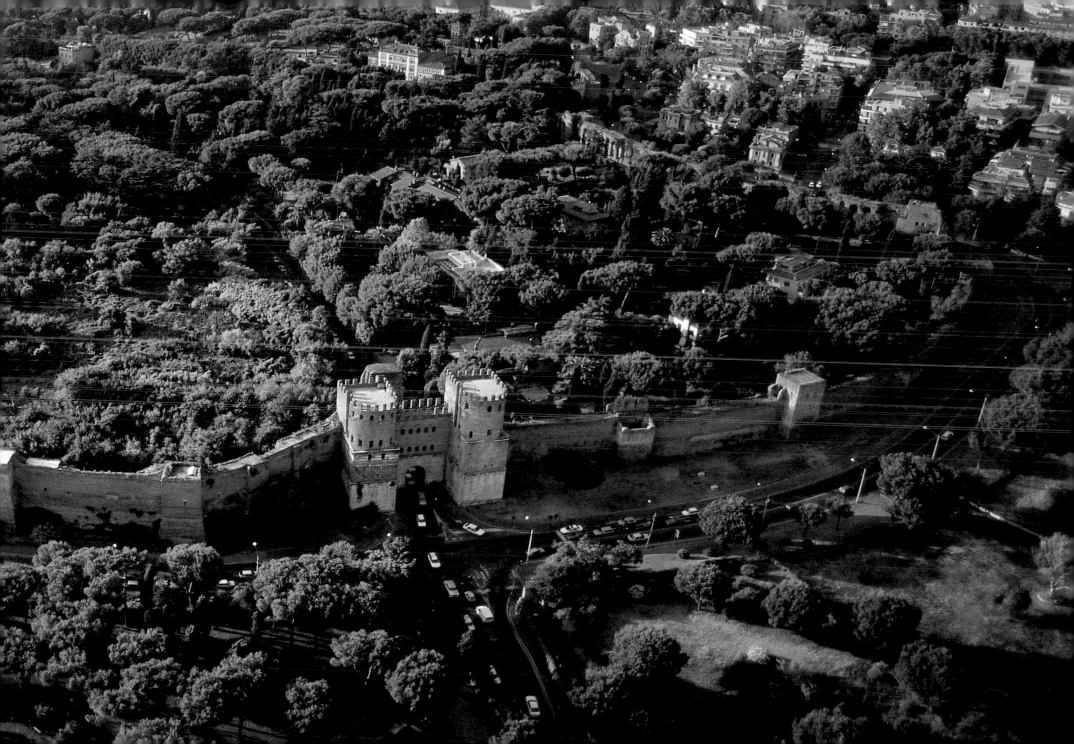

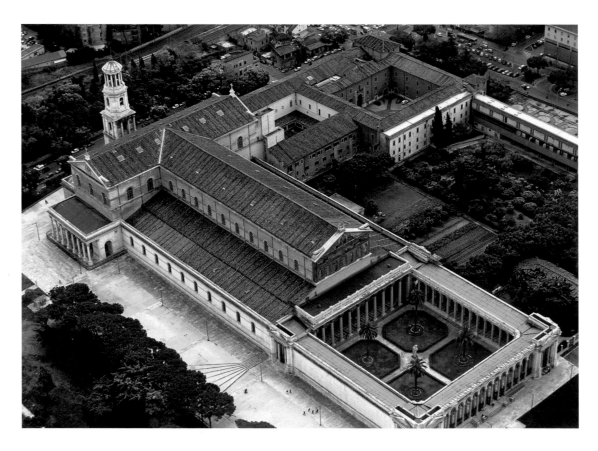

102 The Basilica of San Paolo Fuori le Mura was built by Emperor Constantine, but was almost completely destroyed by a fire in 1823. It was totally rebuilt during the 19th century (the inauguration was held in 1854) and is now an important magnet for the faithful and for tourists.

103 The Basilica of St. John Lateran, founded in 311 by Pope Melchiades, has hosted five ecumenical councils and was the papal residence until Palazzo Quirinale was built. Imposing travertine statues crown the façade, designed by Alessandro Galilei and built in 1735.

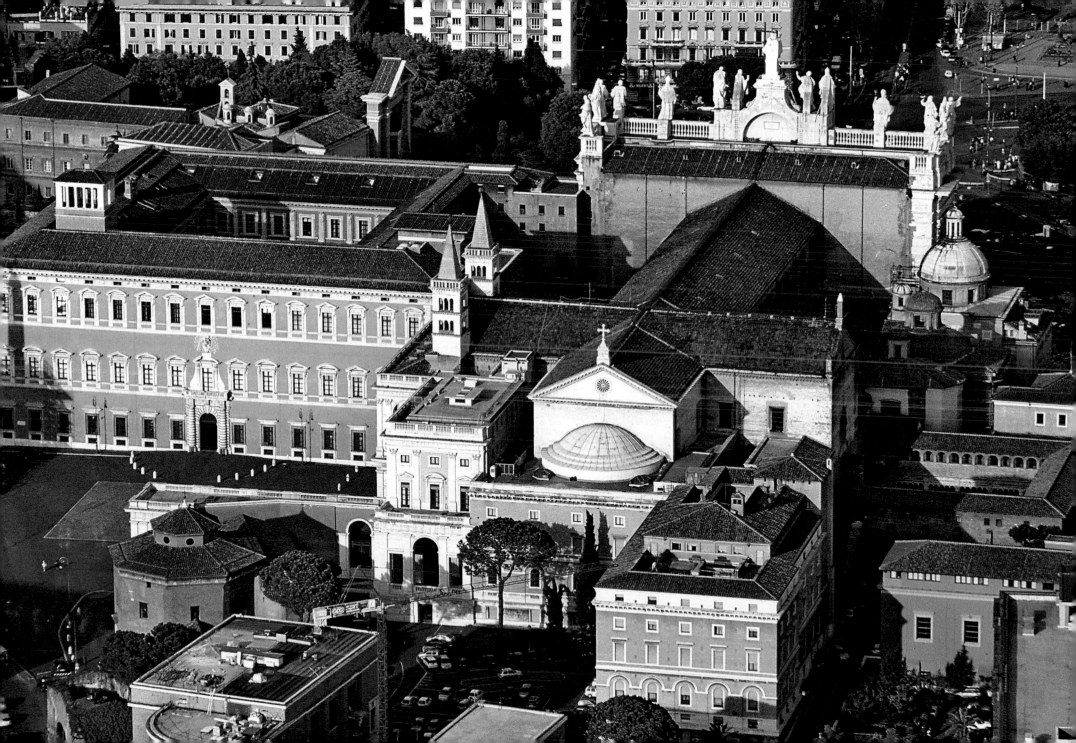

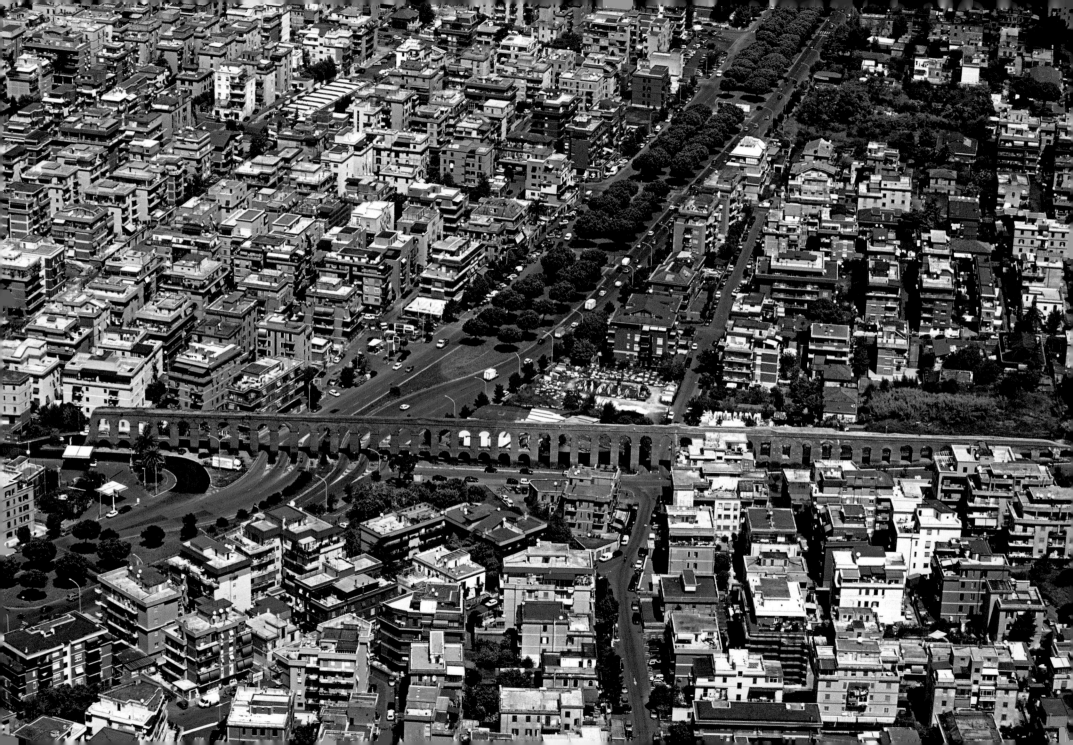

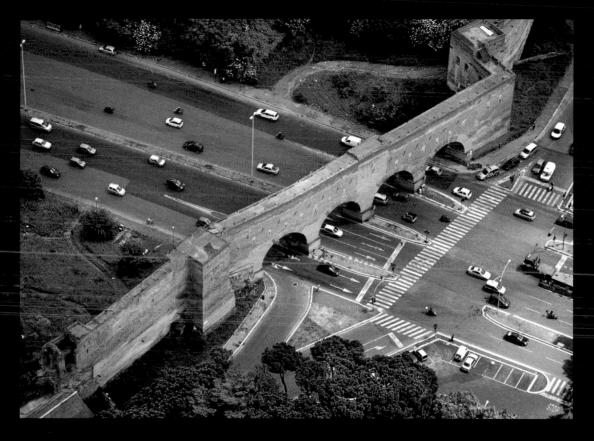

104 The arches of the aqueducts that supplied ancient Rome are still an essential component of the landscape of the Campagna Romana and the southern districts of the city. The Aqua Claudius, built between AD 38 and 52, crosses the Via Tuscolana that leads to the Castelli Romani.

105 Four arches in the Aurelian walls allow the passage of vehicles heading for Via Cristoforo Colombo, the EUR district and Ostia. The 7.7-mile (12,5km) ring of Imperial walls is one of the most evocative and least known of the city's monuments.

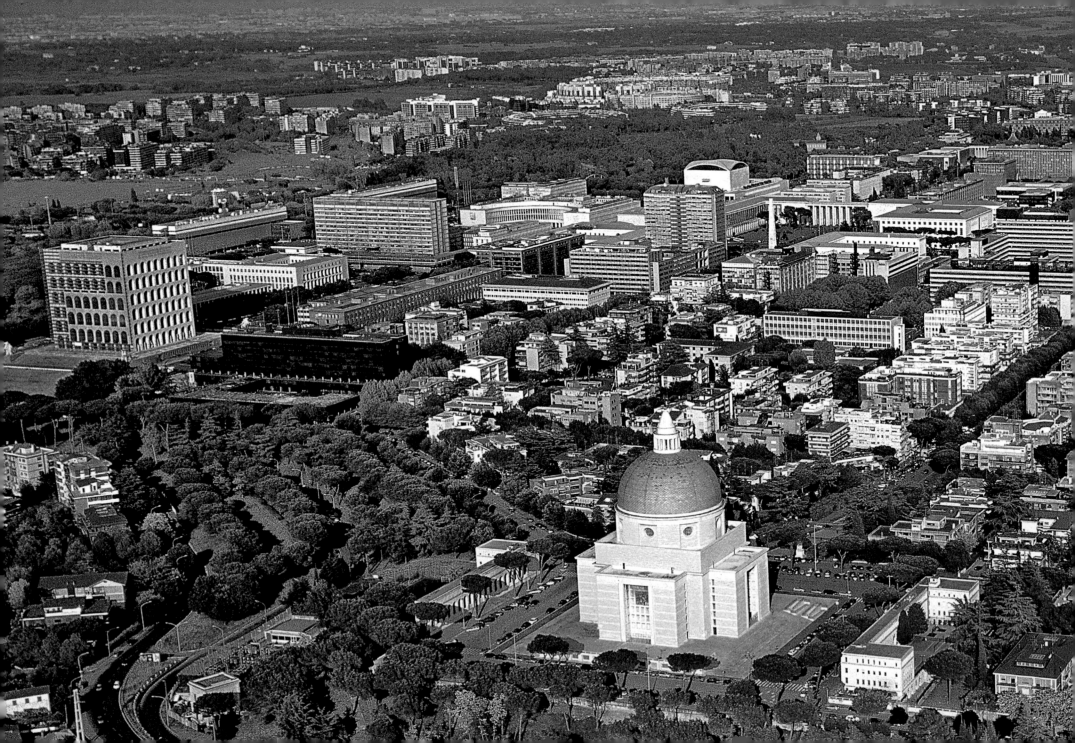

106-107 The EUR district – whose name is derived from the Universal Exposition of Rome (Esposizione Universale di Roma) of 1942, that was canceled because of 212 the war – is one of the city's best-known modern quarters. The photograph shows the church of Santi Pietro e Paolo and the Palazzo della Civiltà del Lavoro, nicknamed the "Square Colosseum."

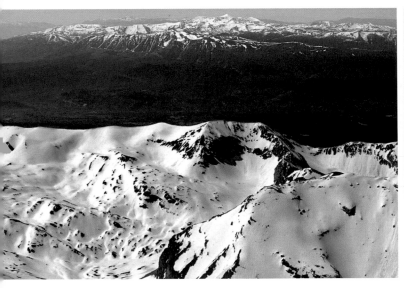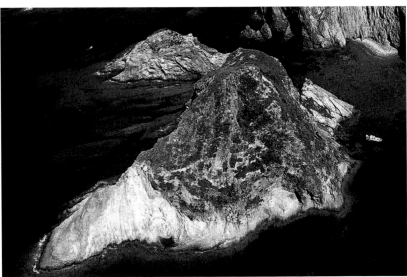

LANDSCAPES

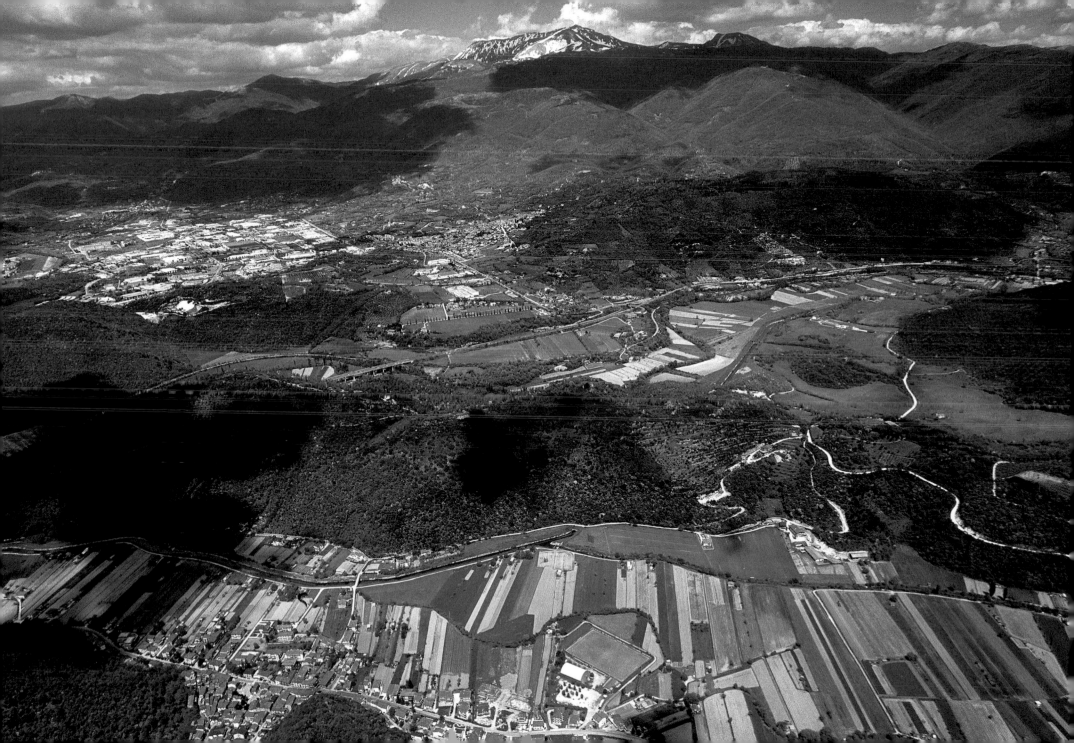

Lazio's most famous natural spectacle is the volcanic massif of the Alban Hills, which rise in full view from a lengthy section of the Rome Ring Road and are also clearly visible from the Janiculum and Rome's other hills. Mt. Cavo, 3114 ft (950 m), is the massif's highest peak. The lower slopes are covered with vineyards and the upper ones with chestnut and oak forests, offering breathtaking views of the Apennines and the coast. Lake Nemi and Lake Albano lie in the heart of these hills, their dark and very deep waters surrounded by old towns and woods.

For centuries travelers, writers and poets have sung the praise of the landscape of the Alban Hills. "Velletri stands on a volcanic hill which is joined to other hills only on its northern side and commands a wide view," Goethe wrote in his *Italian Journey*. "Arricia has the most beautiful forest in the world. The vegetation is punctuated by great black and brown rocks," Stendhal added.

The Roman poet Gioachino Belli described Lake Albano in verse: "Those who haven't seen this part of the world / don't even know why they were born / they've made a pretty lake surrounded / entirely by peperino and completely round / arranged in such a way that / the world is reflected upside down in it." And Byron wrote: "Lo, ! navell'd in the woody hills / So far, that the uprooting wind which tears / The oak from his foundation, and which spills / The ocean o'er its boundary, and bears / Its foam against the skies, reluctant spares / The oval mirror of thy glassy lake."

However, the region's allure is not simply due to the romantic appearance of its volcanic hills and lakes. Indeed, the highlands created by the "mountains of fire" are an equally important aspect of Lazio. While the Alban Hills – formed by terrible eruptions that took place between 700,000 and 30,000 years ago – overlook Rome from the south, the Sabatino, Cimino and Volsinio volcanoes rise north of the city, with Lakes Bracciano, Vico, Martignano and Bolsena nestling in their craters.

Volcanic tuff and pozzolana are also features of the landscape in many other areas of Lazio, commencing with the seven hills of Rome, through which the Tiber has carved its sinuous course to the coast. Similarly, tuff forms the plateaus and deep valleys that are home to

108 left The Gran Sasso and Laga Mountains National Park is one of the largest in Italy. Most of it is in Abruzzo province, but the Laga Mountains section is in Rieti province.

108 right The Pontine Archipelago is made up of two groups of islands of volcanic origin. The western group includes Palmarola island (Latina).

109 Mt. Terminillo's peak (7270 ft/2216 m), with its thick beech woods, is capped with snow until late spring. It towers over the industrial area of Rieti, and the Salarian Way that leads toward the Velino Gorges and the fields of the Turano Valley.

111 Much of the coastline of Ponza (Latina), the largest island of the Pontine Archipelago, is formed by crumbly and often dazzling white tuff cliffs that plunge sheer into the waters of the Tyrrhenian Sea. The five islands were once used as prisons, but are now very popular with bathers.

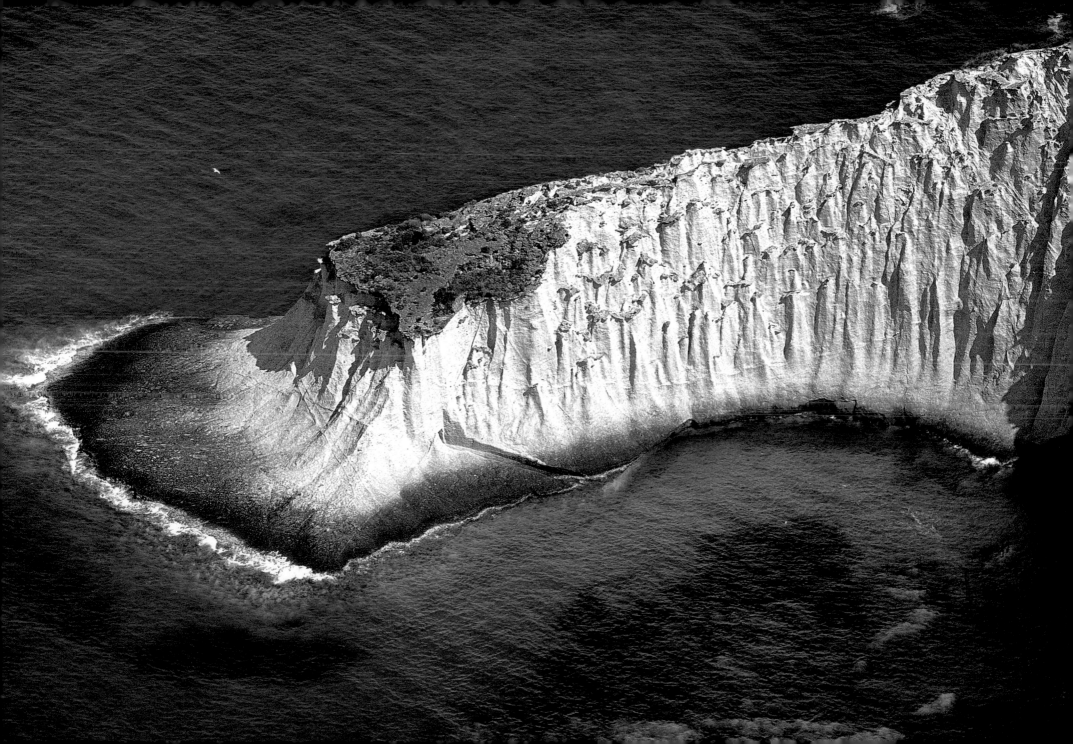

the Etruscan necropolises of Tarquinia, Cerveteri, Veio and Tuscania.

Mt. Cimino is an ancient volcano covered in magnificent beech woods that overlooks Viterbo. It is the only peak over 3300 ft (1000 m) in the hilly part of the region. Other tuff valleys are home to some of Lazio's most beautiful nature reserves, such as the Marturanum Park of Barbarano Romano and the Treja Valley Park, overlooked by the medieval village of Calcata. Volcanic processes were also responsible for the ravines of Civita di Bagnoregio; the rugged Tolfa Mountains overlooking Civitavecchia and the Tyrrhenian Sea, where the *butteri* (mounted cowherds) still follow the Maremma cattle with their long, curved horns; and the Lamone Forest, on the Tuscan border, with its solidified lava flows locally known as *murce*.

Other reminders of ancient volcanic activity are the Viterbo area's hot springs and the mud volcanoes – including the well-known Manziana Caldara – that rumble among the woods and gorges of upland Lazio.

The fertile soil and untamed natural environments of the gorges make volcanic Lazio an ideal habitat for rare plants and animals. Animal species include the Egyptian vulture – a small vulture that was once very widespread in the Maremma – and the short-toed eagle, a little migrant eagle whose diet consists mainly of snakes. Plants include dozens of species of wild orchid.

Volcanic Lazio lives alongside aquatic Lazio. The Tiber separates the tuff of Mt. Cimino and Lakes Bolsena, Bracciano and Vico from

112 left The hilly landscape between the Campagna Romana and the Ciociaria is a mosaic of wheat fields, vineyards and orchards. However, the rapid expansion of residential, commercial and industrial areas is swiftly changing the appearance of these areas.

the limestone of the Apennines, widening into the artificial basins of Lakes Nazzano and Alviano, which offer refuge to ducks, herons and coots. Rising above the Tiber's meanders is the limestone Soratte, a miniature mountain (just 2267 ft/690 m high) with an abundance of wonderful views, medieval hermitages and caves.

In 1884 engineers and laborers from Ravenna began draining the swampy area between Rome and the coast that once surrounded the fortified town of Ostia. The Maccarese, Ostia and Focene marshes recall the old landscape and are an ideal spot for bird watching. More meanders, water birds and reed-beds can also be seen between the Ciociaria and the Campanian border, in the Garigliano and Liri river valleys and crystal-clear Lake Posta Fibreno, where the karst waters of the Abruzzo National Park resurface. This surprising lake, which has a depth of 150 ft (45 m), is home to a floating island of peat, dead plants and reeds, which moves with the wind. However, the heart of aquatic Lazio lies in the four coastal lakes (Fogliano, Monaci, Caprolace and Sabaudia) of the Circeo National Park. Of course, this landscape too has changed. "At last the forest opens up. In front of me appears the spectacle of the coast, the shimmering carpet of the Pontine Marshes and the gleaming Pontine Islands: one of the most beautiful sights in Italy,"

wrote Ferdinand Gregorovius, a German scholar in love with Rome and Lazio in the mid-19th century.

However, the drainage projects carried out over the subsequent 150 years have transformed the wild and evocative landscape into a fertile agricultural plain, which has gradually been covered with industrial settlements. Of the ancient Circeo Forest only 8056 acres (3260 hectares) of turkey oak, hornbeam and common oak remain, separated by seasonal lakes known as piscine. The park, founded in 1934, comprises the lakes, the Forest, the long sand dune and the limestone headland of Mt. Circeo, protected on the seaward side by the sheer rocks of the Precipizio.

It is only a short boat trip from the Circeo to Zannone, the only one of the Pontine Islands situated within the protected area. Limestone cliffs, mouflon, ancient ruins and huge holm oaks make it a fascinating place. Tuff reappears on the islands of Ponza, Palmarola, Ventotene and Santo Stefano, in the form of breathtaking cliffs and stacks.

However, the finest and highest cliffs in Lazio, extending along the coast between Terracina and Sperlonga, are limestone. They overlook the Roman Via Flacca and protect the Gaeta headland, topped with the munitions depots and walls of the fortress that in

112 center During winter the snowy peak of Mt. Terminillo, near Rieti (center of photograph) is a favorite destination of skiers and mountaineers. The ski lifts that have made the area famous serve Mt. Terminilletto (right). The Mt. Elephant massif is visible in the background.

112 right Although less well known than the reclamation of the Agro Romano, the drainage of the Rieti Basin, which was begun by the Romans, has created thousands of acres of highly fertile countryside. The old marshy landscape still survives in the Lake Lungo and Lake Ripasottile Nature Reserve.

1861 witnessed the final stand of the Bourbon king of Naples and the Two Sicilies during the creation of a unified Italy.

Steps lead from the sanctuary of Montagna Spaccata to the Grotta del Turco, a huge natural arch overlooking the Tyrrhenian Sea. Climbers from all over Europe tackle the challenging routes marked out on the highest part of the cliff, which rises over 330 ft (100 m) above the sea. The presence of the peregrine falcon and the kestrel has led the Ulysses Riviera Park, which is responsible for the conservation of the coast, to set aside part of the cliff for the birds.

Almost all the rest of Lazio is mountainous. Only two hill areas – the Campagna Romana and the Ciociaria – separate Rome and the coastal mountains from the Apennines, which stretch for over 60 miles along the border with Abruzzo. The Ciociaria and the Campagna Romana have many historic monuments and towns and were favorite destinations of the travelers of the past. However, progress has disfigured the landscape with roads, quarries, industries, railways and uncontrolled urban expansion.

The mountains provide the backdrop to the tuff gorges and sinkholes of the Campagna Romana and to the karst lakes and ravines of the Ciociaria. The limestone foothills of the Apennines, with their karst fields and thick oak woods, give way to the meadows and beech woods of the higher ranges. The Lepini, Ausoni and Aurunci Mountains rise to the south, between the Ciociaria and the sea, while Mt. Navegna stands between Lake Turano and Lake Salto. Roman day-trippers are particularly fond of the Lucretili Mountains, which form the eastern boundary of the Campagna Romana, overlooking Hadrian's Villa and Tivoli. They are home to rare plant species, such as the storax, from which an incense-like resin was once extracted. The golden eagle nests on the crags of Mt. Pellecchia, less than 20 miles (32 km) from Rome as the crow flies, and the highest peaks rise just a few miles beyond.

The Simbruini and Ernici ranges to the south are home to the source of the Aniene River and the Benedictine abbey of Subiaco, culminating in the 7073-ft (2156-m) peak of Mt. Viglio and widening into magnificent upland pastures. Farther north, the Duchessa Mountains, which rise around the lake of the same name, play second fiddle to the Abruzzo Velino Massif, which can be seen from the Janiculum Hill in Rome, while limestone Mt. Terminillo, famous for its skiing, dominates Rieti and the Sabina from a height of 7264 ft (2214 m). Higher still are the Laga Mountains, the only sandstone and marl range in Lazio, where the streams formed by thawing ice and snow create spectacular waterfalls. Standing 8064 ft (2458 m) above sea level, Mt. Gorzano is the "roof" of the Laga Mountains and the whole of Lazio and offers views of the Adriatic coast on clear days. It belongs to the magnificent national park that also includes the peaks of the Gran Sasso mountain group in Abruzzo.

115 The fertile volcanic soil of the eastern part of the Campagna Romana, at the foot of the Alban Hills and limestone massifs of the Apennines, is furrowed with deep tuff gorges covered with dense undergrowth. It is ideal for vineyards.

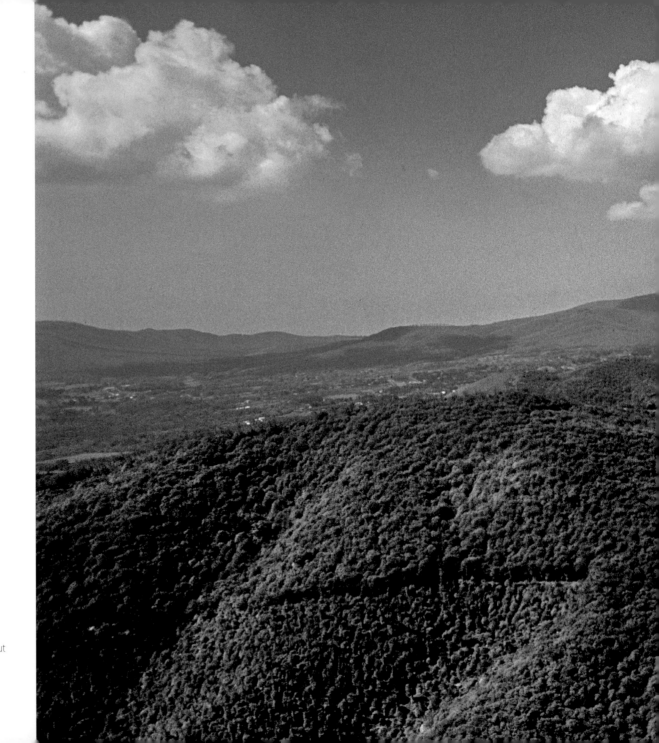

116-117 Toward Rome, the volcanic massif of the Alban Hills, culminating in the 3114-ft (950 m) peak of Mt. Cavo, has been subject to widespread development; however, the massif is covered with dense woodland toward the Ciociaria and the Lepini Mountains. The chestnut is the commonest tree on these uplands.

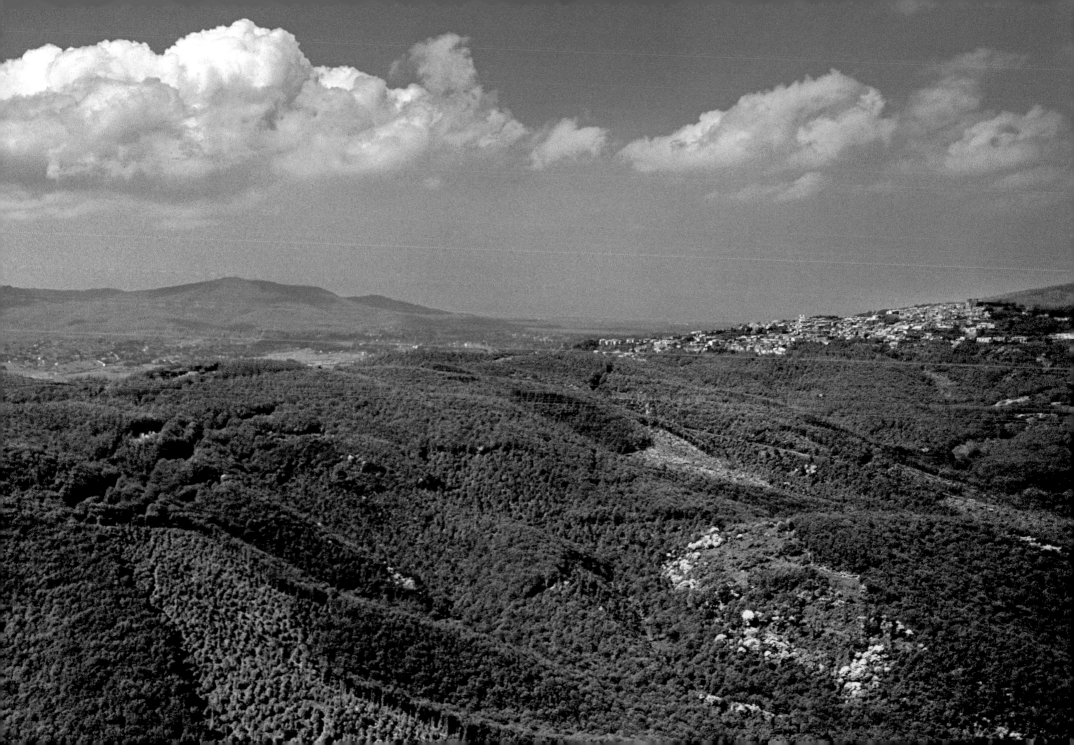

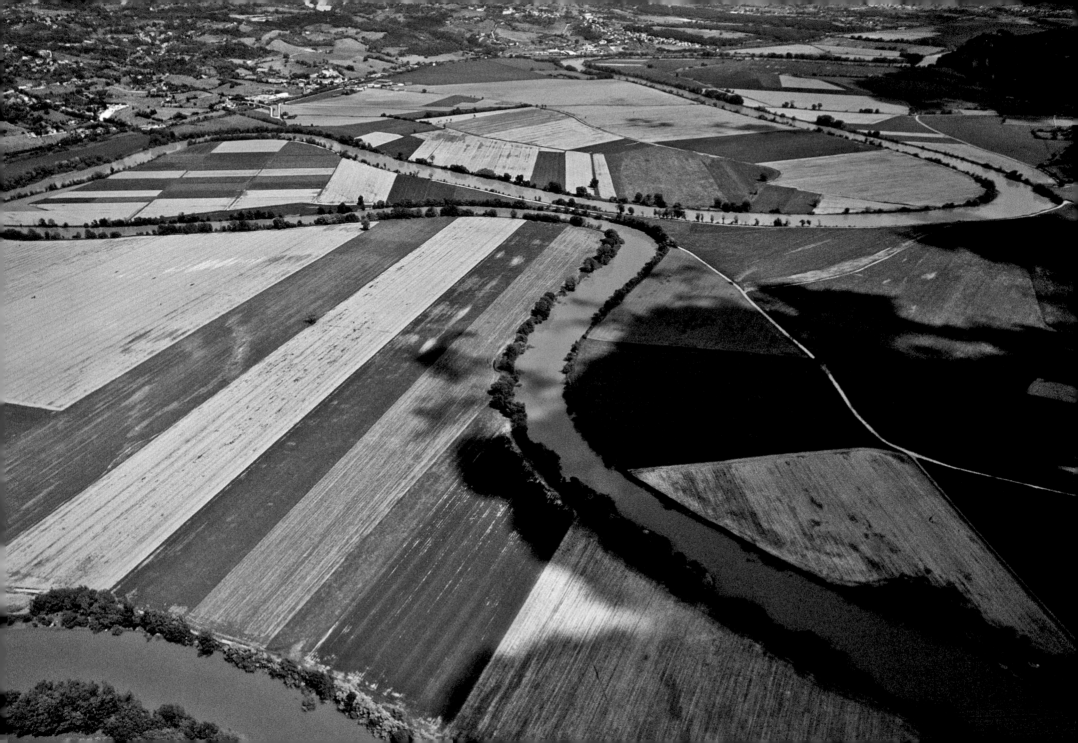

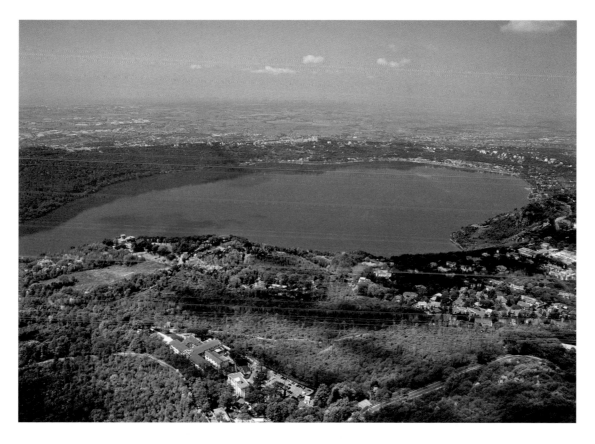

118 The Tiber meanders through the countryside between the abbey of Farfa and Nazzano, about 12 miles (19.3 km) from the Rome Ring Road. Despite the proximity of the main North-South expressway and the Rome-Florence railway line, the area is of great natural interest.

119 Lake Albano, the largest of the lakes occupying the ancient craters of the Alban Hills, is situated at an altitude of 961 ft (293 m) between the towns of Albano, Castelgandolfo (visible in the background) and Marino. The monastery of Palazzolo is silhouetted against the waters.

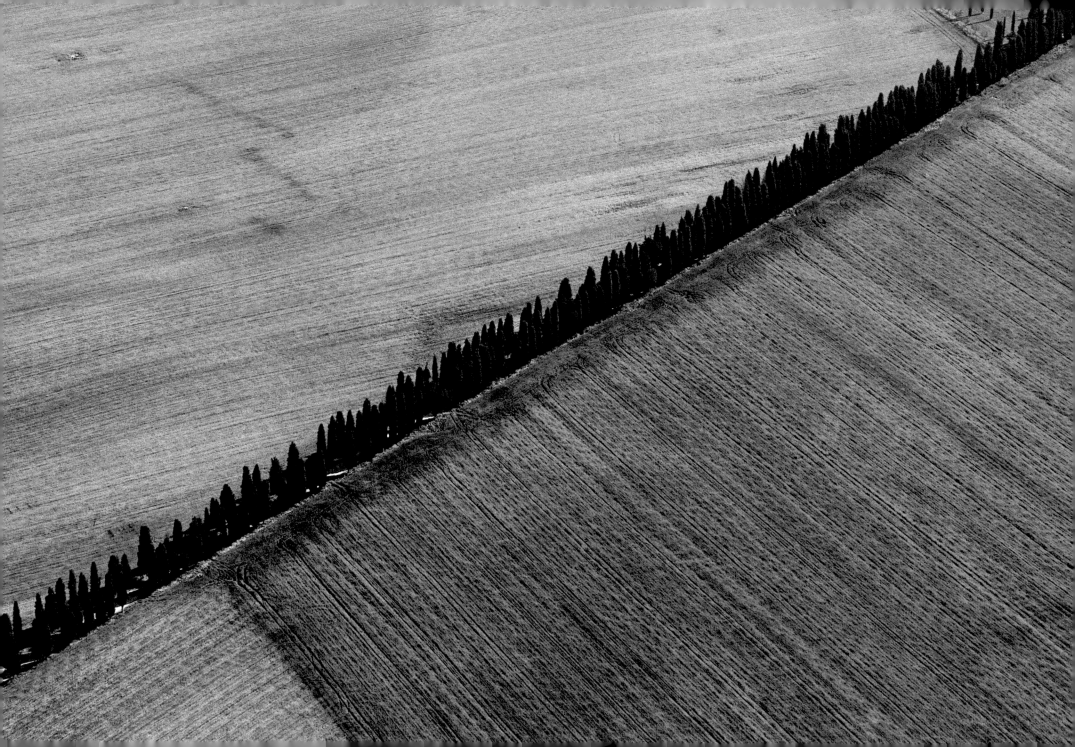

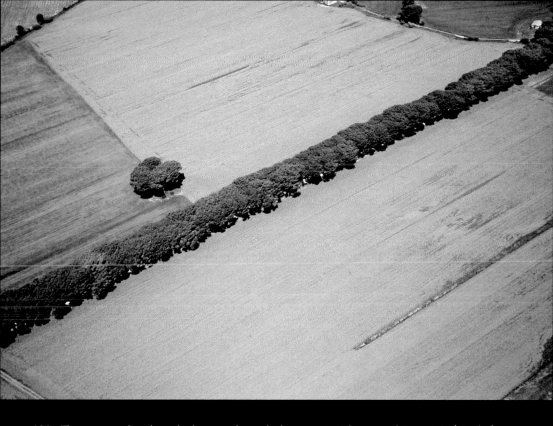

120 The cypress-lined roads that cut through the countryside around Tarquinia (Viterbo) are a visual reminder that the Lazio Maremma, in the provinces of Viterbo and Rome, adjoins the better-known Tuscan Maremma. The fields are flanked by huge expanses of pastureland on both sides of the regional border.

121 Maritime pines, with their wide shady crowns, are the commonest trees along the streets of Rome and the rest of Lazio. Large agricultural areas protected by parks and nature reserves, such as the Marcigliana and Decima Malafede, preserve these landscapes, even inside the Ring Road.

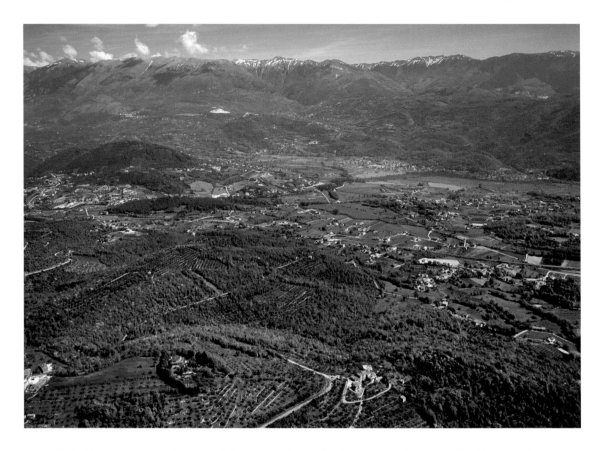

122 The snowcapped peaks of the mountains of the Abruzzo, Lazio and Molise National Park provide the backdrop to the hills of the Comino Valley, one of the most picturesque corners of the Ciociaria. The mountain waters resurface in Lake Posta Fibreno, which is protected by a nature reserve.

123 Despite the rapid expansion of Rome, large areas of the countryside at the foot of the Castelli Romani have preserved the old and evocative rural landscape of orchards, fields and vineyards, which produce fine red and white wines.

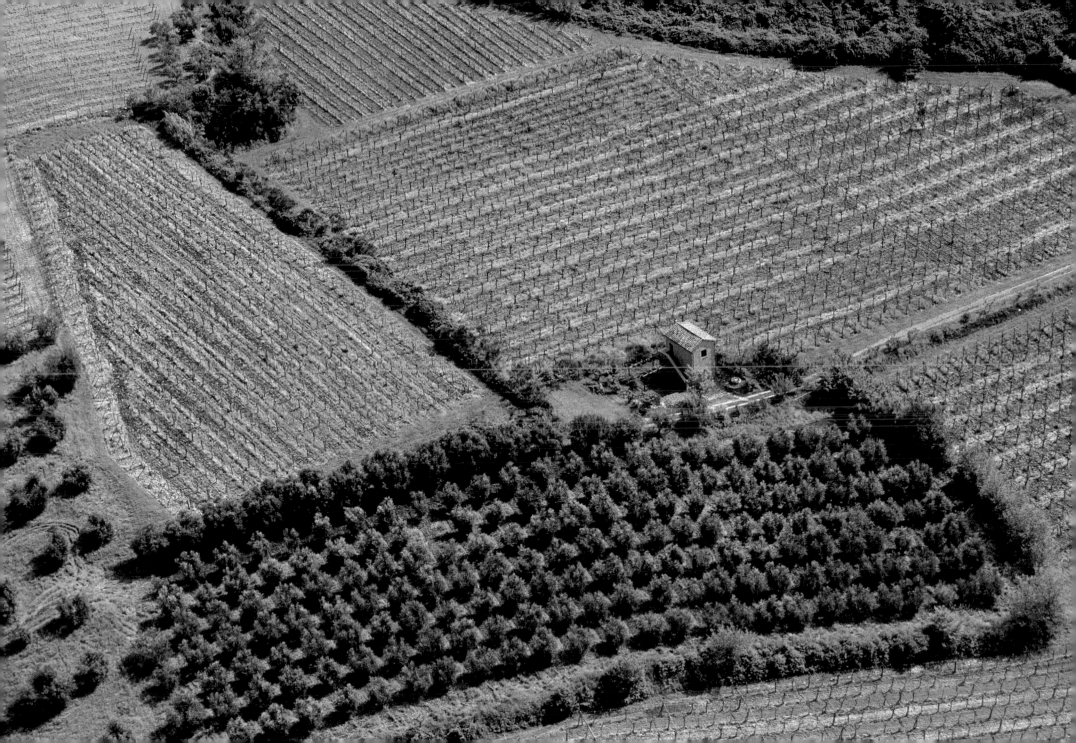

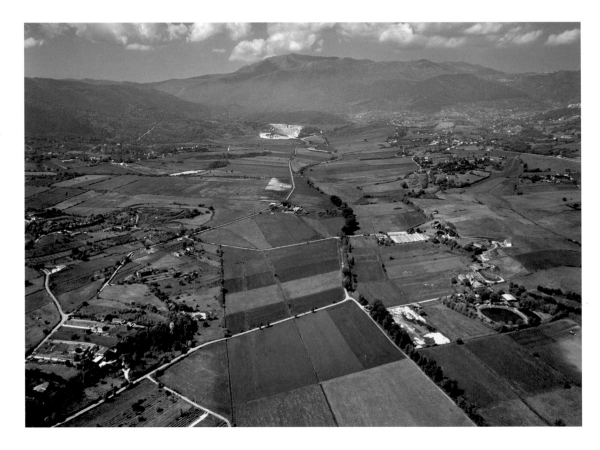

124 The dark and wooded ranges of the Sabine Hills and Lucretili Mountains remain unspoiled and untamed, despite their low altitudes, forming the backdrop to the Tiber Valley that marks the western border of the Sabina and approaches Rome from the north.

125 From Etruscan times until the end of the 19th century, boat services ran on the Tiber from Rome to Perugia. However, construction of the Castel Giubileo, Nazzano and Alviano dams made navigation impossible.

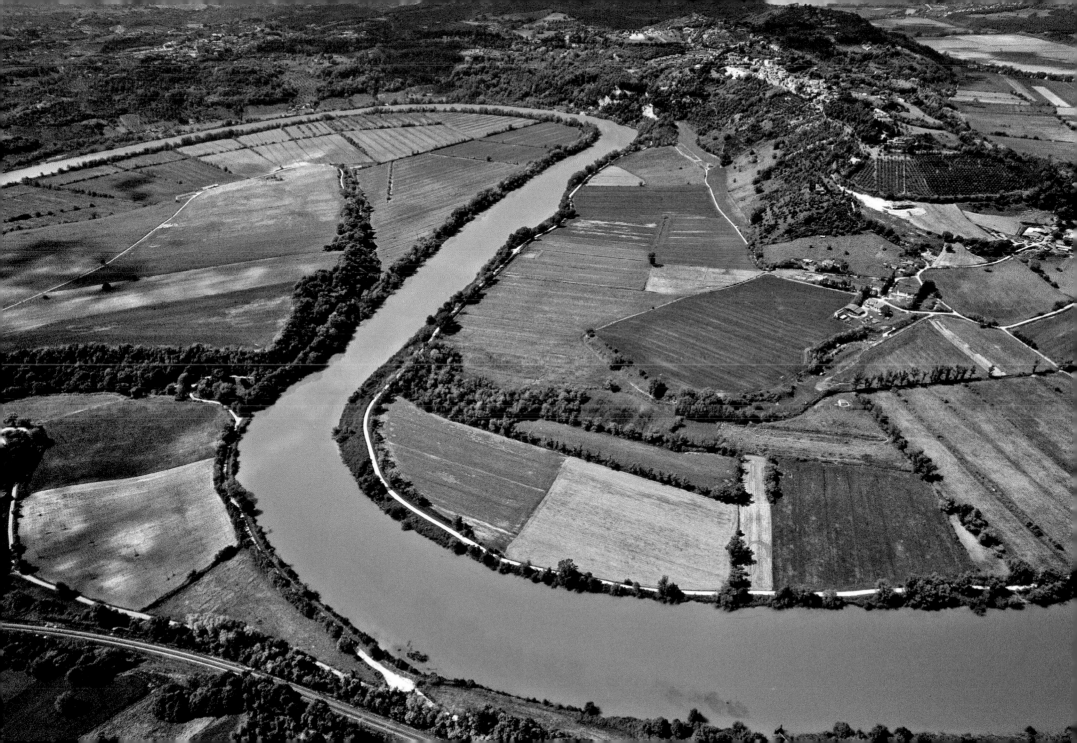

126 Almost 5 miles (8 km) long, but just 218 yards (200 m) at its widest point, Ponza (Latina) is a narrow and sinuous strip of land surrounded by the blue Tyrrhenian Sea. The town of Ponza and the crumbly cliffs of Chiaia di Luna (on the left) can be seen in the middle of the island.

127 At several points the island of Ponza is just a narrow strip of land, crossed by a single road and protected by cliffs on both sides. About 3500 people live on the island, but the number rises to 15-20,000 during the summer.

128 The bay of Chiaia di Luna, surrounded by a crumbly cliff about 165 ft (50 m) high, is one of the most famous and frequented spots of Ponza (Latina). It can be reached only by sea or through a pedestrian tunnel that connects it to the town.

129 The extraordinarily clear waters make Ponza and the other islands of the archipelago (Palmarola, Zannone, Ventotene and Santo Stefano) very popular with bathers during the summer. During the other seasons the islands attract hikers or birdwatchers.

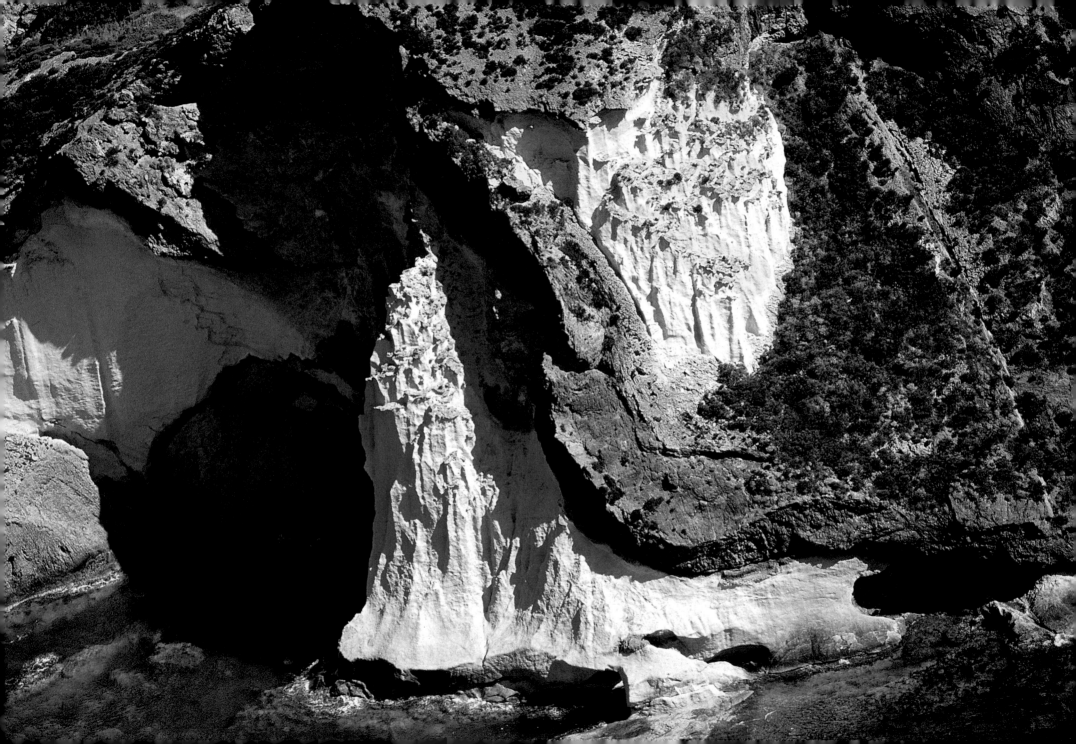

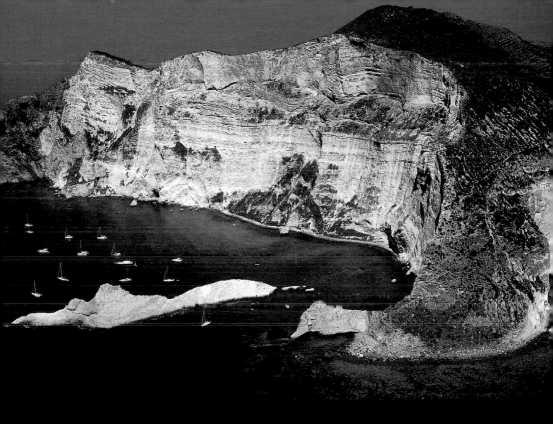

130 The Pontine Islands were formed by volcanic eruptions 5 million years ago and the rocks were subsequently eroded. The sun and wind have given rise to a typically Mediterranean flora, characterized by hardy species, such as agave, prickly pear, broom and spurge.

131 Landslides have forced Ponza's council to close the narrow beach of Chiaia di Luna (Latina) to bathers several times. Consolidation work has made the area safer. During the summer large numbers of visitors flock to the beach, arriving by land and sea.

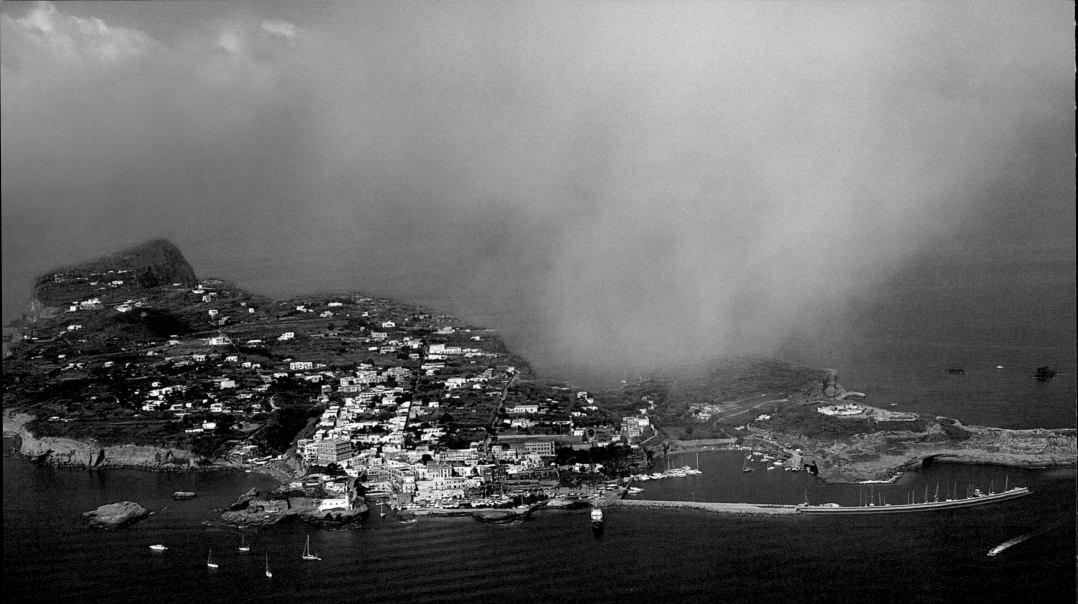

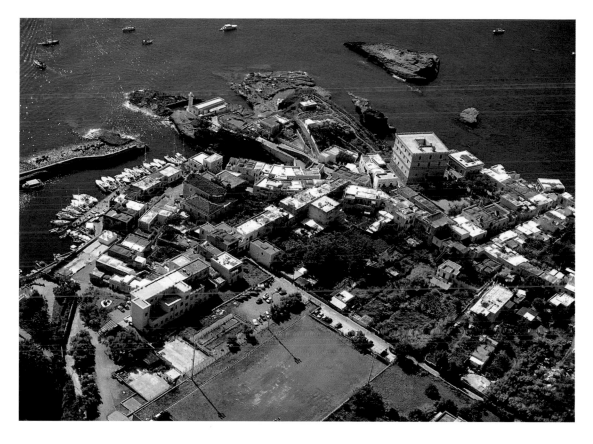

132 Ventotene (Latina), midway between Ponza and Ischia, is the smallest of the Pontine Islands. Here, legend tells us, Odysseus listened to the luring song of the sirens on its cliffs.

133 The old port of Ventotene was carved out of the tuff by the ancient Romans. The fish farm they built, featuring an ingenious system to channel water into covered tanks, can be seen by the entrance to the port, marked by the lighthouse.

134

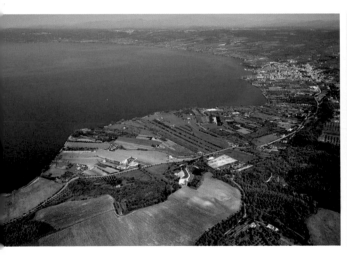 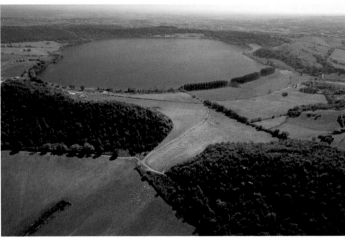

134 left The coast of Lake Bolsena (Viterbo), south of the town of the same name (visible in the background), is of great archaeological interest. In 1966 the prehistoric settlement of Gran Carro was discovered 23-26 ft (7-8 m) below ground, built on piles and with rocks furrowed by the transit of carts.

134 right Lake Martignano (Rome), between Lake Bracciano and the Cassian Way, is a favorite bathing resort; the two lakes are part of a regional park covering 41,222 acres (16,682 hectares); it was established in 1999.

135 Lake Posta Fibreno (Frosinone) is fringed by large reed thickets. It has a maximum depth of 148 ft (45 m) and is protected by a 988-acre (400-hectare) regional reserve.

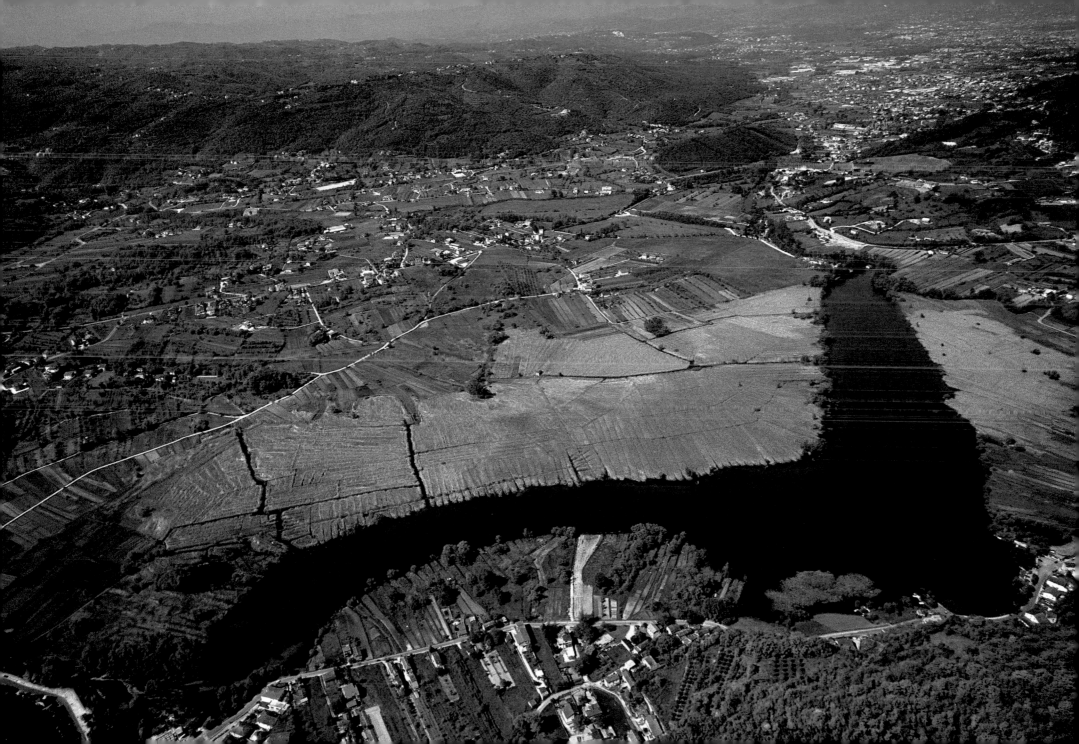

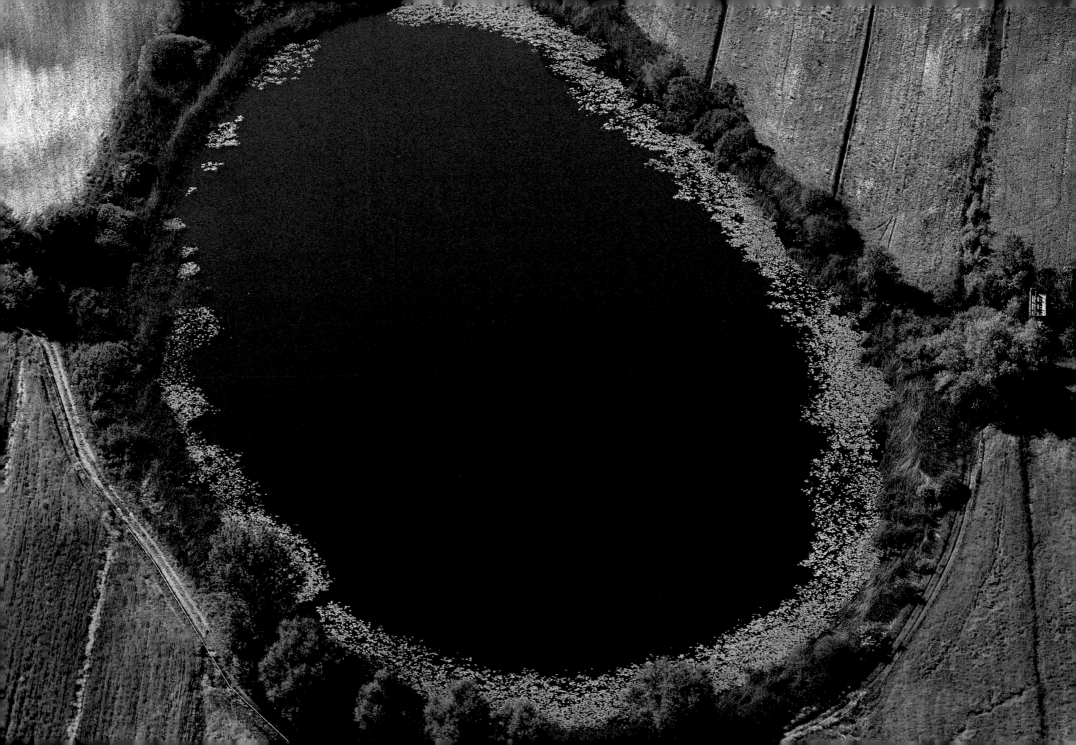

136 At the foot of Mt. Terminillo, Lake Ripasottile (Rieti) is surrounded by reed thickets and fields and is protected by a 7500-acre (3035-hectare) regional nature reserve, along with nearby Lake Lungo. The Visitors' Center is housed in the drainage pump building, visible on the right.

137 Gorges covered with a thick blanket of holm oak furrow the Campagna Romana at the foot of the steep limestone slopes where Tivoli lies. Some of these gorges, such as the Fosso di Ponte Terra (Rome), offer hiking in a particularly untamed setting.

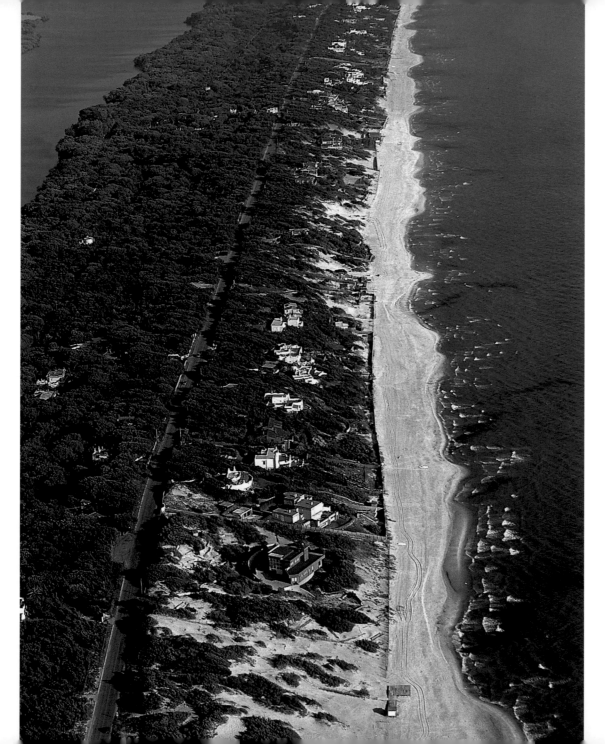

138 The sand dune that separates Lake Sabaudia (or Lake Paola) from the Tyrrhenian Sea is part of the Circeo National Park (Latina), established on the Pontine coast in 1934. Although dozens of villas were built in the zone following World War II, it is still a very important natural area.

139 Cliffs and small sandy beaches characterize the coast north of Gaeta (Latina), clearly visible in the photograph, and the Mt. Orlando headland, protected against the open sea by high limestone cliffs. The coast between Formia, Minturno and Campania can be seen in the background.

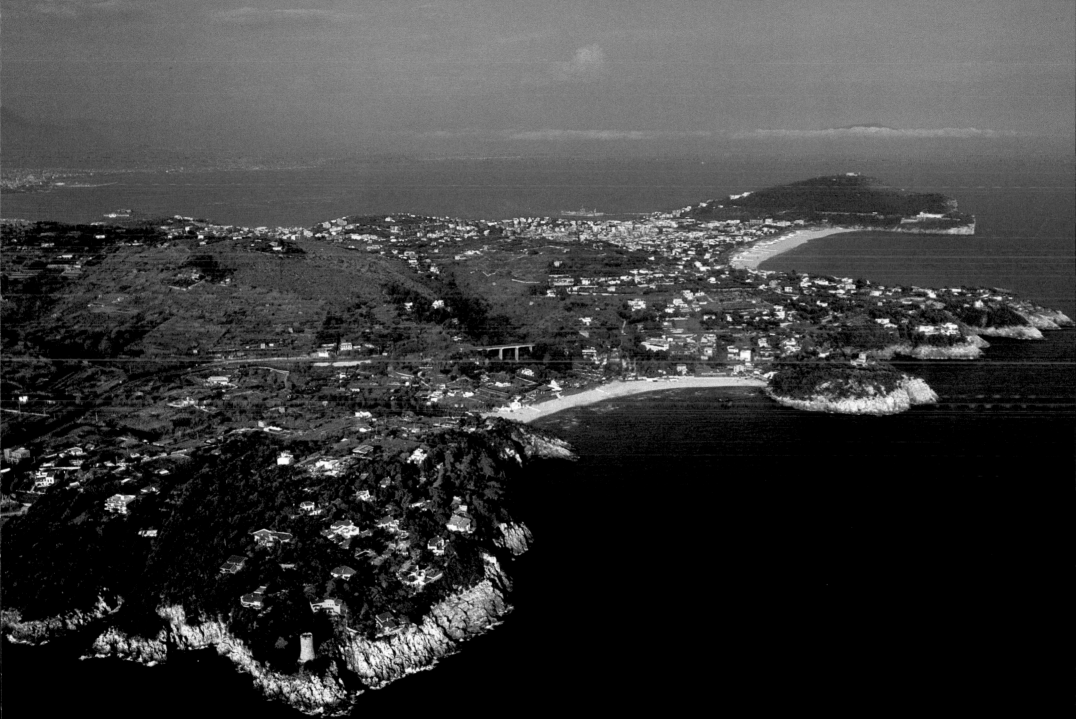

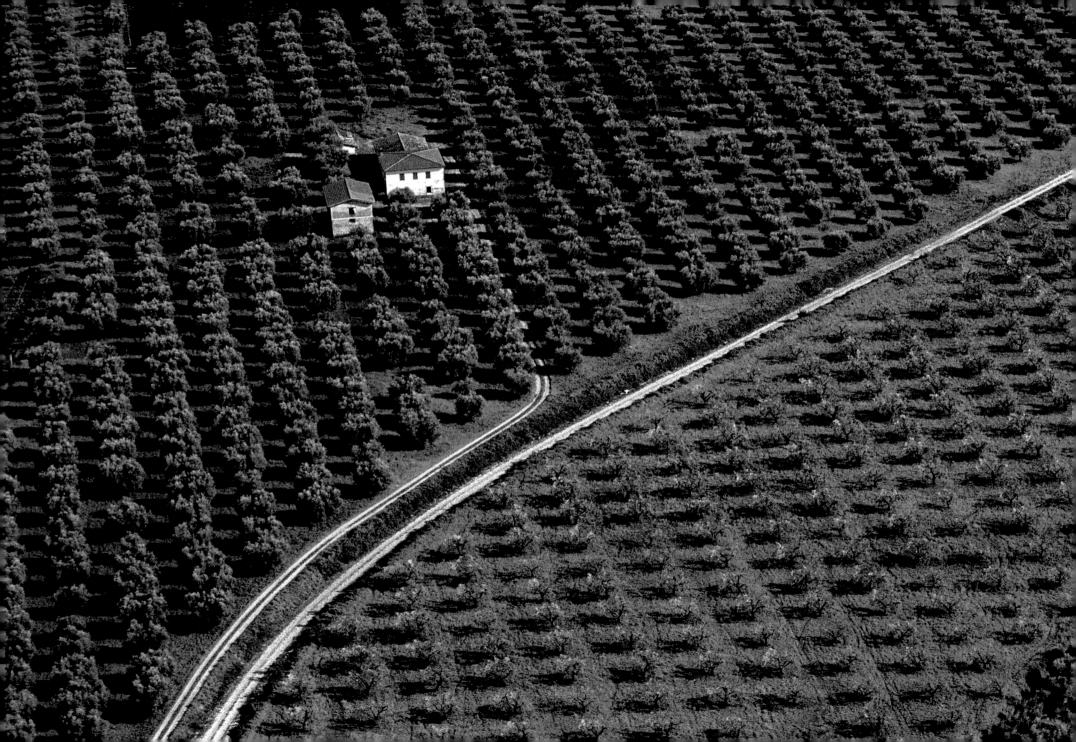

140-141 The drainage of the marshy Pontine Plain, commenced by the popes in the XVI century and completed during the 1930s, made the area one of the most fertile in Lazio. The fruit and vegetables grown in this area supply the markets of the whole of Italy.

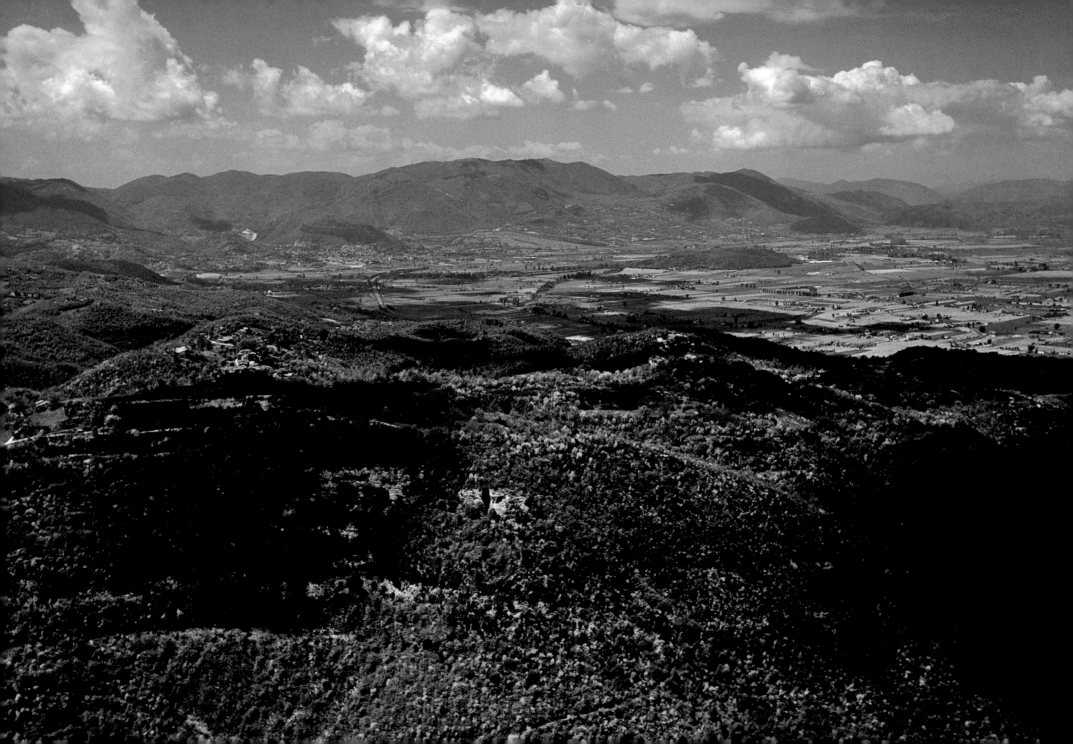

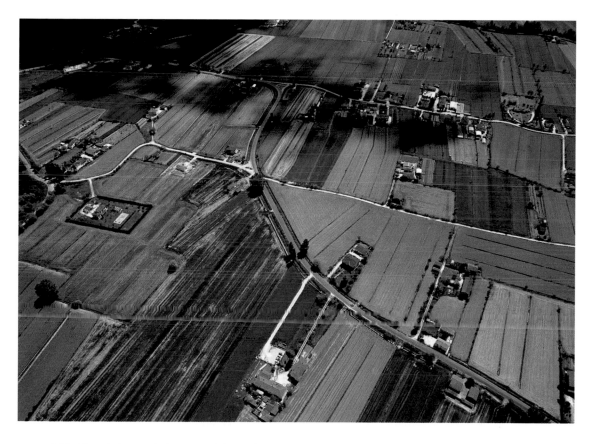

142 The dark wooded range of the Sabine Hills, which culminates in the 4206-ft (1286-m) peak of Mt. Tancia, separates the Rieti Basin from the Tiber Valley and the part of the Sabina closest to Rome. Similar hills, slightly farther north, mark the border with Umbria.

143 In ancient times, the basin north of Rieti was a huge insalubrious marsh. The enterprising Romans drained it by means a channel that allowed the water to flow into the Marmore Waterfall and the Nera River. It is now one of the most fertile areas in Lazio.

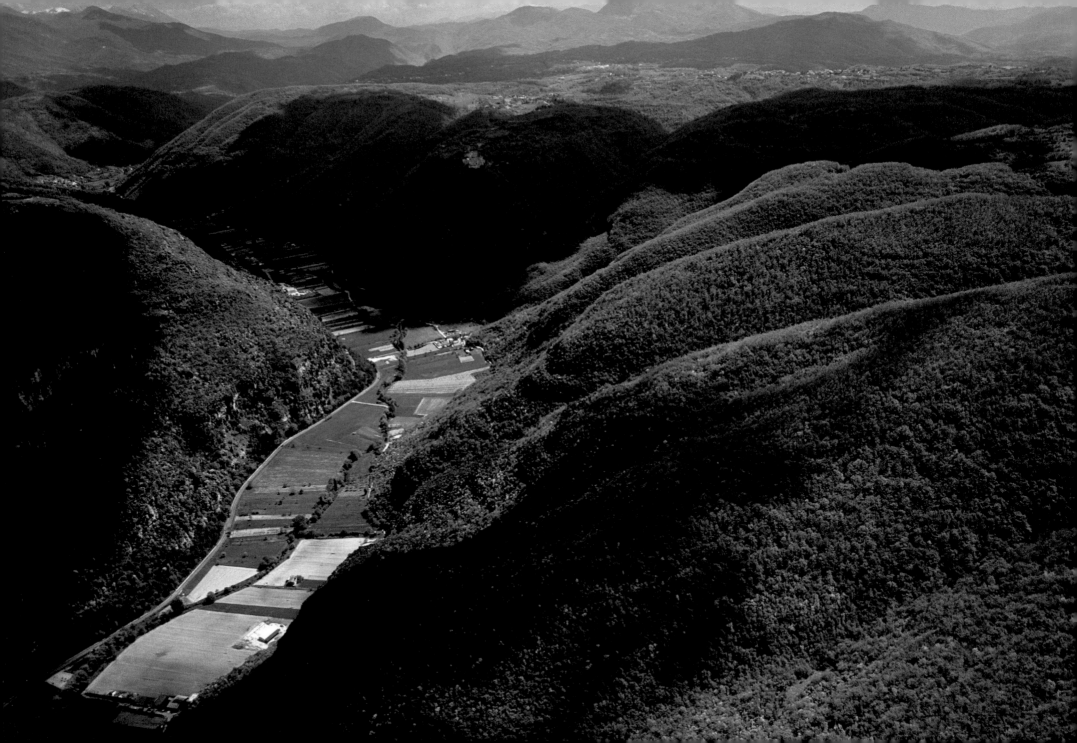

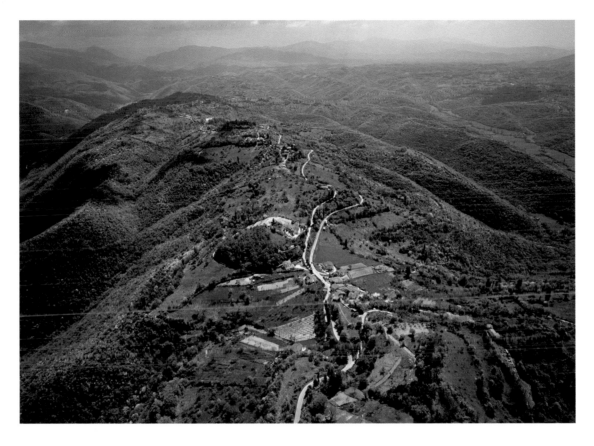

144 The Turano River, which empties into the Velino just outside Rieti, runs through a deep valley edged with hills covered with thick oak woods. Farther upstream, the river is blocked by a dam that creates a large and spectacular artificial lake.

145 These valleys around Rieti were trodden by St. Francis, who preached in their sanctuaries, forests and hamlets. They have preserved the appeal of their long history.

146 and 147 The countryside around Latina is intensively farmed and its fields and greenhouses supply fruit and vegetable markets throughout Italy. The most popular greenhouse crop is zucchini, followed by tomatoes and lettuce, which can thus be consumed all year round.

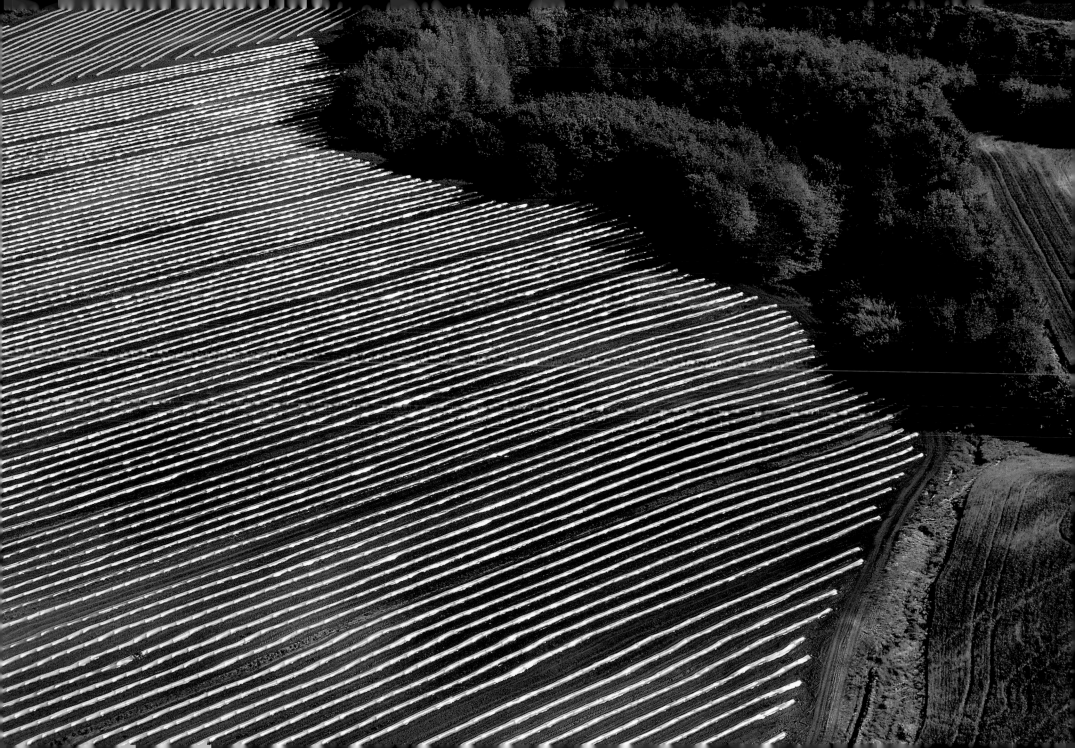

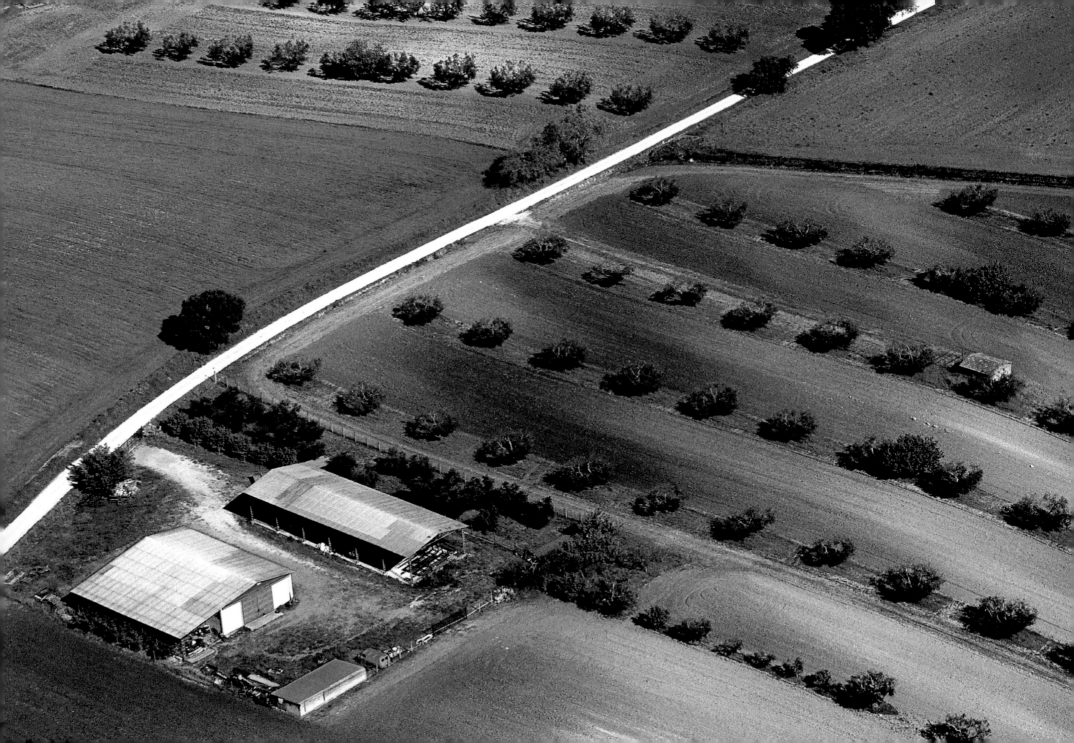

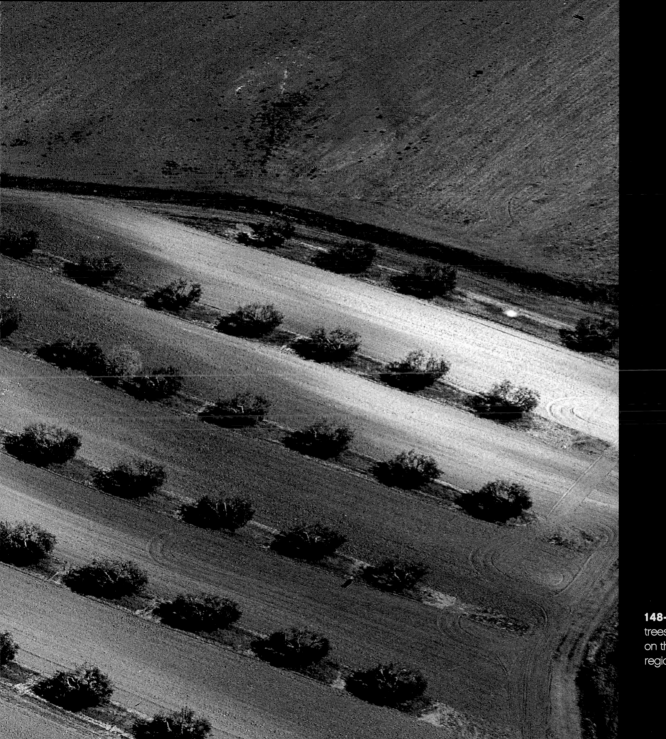

148-149 An olive grove with endless rows of trees near Tuscania (Viterbo). The area bordering on the municipal territory is home to one of the regional natural parks, established in 1997.

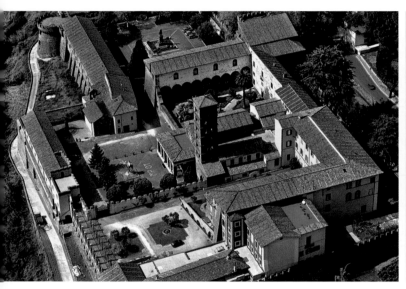 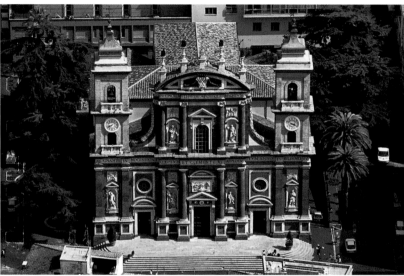

TOWNS AND CITIES

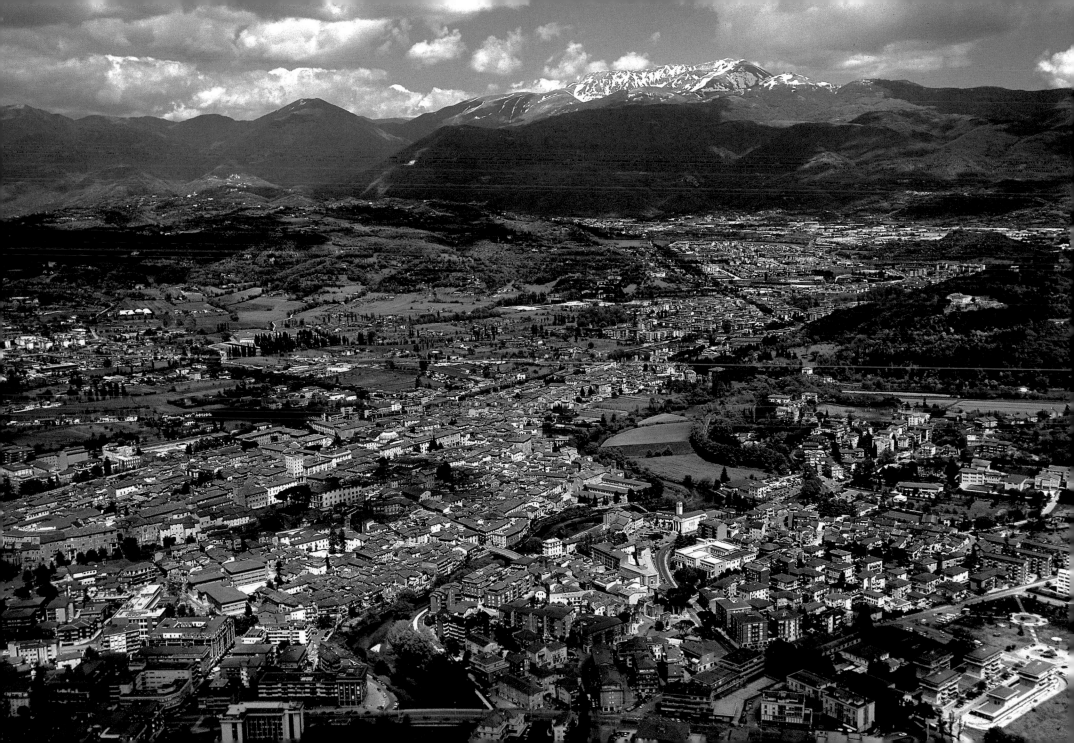

An aerial view of the gorges of the Tolfa Mountains near the Tyrrhenian Sea reveals a surprising series of grassy mounds. Although they look like natural features, they are actually manmade. These are the burial mounds of Cerveteri, the Etruscan city that for 300 years played a leading role in Mediterranean history. Overlooking the Tyrrhenian Sea, with the ports of Alsium (modern-day Palo), Pyrgi (Santa Severa) and Punicum (Santa Marinella), Cerveteri allied itself with Carthage against the Greeks, gave refuge to Tarquin the Proud following his expulsion from Rome, and was sacked by Dionysius of Syracuse before becoming Roman territory. The city was rediscovered in 1561 and became famous in 1838, when the Regolini-Galassi Tomb and the Tomb of the Shields and Chairs were opened.

"There is a stillness and a softness in these great grassy mounds with their ancient stone girdles, and down the central walk there lingers still a kind of homeliness and happiness... They are surprisingly big and handsome, these homes of the dead... But whoever it is that has departed, they have left a pleasant feeling behind them, warm to the heart, and kindly to the bowels," D. H. Lawrence wrote in Etruscan Places in 1927.

However the outskirts of Rome have now reached Cerveteri, and while the archeological interest of the zone remains, sadly the harmony of the landscape has disappeared. The same fate is shared by many of Lazio's villages and monuments. Modern building along the Cassian Way now encroaches on the plateau of Veio, the Etruscan city conquered by Rome in 396 BC, which still is still home to ancient tombs and streets, the Portonaccio Temple, where the enigmatic Apollo of Veio statue was discovered, and the surprising Ponte Sodo, a 650-foot tunnel cut into the tuff. The huge travertine quarries of Guidonia scar the foot of the Apennines, while a rash of illegal housing has surrounded Hadrian's Villa. Here, between AD 118 and 134, the philosopher emperor ordered the construction of replicas of the landmarks that had impressed him on his travels, from the Lyceum and the Stoa Poikile (Painted Porch) of Athens to the canal linking Canopus and Alexandria.

Abandoned for 1000 years, the Villa was sacked by "archaeologists," who removed hundreds of statues now housed in museums throughout the world. The enchanting interiors are matched only by the view from above when the sun illuminates the colon-

152

150 left The town of Grottaferrata (Rome) developed over the centuries around the abbey of San Nilo (in the photo) and the ruins of the Roman villas that once stood there.

150 right The church of San Pietro Apostolo in Frascati (Rome) was consecrated in 1610, although the façade was not completed until 1700.

151 Rieti, the capital of the Sabina, lies in a fertile basin crossed by the Salarian Way, which links Rome with Picenum and Abruzzo. The city is home to the cathedral of Santa Maria Assunta, with its Romanesque bell tower. Mt. Terminillo, in the background, is a favorite destination for hikers and skiers.

153 Ventotene (Latina) is the only town on the island of the same name. It is flanked by an evocative harbor carved out of the tuff and a larger modern port.

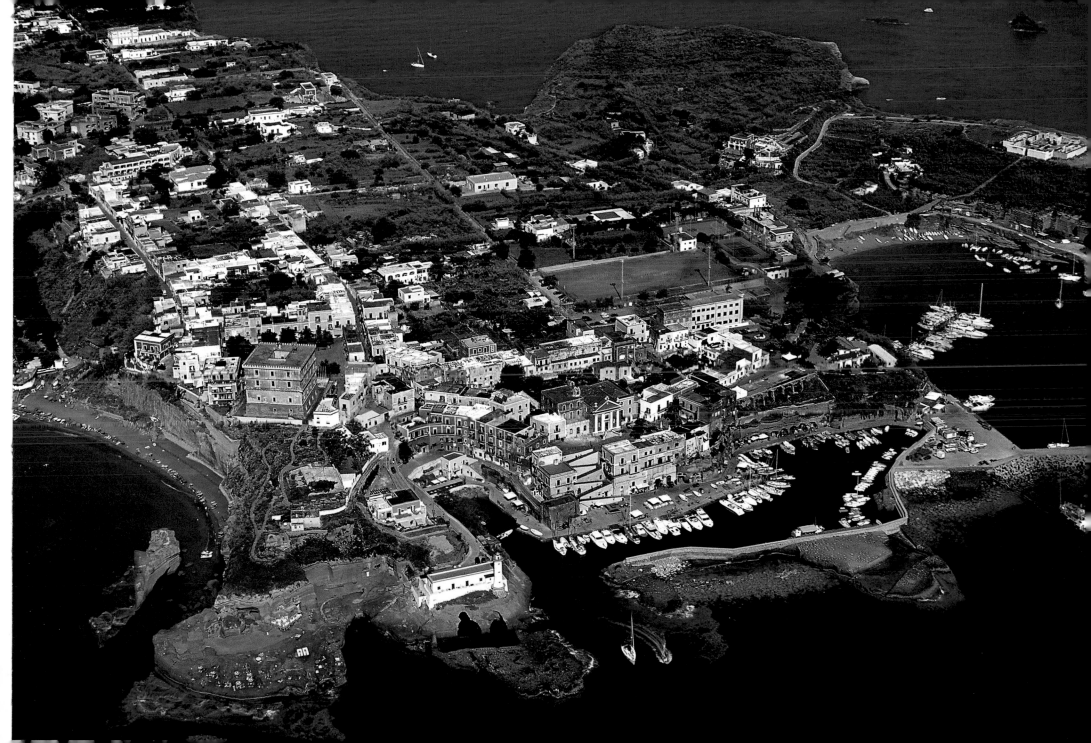

The region is also home to imposing urban castles, such as those of the Odescalchi and Savelli families in Palonbara Sabina, the Rocca Pia of Tivoli, and Fondi castle. Fumone castle attracts visitors with its magnificent views over the Ciociaria and the fact that it was once home to Fra' Pietro da Morrone, the former Pope Celestine V – the only pope in history to have resigned.

Southern Lazio is characterized by the polygonal masonry walls built by the Italics around the 5th century BC, which astounded the engineers of ancient Rome. The most spectacular, from both the ground and the sky, are in Segni, Castel San Pietro Romano, Arpino, Alatri and Norba. Rocky Mt. Circeo is the site of the "Acropolis of Circe," a ring of polygonal walls built two and a half thousand years ago by the Volsci.

A last glimpse should be reserved for the "little capitals," which demonstrate that Lazio does not just mean Rome. Latina was built in 1932 and boasts some fine examples of the architecture of the Fascist period around the Piazza del Popolo. Gaeta lies on the border with Campania. It was an important Roman town and is home to the cathedral of Sant'Assunta e Sant'Erasmo, built shortly after the turn of the 11th century. The castle founded by Frederick II and fortified by the King of Naples stands on a headland. Frosinone, the capital of the Ciociaria, was founded by the Volsci, although few traces of its ancient history remain. Although the economic heart of the province has now shifted toward the factories of Cassino, the memory of this part of Lazio is concentrated between the palaces and churches of Anagni, with its cathedral commenced in 1077. The interior boasts a ciborium and a candelabra in Cosmati work (a type of mosaic technique), and a frescoed crypt, dating from the mid-13th century. Riet lies at the foot of Mt. Terminillo, and is across from a huge industrial area with splendid medieval walls and the austere cathedral of Santa Maria Assunta with its Romanesque bell tower. Further north, Amatrice is the capital of "Abruzzian Lazio" and owes its fame to its cuisine (it is the birthplace of the famous "Matriciana" pasta) and the nearby Laga Mountains.

However, the most beautiful capitals are situated toward the Tuscan border. Tarquinia boasts a handsome medieval center and Etruria's finest painted tombs, while Tuscania has a perfectly preserved medieval center, flanked by the Romanesque churches of Santa Maria Maggiore and San Pietro.

Nonetheless, the title of Lazio's most beautiful city – apart from Rome – must go to Viterbo, the capital of the Tuscia. The papal palace, cathedral, city walls and medieval district of San Pellegrino create a setting that harks straight back to the Middle Ages. Just outside the city, visitors can choose between the Etruscan atmospheres of Castel d'Asso and Norchia and the Renaissance air of Bagnaia, which is home to Villa Lante, one of Lazio's finest Italian gardens.

157 The imposing façade of Palazzo Camuccini, originally a medieval castle, overlooks the town of Cantalupo in Sabina (Rieti). The palace is flanked by the church of San Biagio, which was embellished with an imposing Baroque façade during the 18th century.

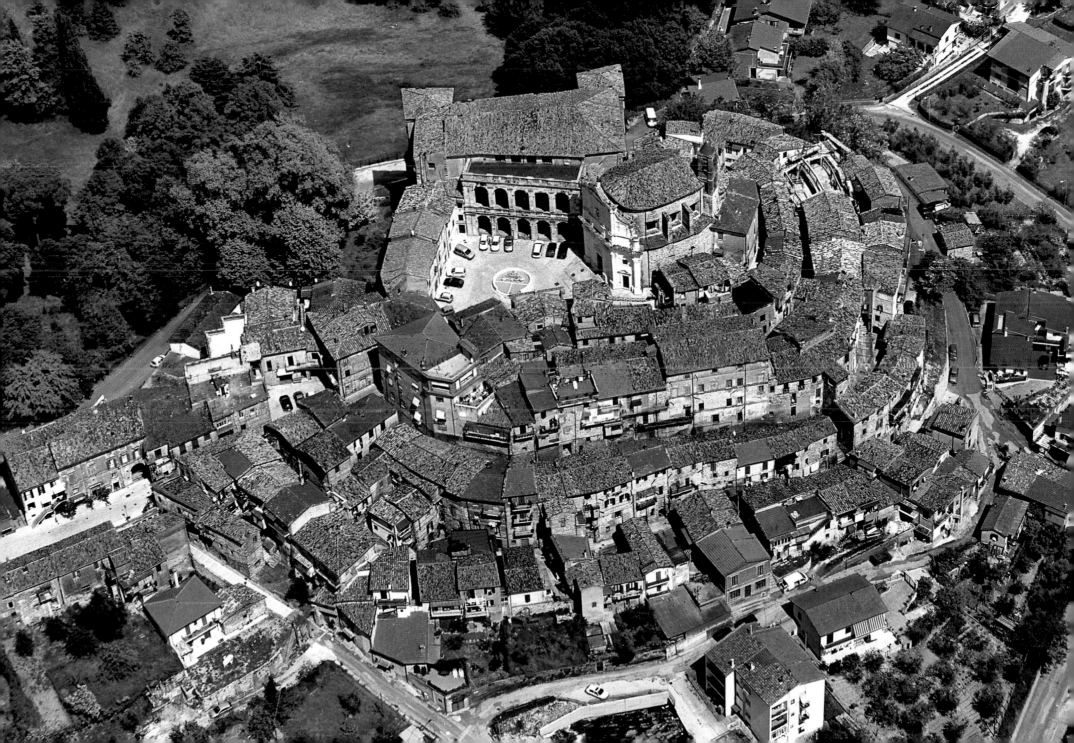

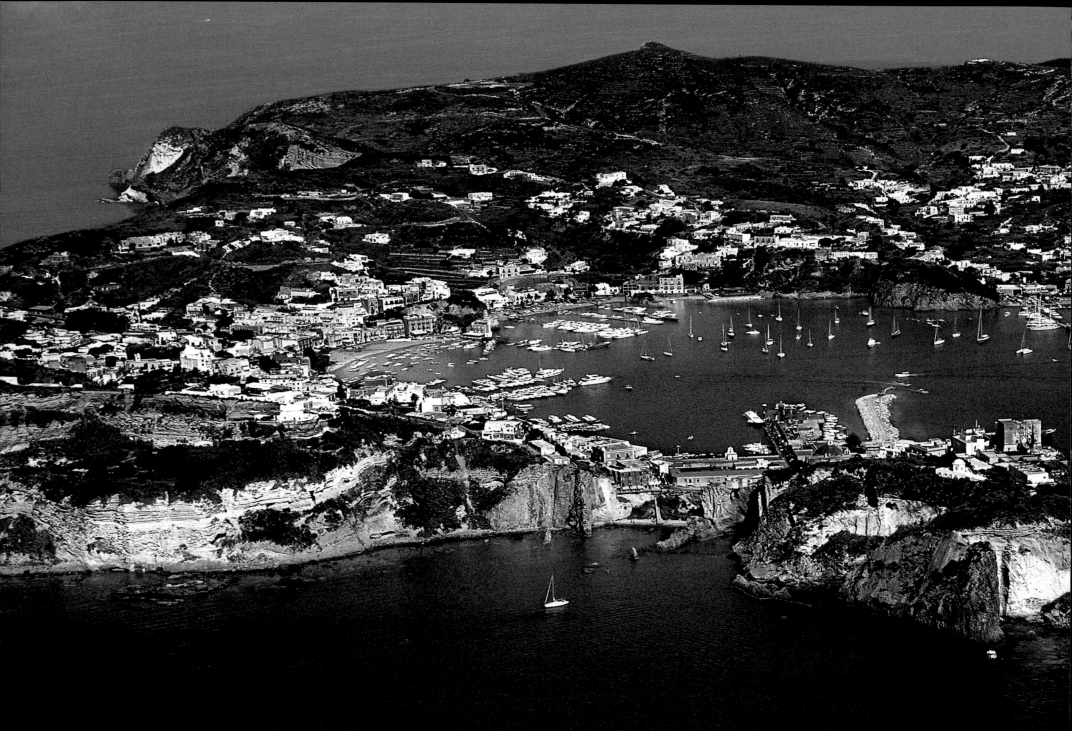

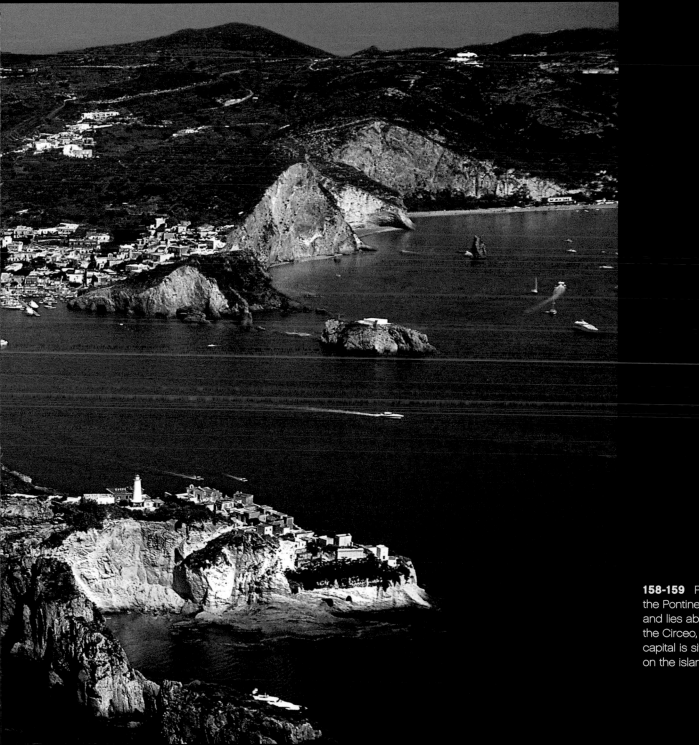

158-159 Ponza (Latina), the largest island of the Pontine Archipelago, is 5 miles (8 km) across and lies about 20 miles (32 km) off the coast of the Circeo, protected by mighty tuff cliffs. The capital is situated next to the best landing point on the island, on the eastern coast.

160-161 The historic town of Tolfa (Rome) lies in the center of the mountains of the same name, which are actually a range of rugged volcanic hills overlooking the Tyrrhenian Sea, just south of Civitavecchia. The area is of great natural interest and is dominated by the ruins of a medieval fortress on a hill.

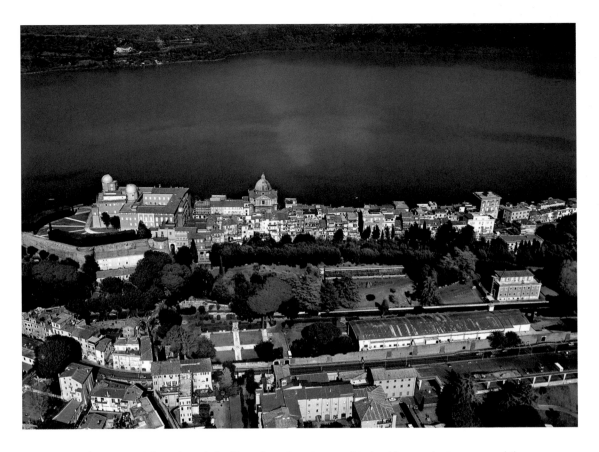

162 The town of Castelgandolfo (Rome) on the shores of Lake Albano clusters around the imposing Papal Palace, built between 1624 and 1629 on the ruins of Domitian's Villa. The building belongs to the Vatican and is the pope's summer residence.

163 The abbey of San Nilo, just outside the old town of Grottaferrata (Rome), is one of the oldest and most important in Lazio. It was founded in 1004 by San Nilo and is built around the church of Santa Maria, which was consecrated in 1024 and is flanked by a Romanesque bell tower. The monastery building was designed by Antonio da Sangallo.

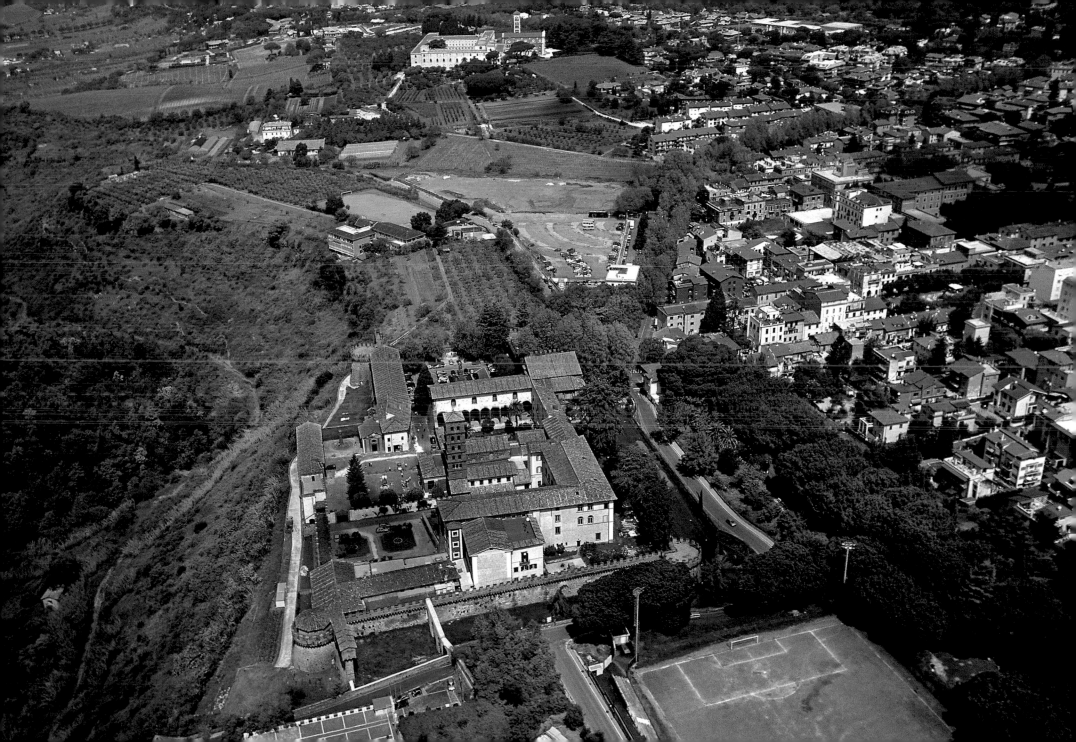

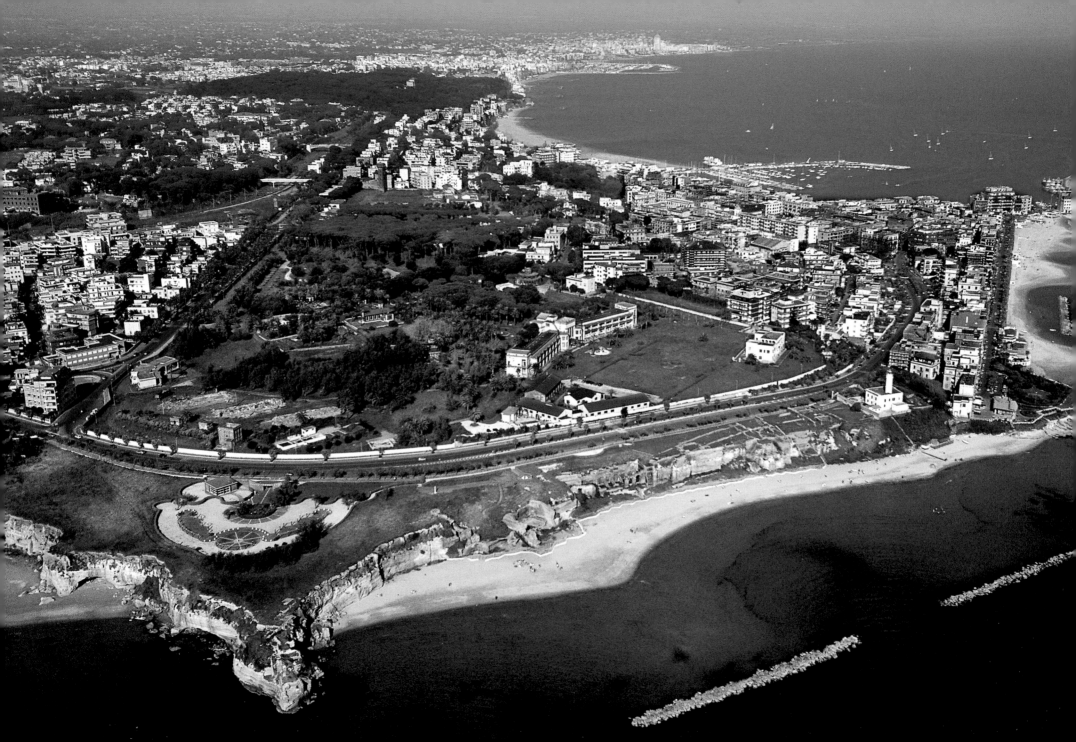

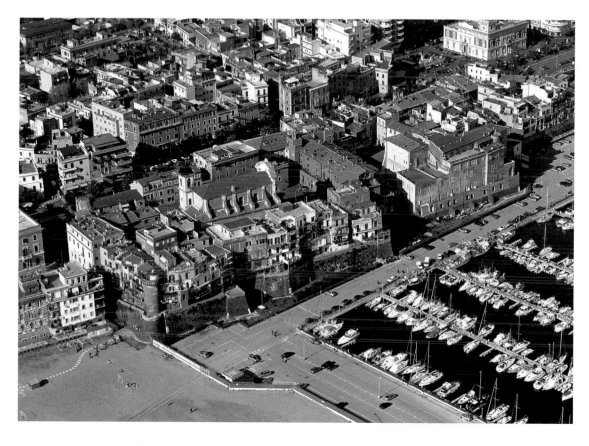

164 Towering yellow tuff cliffs dominate the ruins of Nero's Villa at Anzio (Rome), an important coastal town south of Rome, famous for the Allied landing of January 1944. Nettuno can be seen behind the town and its port, from which a ferry and hydrofoil service connects the mainland with the island of Ponza.

165 The mighty fortress overlooking the medieval town and tourist port of Nettuno (Rome) was built between 1496 and 1503 for Pope Alexander VI, of the Spanish Borgia family, and now houses a museum. For many centuries the wilderness of the Pontine Marshes extended south of this little town on the Lazio coast.

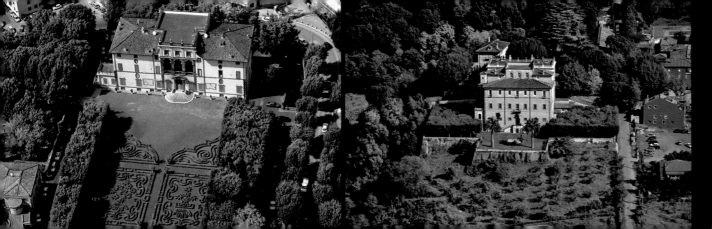

166 left and right The large villas built by the noble families of Rome punctuate the residential zones of Frascati (Rome). Villa Falconieri (left), the oldest in the area, was built between 1546 and 1548 and now belongs to the Ministry of Education. Villa Aldobrandini (right) and its magnificent grounds were constructed between 1598 and 1602.

167 Frascati, which reaches down toward Rome from the Castelli Romani hills, is an important residential town and a favorite spot for day trips. It was much visited by travelers on the Grand Tour, and still bears the scars of the Allied bombings of 1944.

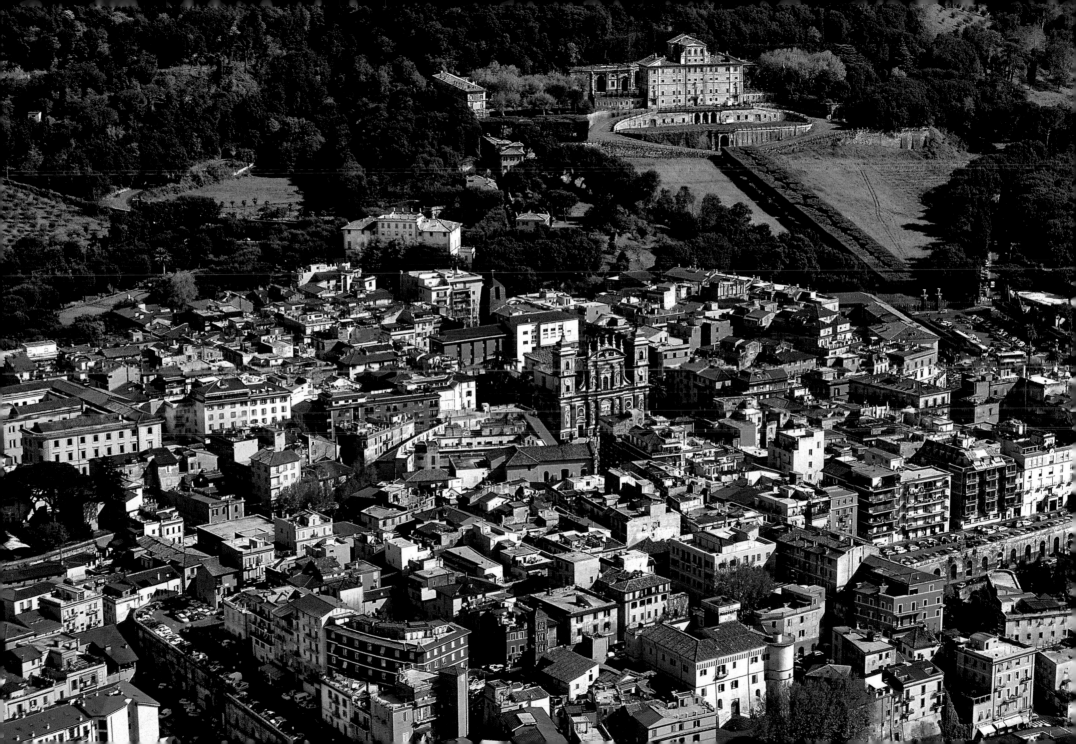

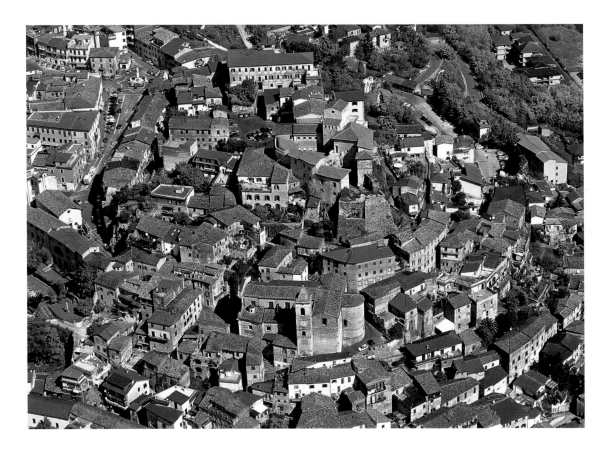

168 The isolated town of Gerano (Rome) lies among the thick woods of the Ruffi Mountains, which separate the Campagna Romana from the Aniene Valley. Its fine medieval center boasts the churches of San Lorenzo Martire and Santa Maria Assunta.

169 Situated an altitude of 2520 ft (768 m), Rocca Priora (Rome) is the highest town in the Alban Hills, a volcanic range overlooking Rome from the south. In the center of the town stands the Baronial Palace, now the Town Hall, built in 1880 following the demolitionn of the medieval fortress.

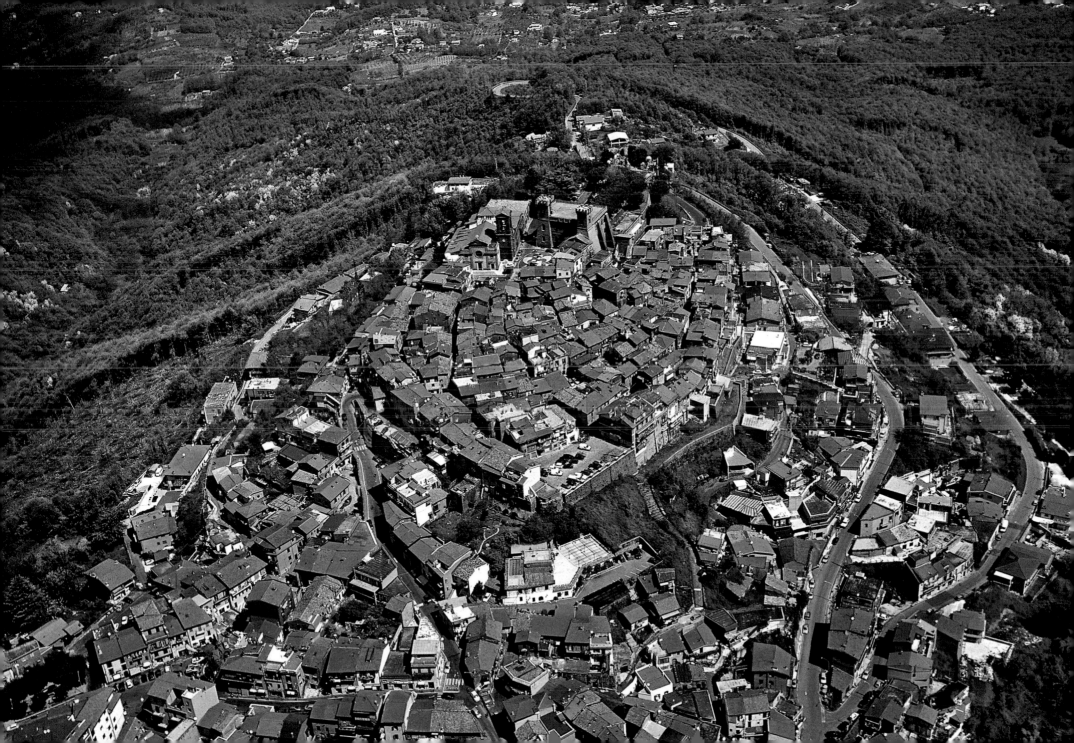

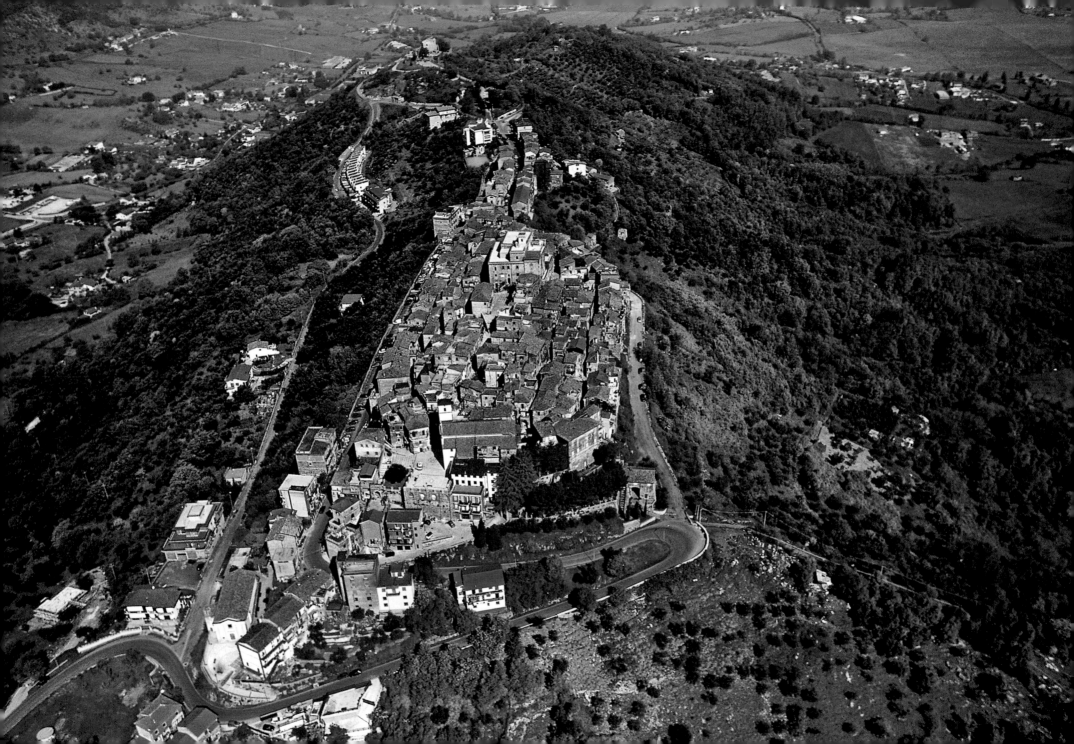

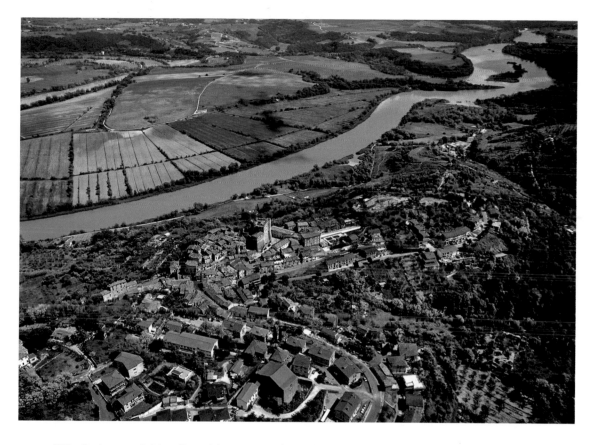

170 Gavignano Sabino (Rome) lies among the rolling hills on the eastern side of the Tiber Valley. It has a fine historic center, surrounded by fields, woods and olive groves. In addition to the parish church, the town also boasts Roman ruins and columns.

171 The imposing castle built during the 13th century by the Savelli family dominates the historic center of Nazzano (Rome) and the artificial lake, protected by the Tiber-Farfa Nature Reserve since 1979. The nature reserve, the first of its kind to be founded in the Lazio region, is home to many birds species.

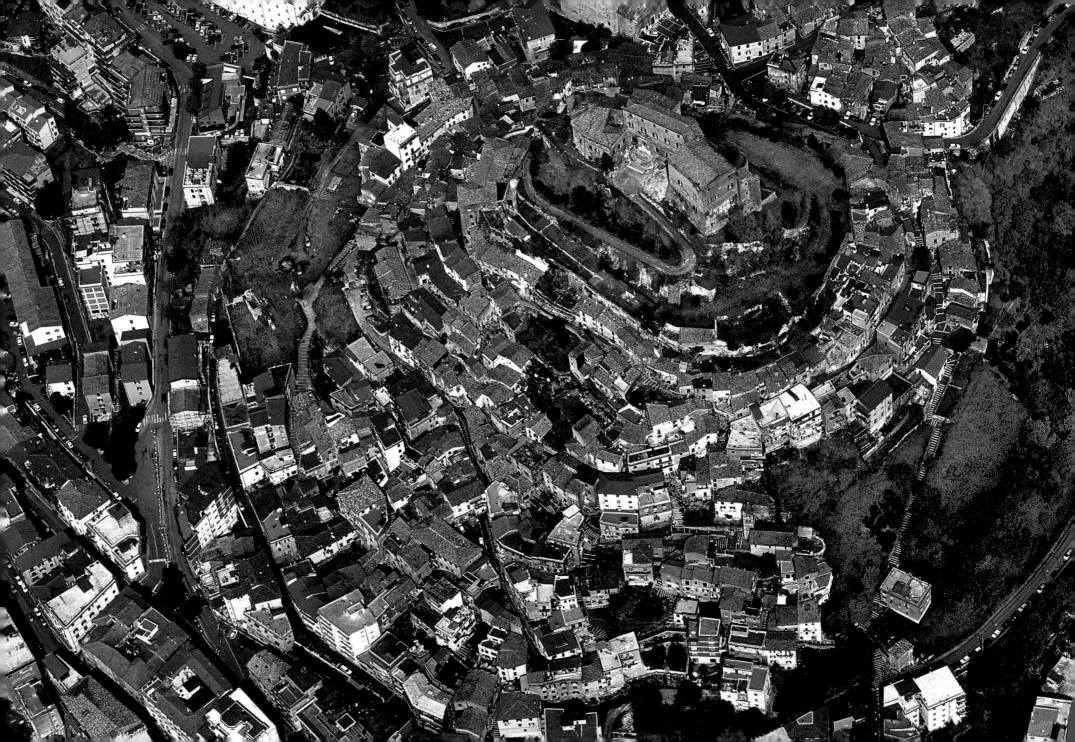

72 Lying at the foot of the Simbruini Mountains, Subiaco (Rome), is the most important town of the upper Aniene Valley and attracts visitors with the abbeys of San Benedetto (or San Speco) and Santa Scolastica. The austere Rocca Abbaziale dominates the town.

73 left The Benedictine abbey of Santa Scolastica (left) is one of the most evocative in Lazio. Its Romanesque bell tower dates from 1052-53; the church, founded in 980, has been remodeled in the Baroque style; and the third cloister is a masterpiece of Cosmati work. In 1464 the monastery became home to the first Italian printworks.

73 right The co-cathedral of Sant'Andrea in Subiaco was consecrated in 1789 with a six-hour ceremony.

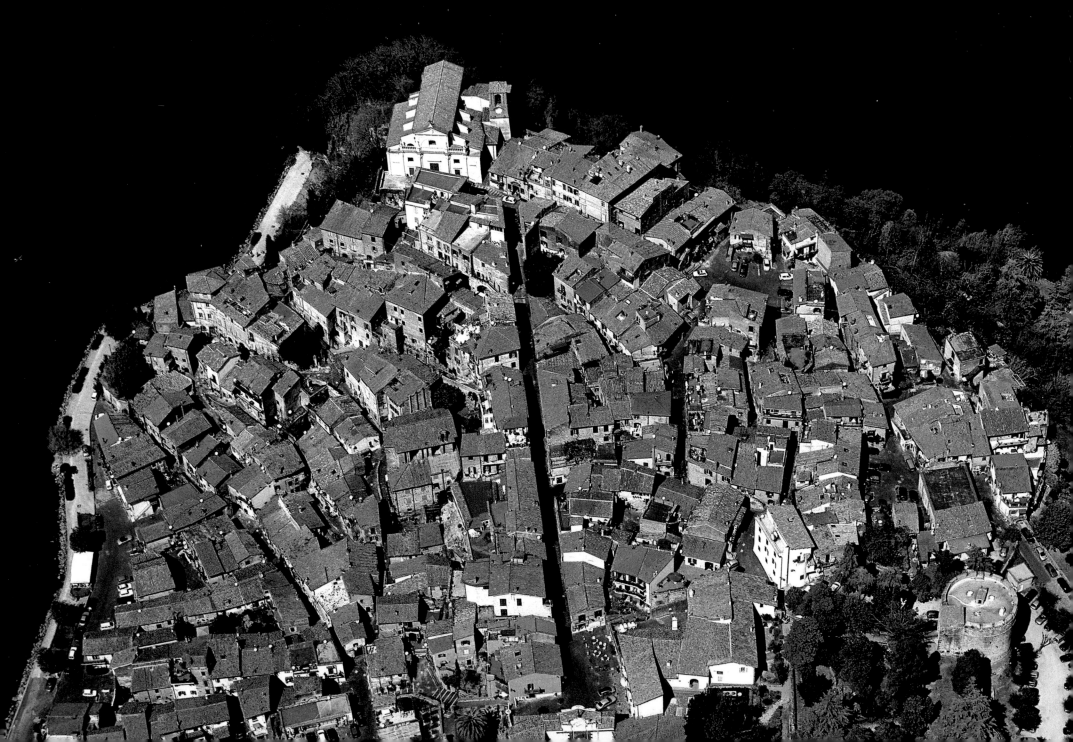

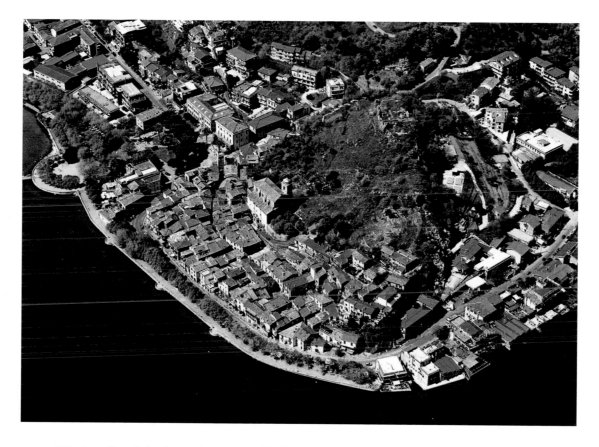

174 Anguillara Sabazia, on the shores of Lake Bracciano, is the nearest of the lakeside towns to Rome. The streets of the medieval town rise toward the 18th-century collegiate church of Santa Maria Assunta and its imposing Baroque façade.

175 Trevignano Romano (Rome) on the northern shore of Lake Bracciano is a favorite place for outings. The ruins of the castle, destroyed by Giovanni Borgia in 1496, overlook the lakeside and the pretty historic center with the 16th-century church of Santa Maria Assunta.

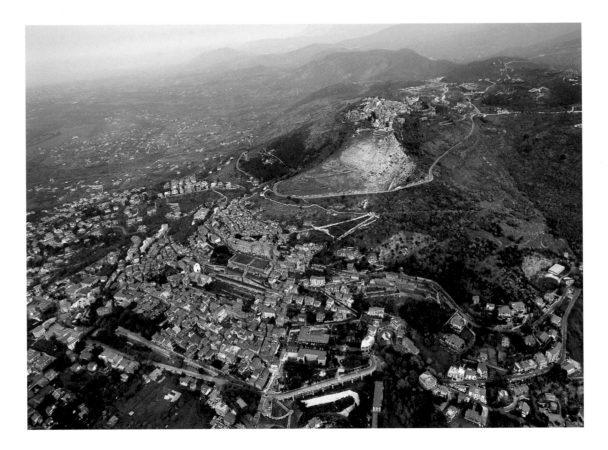

176 Palestrina (Rome), known in ancient times as Praeneste, was built on the six enormous terraces of the Sanctuary of Fortuna Primigenia, built between the 2nd and 1st centuries BC on the site of an even older place of worship. Palazzo Colonna-Barberini, rebuilt in its current form in 1640, stands above the town.

177 Imposing Odescalchi Castle, commenced in 1470 by the Orsini family, dominates the historic center of Bracciano (Rome), which overlooks the western shore of the lake of the same name. The fortress, defended by six keeps, hosts events and conferences and its parapet walk offers magnificent views.

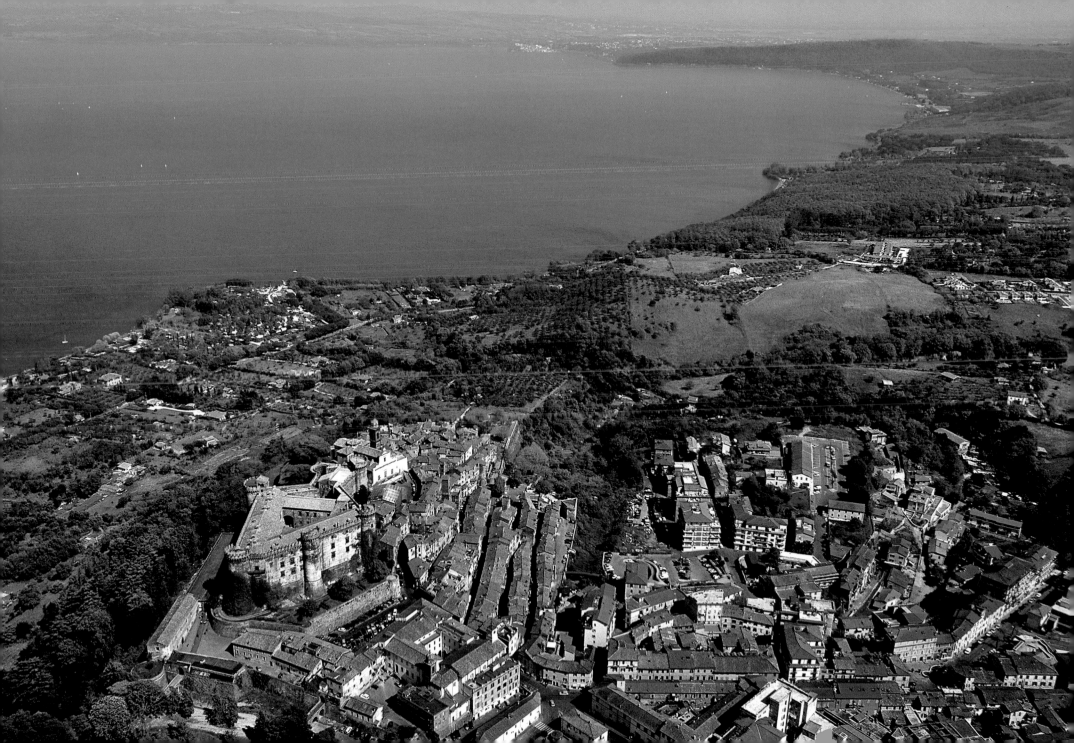

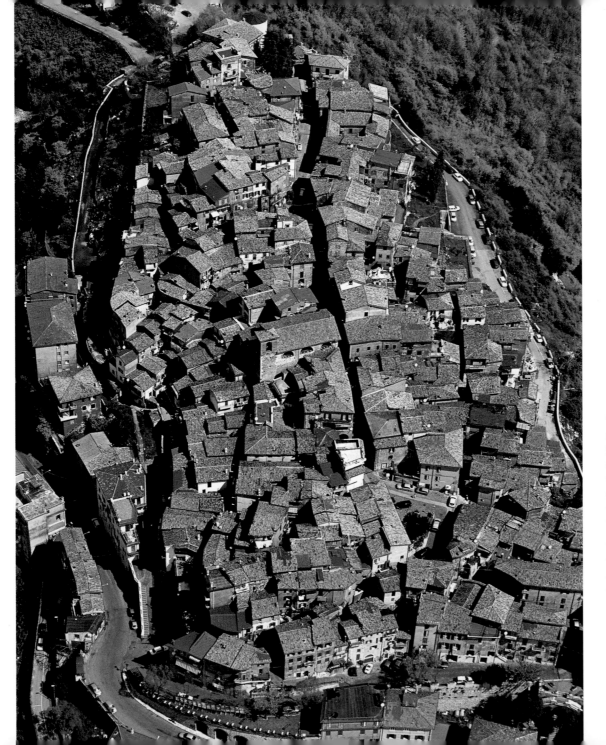

178 Bellegra (Rome) is the modern name of the Roman colony of Vitellia, founded during the 4th century BC and known as Civitella from the 9th to the 10th century AD. It lies in central Lazio, between the river valleys of the Aniene – an affluent of the Tiber – and the Sacco.

179 The imposing medieval-style fortress of Torre Alfina (Viterbo), built at the end of the 19th century, towers over the plateau between Lake Bolsena and Orvieto. The woods behind the castle reach down to the Paglia Valley and are part of the 7146-acre (2892-hectare) Mt. Rumeno Nature Reserve.

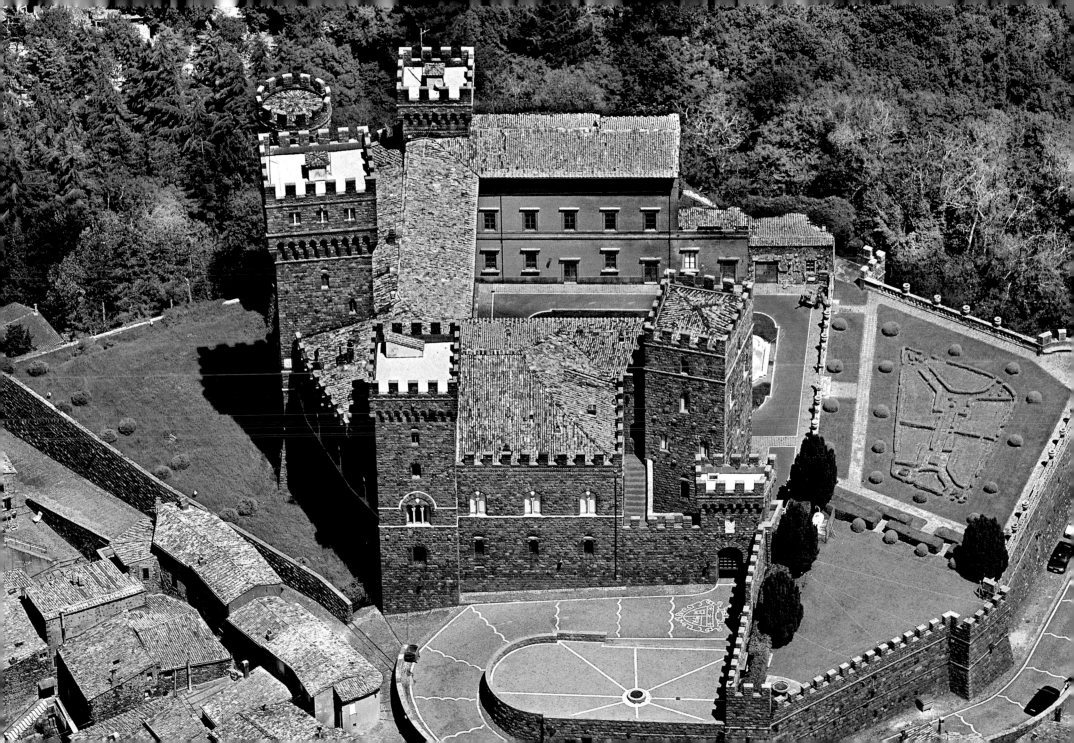

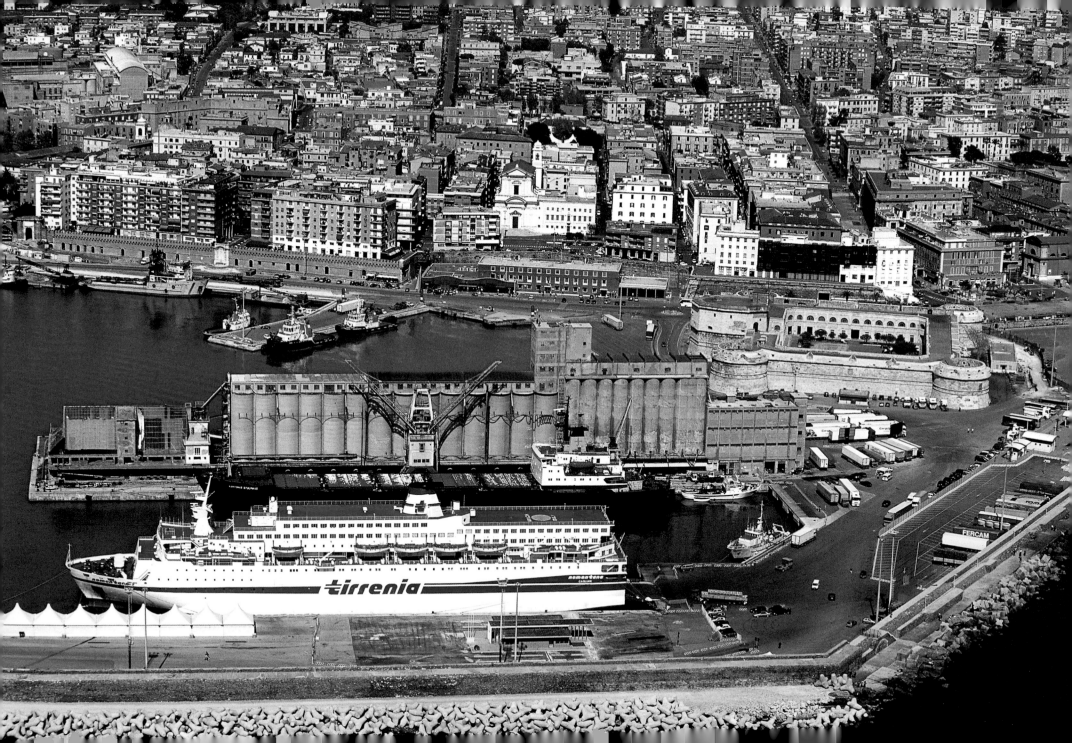

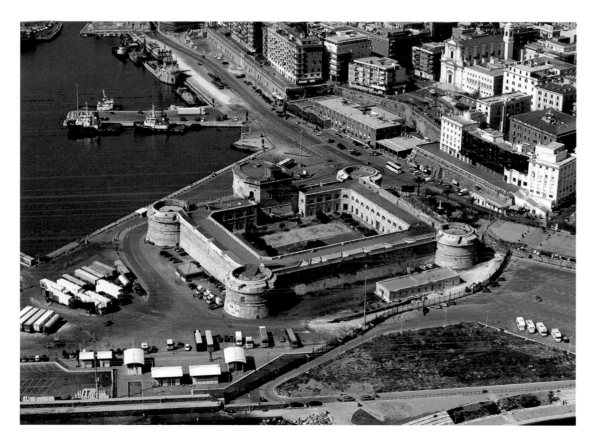

180 The port of Civitavecchia (Rome) has been the main terminal for shipping to and from Rome for many centuries. Today the ferries to Olbia and other Sardinian ports are joined by cruise ships, whose passengers come ashore to visit the Forums, Colosseum and St. Peter's.

181 The historic district of Civitavecchia was severely damaged by bombing during World War II and the town now has a modern appearance. The most interesting monument is the Michelangelo Fort, built in 1508, which is now home to the Port Authority.

182 Albano (Rome) is the most interesting of the Castelli Romani towns from the point of view of ancient history. This little town, crossed by the Appian Way, is home to the Early Christian catacombs of San Senatore, an imposing cistern from the Imperial Age and the collections of the Civic Museum.

183 Genzano (Rome) on the shores of Lake Nemi is the town of the Infiorata: a short-lived floral carpet that is laid over the street leading to the church of Santa Maria della Cima on the festival of Corpus Domini. The stately Palazzo Cesarini stands in the center of the town.

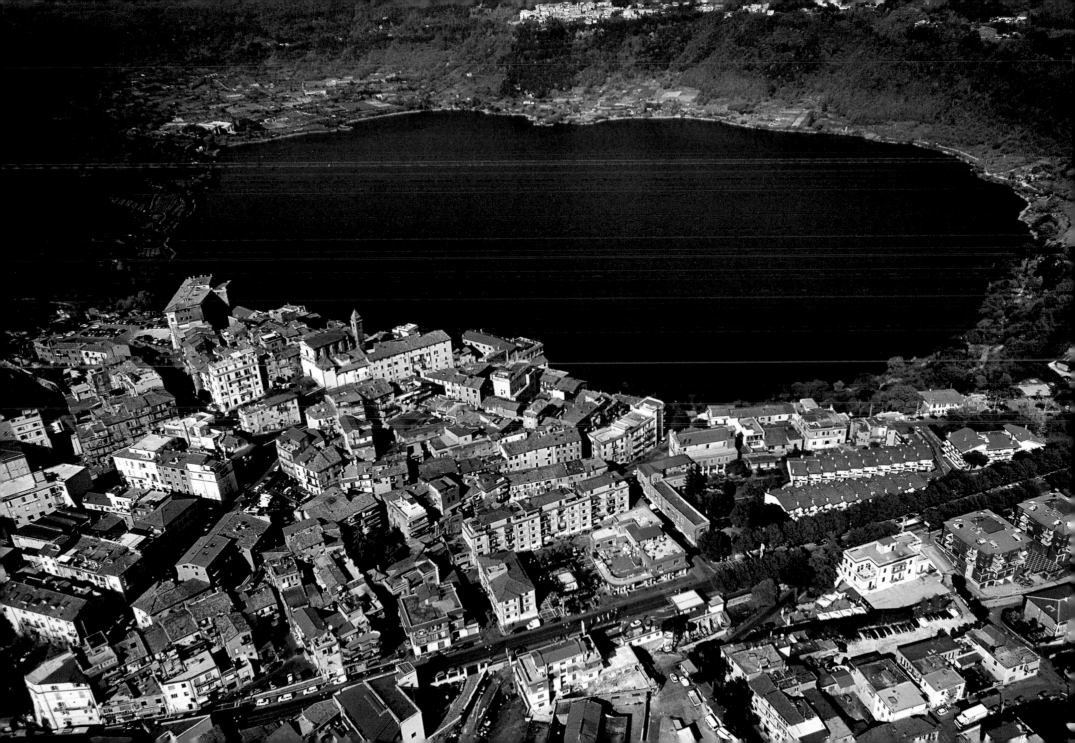

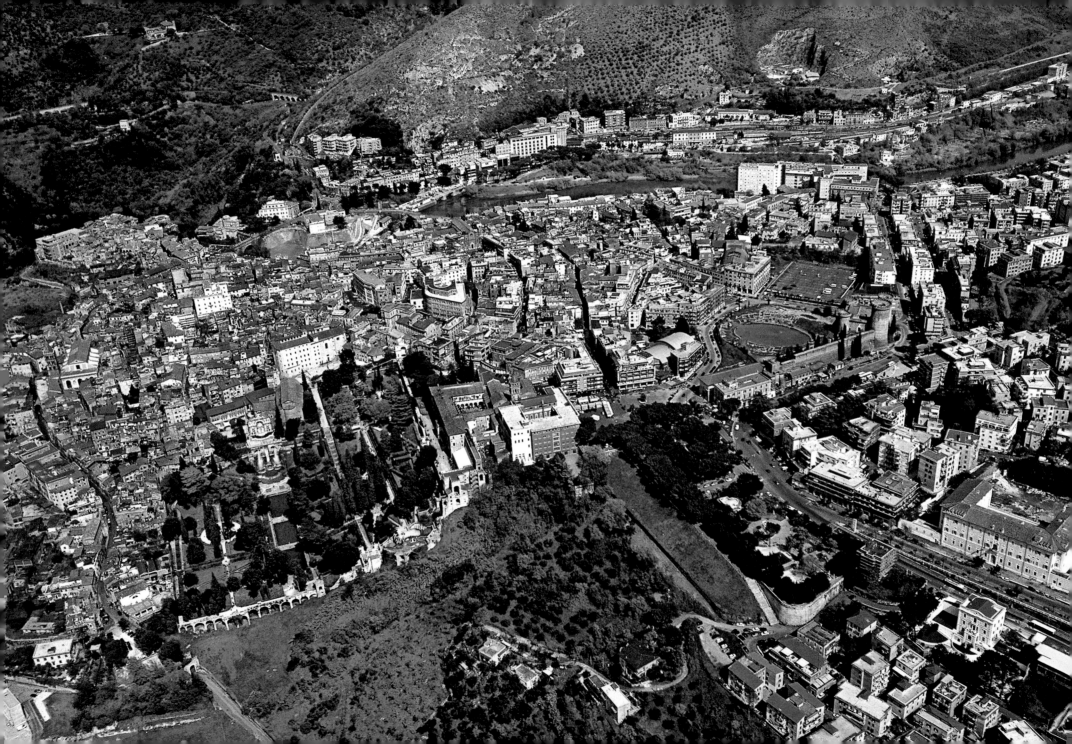

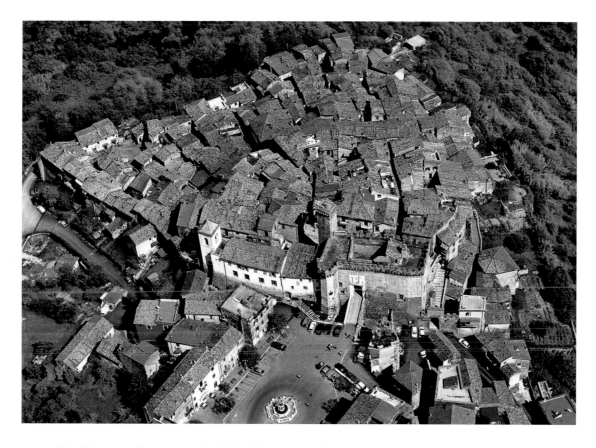

184 The magnificent grounds of Villa d'Este, remodeled after 1530 for Cardinal Ippolito d'Este, stretch up to the historic district and the Rocca Pia castle of Tivoli (Rome). This important town on the banks of the Aniene River overlooks the Campagna Romana and the capital to the west.

185 Civitella San Paolo (Rome) is one of the most evocative little villages overlooking the Tiber Valley just north of Rome. The entrance to the historic center, crisscrossed with a maze of narrow streets, is guarded by the castle of the monks of San Paolo.

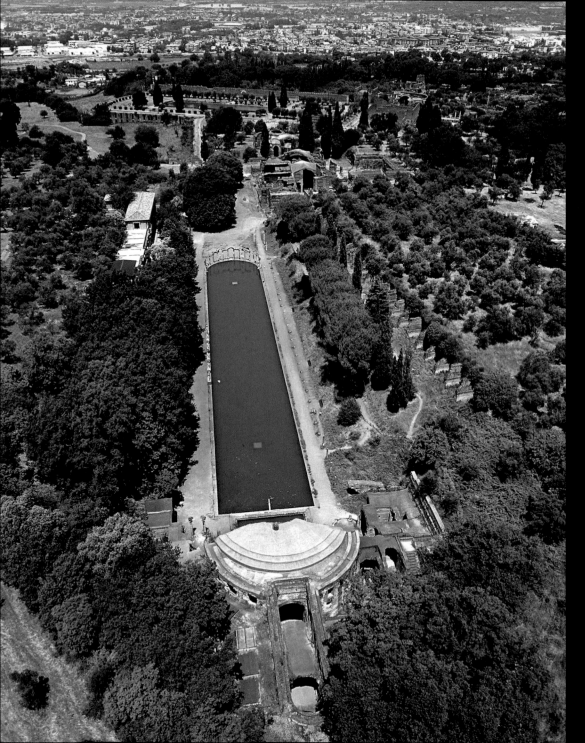

186 Hadrian's Villa, built between AD 118 and 134, stands at the foot of the hills in Tivoli (Rome), and features replicas of buildings that impressed the emperor on his travels. The 761-foot pool in the photograph was inspired by the canal that linked Canopus with Alexandria in Egypt.

187 Hadrian's Villa is surrounded by the ancient landscape of the Campagna Romana. The villa was rediscovered in the 1400s and sacked over the following centuries by "archaeologists" who removed hundreds of statues. The expanse of water in the background is the Poikile, inspired by the stoa of the same name in Athens.

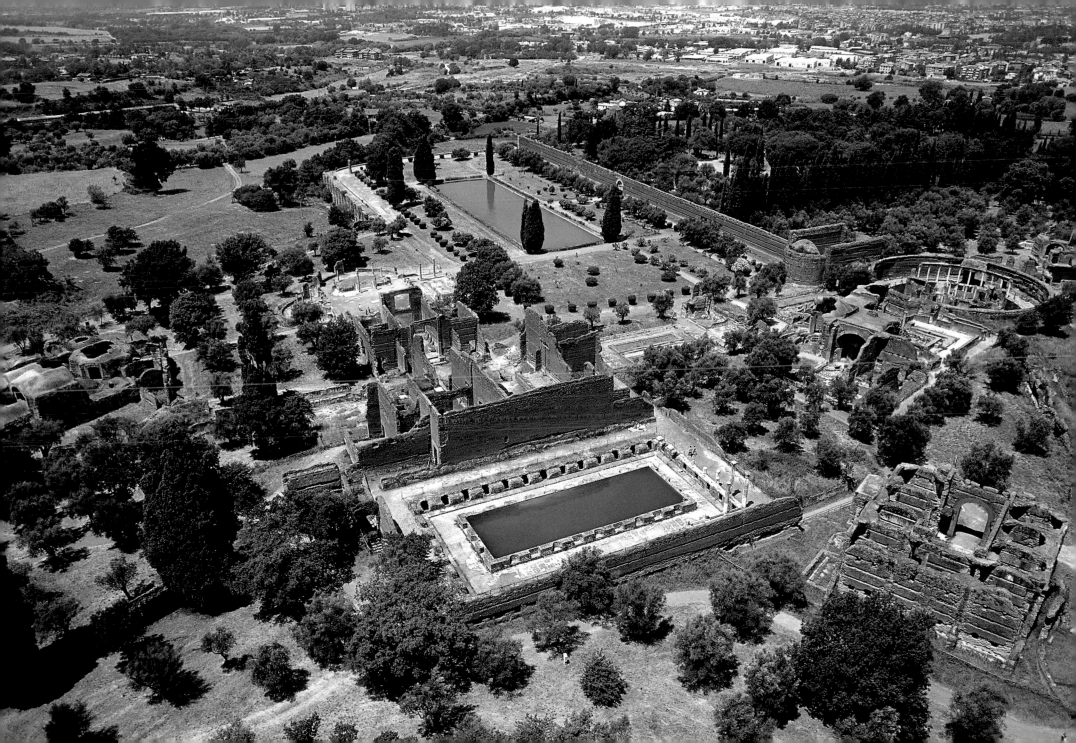

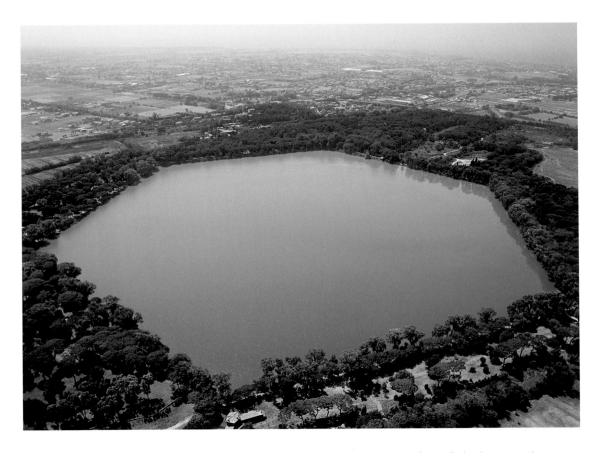

188 Just a few hundred yards from the runways of Fiumicino Airport (Rome), the hexagonal basin of Trajan's port served as a landing place for the ships of the imperial fleet for centuries. It was connected to the open sea by Trajan's Canal, which is still navigable today.

189 According to legend, Ostia was founded by King Ancus Martius in the spot visited by Aeneas. However, archeological excavations have dated its construction to the 4th century BC, when it was founded as a military outpost to defend the mouth of the Tiber, which can be seen in the background.

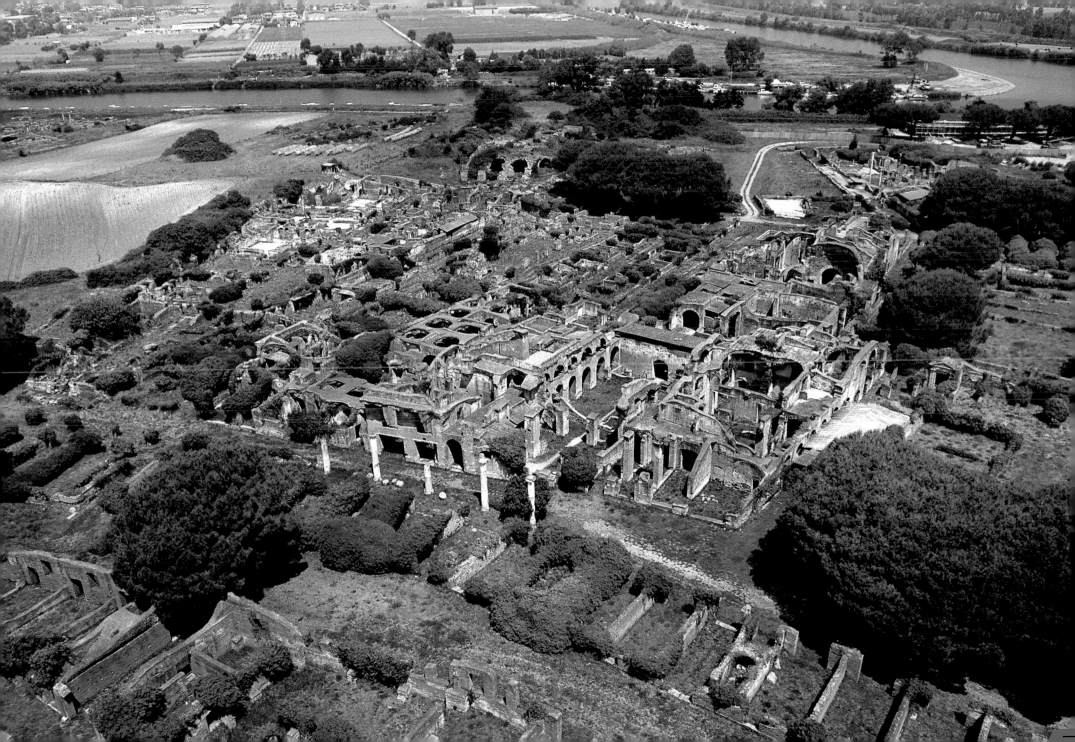

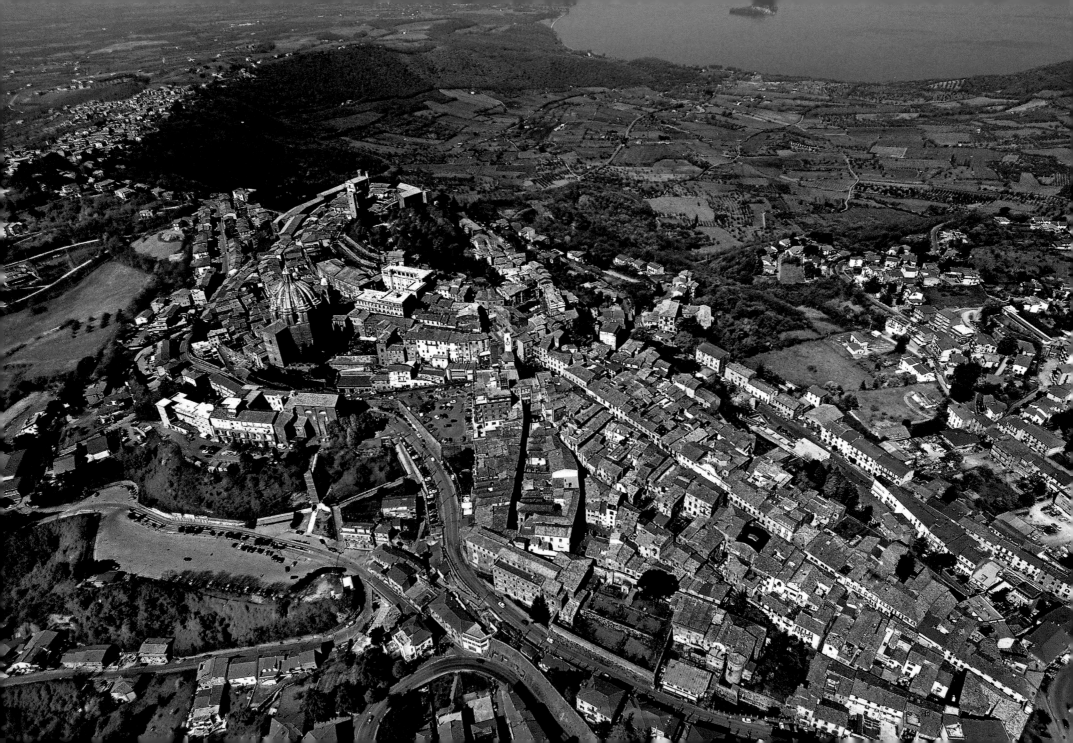

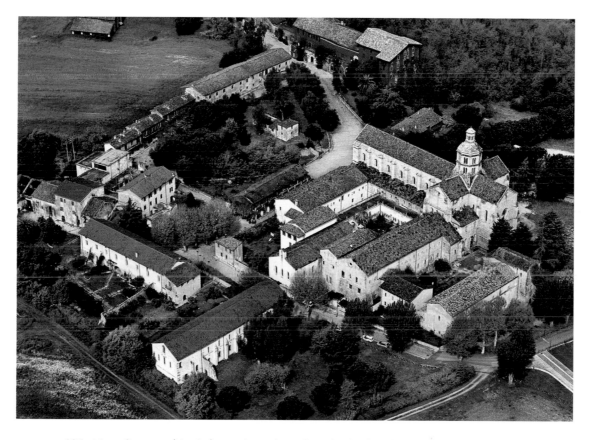

190 Montefiascone (Viterbo) stands on the edge of a fertile volcanic caldera filled with the blue waters of Lake Bolsena. The great dome of the cathedral of Santa Margherita and the Rocca dei Papi fortress on the top of the hill are clearly recognizable.

191 The abbey of Fossanova (Latina) – situated in the heart of the Pontine Plain in clear view of Mt. Circeo and the Ausoni Mountains – was founded in the 9th century by the Benedictines not far from the Roman and medieval Appian Way, and transferred to the Cistercians in 1133. The church was consecrated in 1208 by Pope Innocent III.

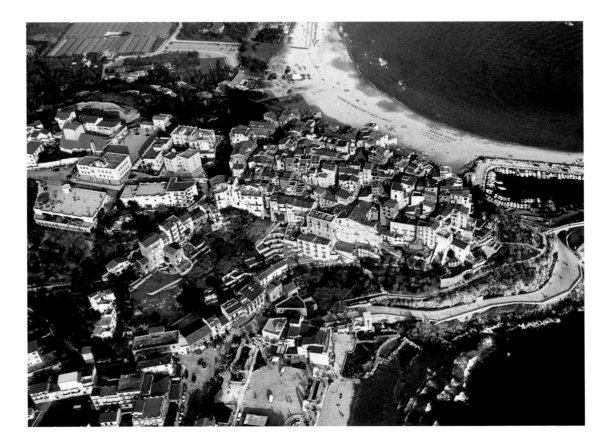

192 The unmistakable whitewashed houses of Sperlonga (Latina) overlook the Tyrrhenian Sea, between the marshes of the Fondi Plain and the sheer cliffs of the coast crossed by the Via Flacca. The Villa and Grotto of Emperor Tiberius are situated nearby.

193 Terracina (Latina), formerly an outpost of the Papal States on the border with the Kingdom of Naples, is one of the most important ports in Lazio. The center is dominated by the ruins of the Temple of Jupiter Anxur. The limestone turret of the Pisco Montano rock was cropped during Trajan's rule in order to allow the passage of the Appian Way.

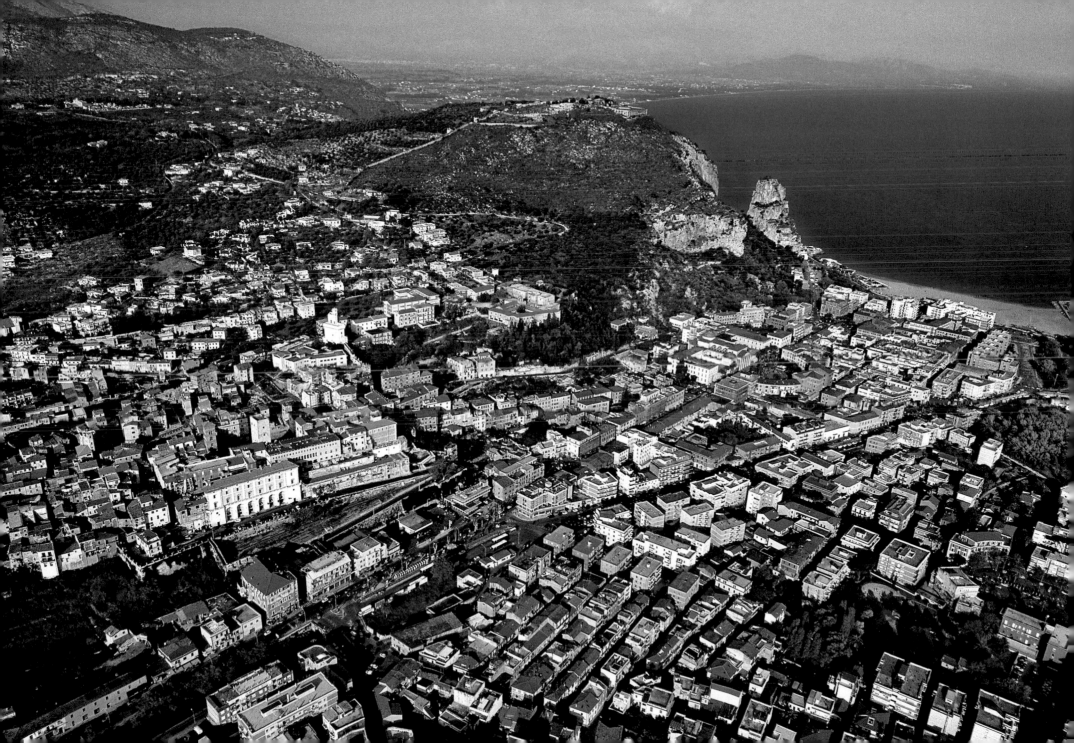

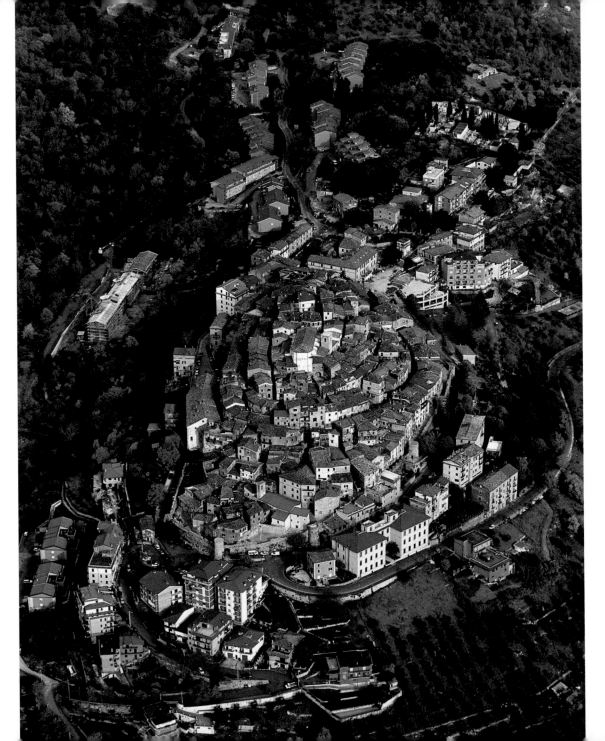

194 Bassiano (Latina) stands on a hillock at the foot of the Lepini Mountains, the rugged limestone range that separates the Pontine Plain from the Ciociaria. Aldus Manutius the Elder, one of the greatest printers of the Renaissance, was born in Bassiano in 1449.

195 Cori (Latina), on the northern spurs of the Lepini Mountains overlooking the Castelli Romani and the coast, was one of the most important cities in Lazio prior to the expansion of Rome. The polygonal walls and the Temple of Castor and Pollux still recall its ancient power.

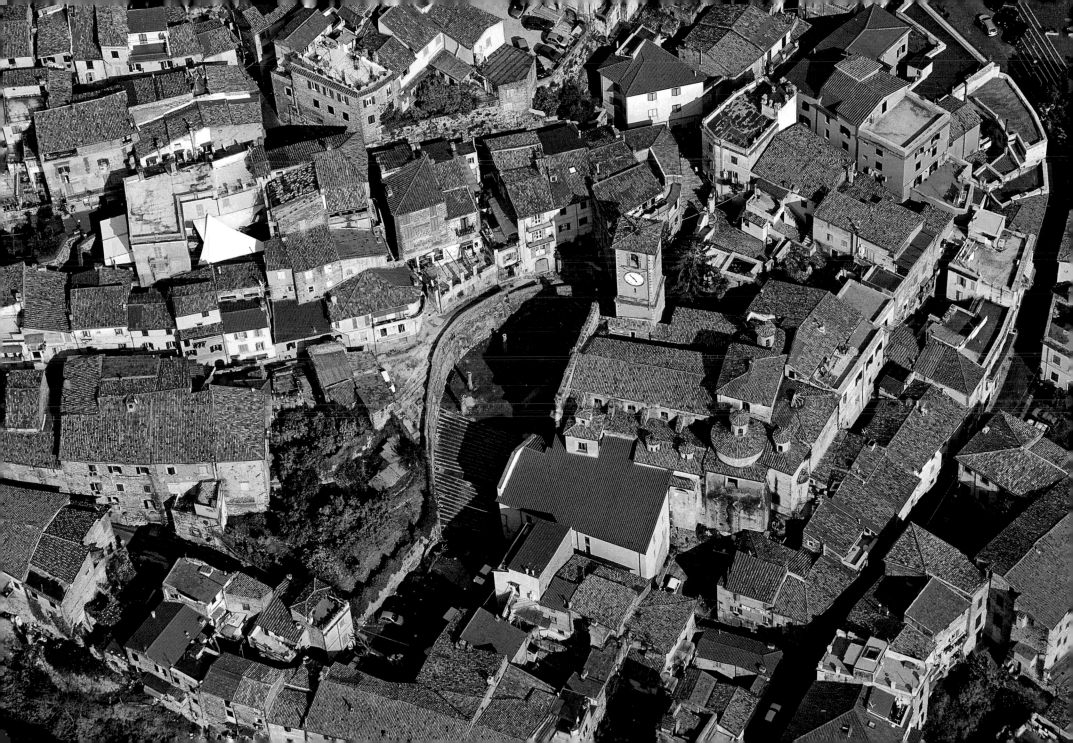

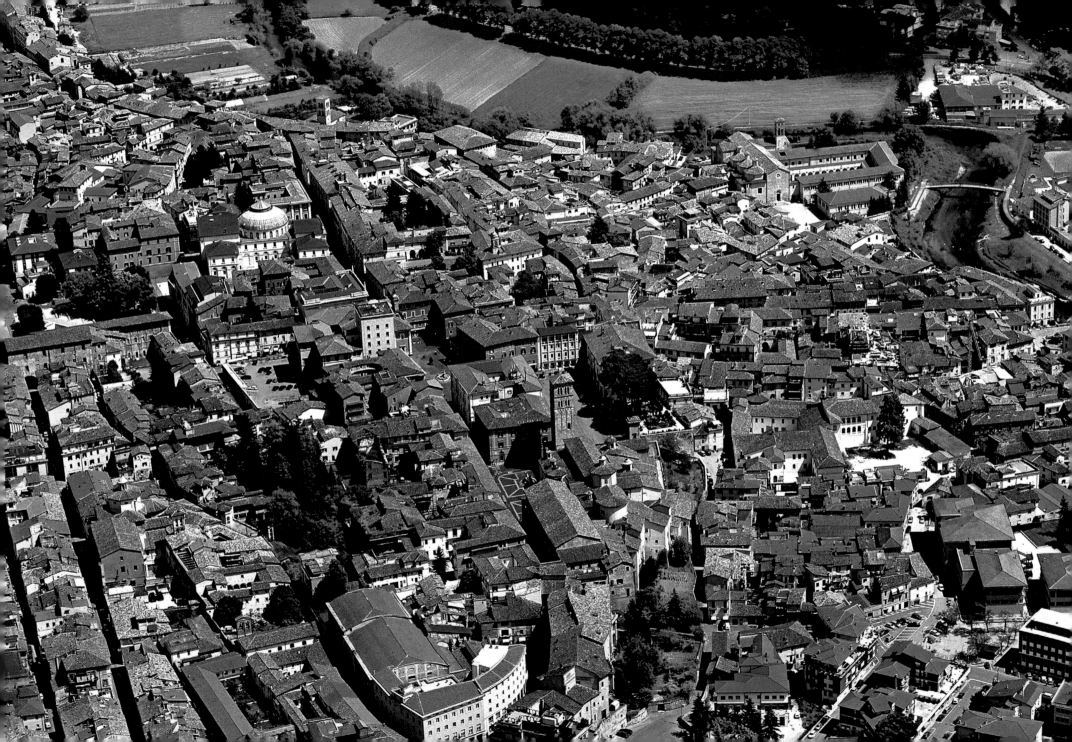

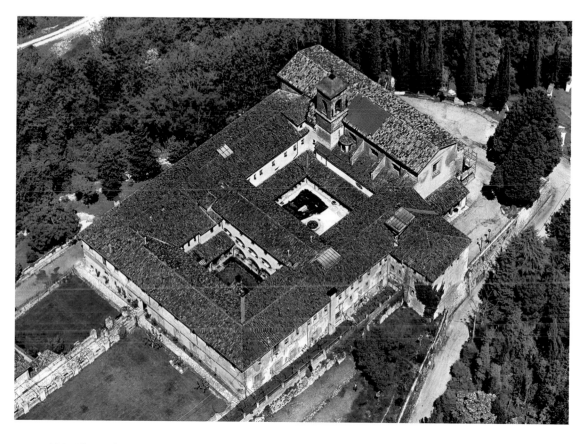

196 The cathedral of Santa Maria Assunta – commenced in 1109, consecrated in 1209 and renovated during the 17th century – overlooks the modern streets and Renaissance palaces of the historic district of Rieti. A monument reminds visitors that the city is located in the exact center of Italy. The Velino River runs alongside the city.

197 La Foresta Monastery is one of the four small monasteries that commemorate Saint Francis' long stays in the Rieti area (the others are Poggio Bustone, Greccio and Fonte Colombo, all in the province of Rieti). The saint stopped at La Foresta (or Santa Maria della Foresta) in 1225 during a journey to Rome.

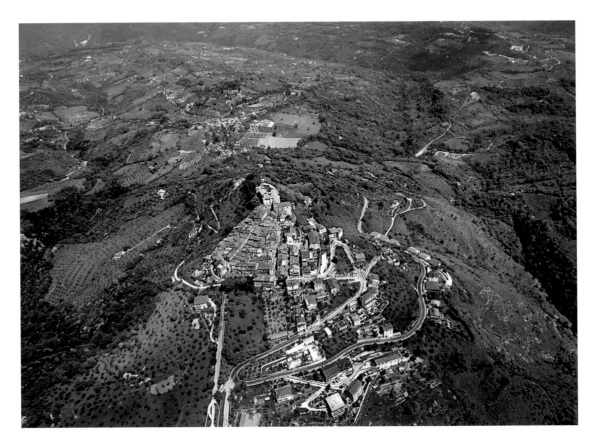

198 The medieval village of Mompeo (Rieti), situated between the Salarian Way and the Tiber Valley, was long a feudal possession of the abbey of Farfa. It is still overlooked by an imposing baronial palace that belonged to the Orsini, Savini, Naro and Patrizi families and boasts several frescoed rooms.

199 Cittaducale (Rieti) lies at the foot of the valleys and woods of Mt. Terminillo, where it controls the Salarian Way and thus traffic toward Picenum and Abruzzo. The church of Santa Maria del Popolo and the slender Municipal Tower overlook the central piazza. Several Renaissance palaces stand nearby.

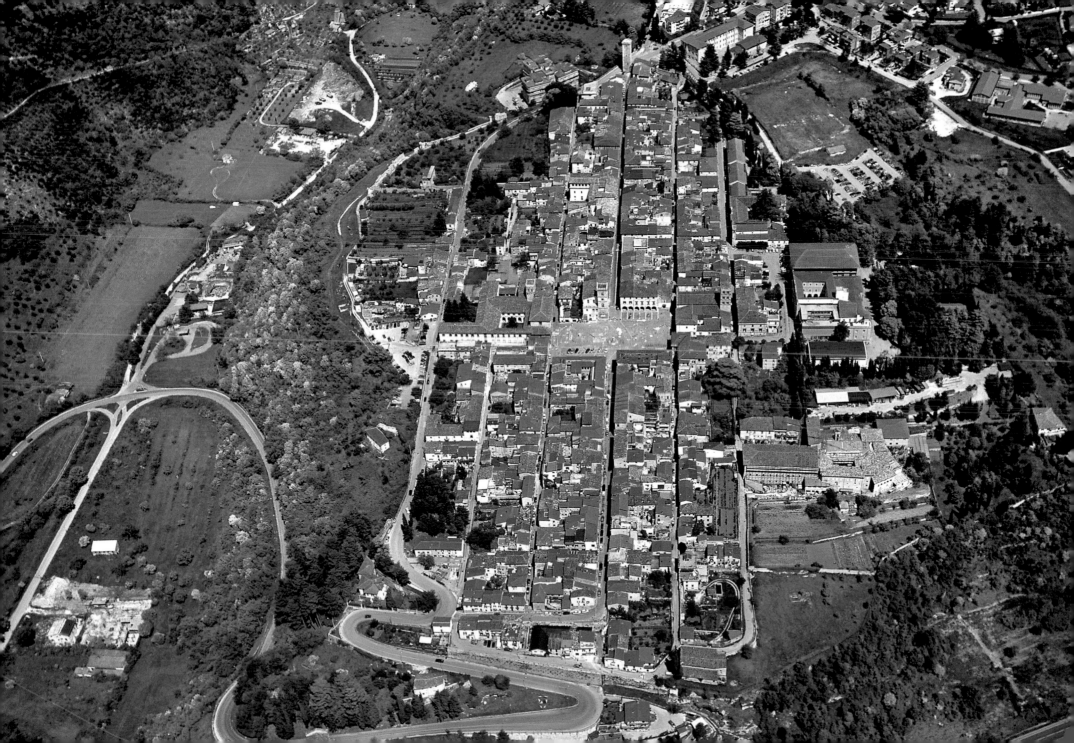

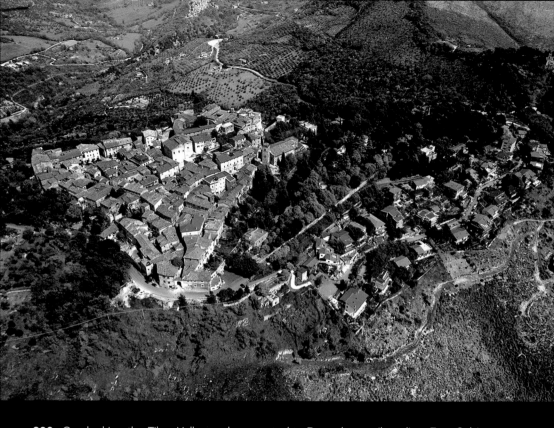

200 Overlooking the Tiber Valley and connected to Rome by a railway line, Fara Sabina (Rieti) stands on a steep hill among famous olive groves. The word "Fara," also present in several Abruzzo place names, is a reminder that the town was founded by the Lombards.

201 Like many other settlements of the lower Sabina, Salisano (Rieti) was founded around AD 1000 by the monks of Farfa, subsequently becoming part of the territory of the Orsini family. The parish church of Santi Pietro e Paolo stands in the center, still surrounded by a circle of handsome medieval walls.

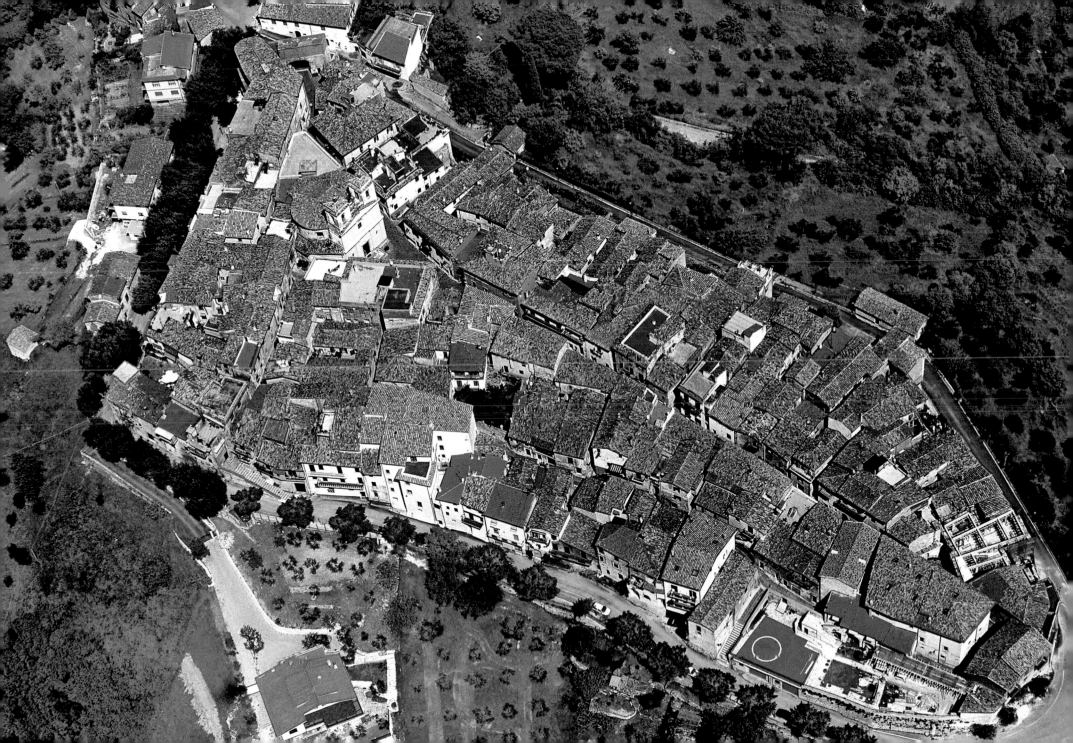

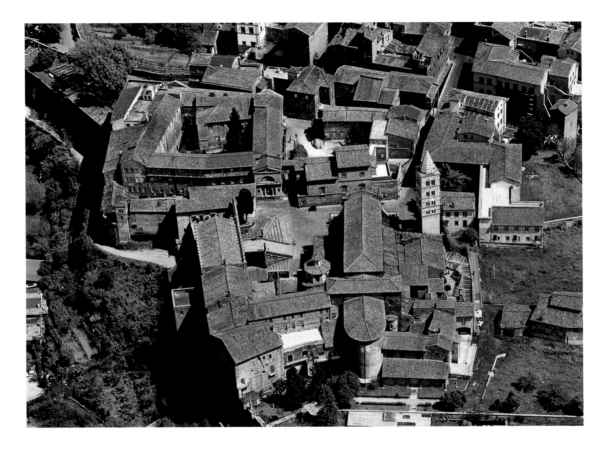

202 The Romanesque cathedral of San Lorenzo in the center of Viterbo is flanked by the mighty Papal Palace, which reminds visitors that the city was the residence of the popes for many years during the 14th century. The building hosted the conclaves that elected Gregory X (1271), John XXI (1276) and Martin IV (1281).

203 Viterbo, situated between the volcanic massif of the Cimini Mountains and the fertile plain of the Tuscia, is one of the most beautiful and interesting cities in Lazio. The San Pellegrino district, with its arches, towers and balconies (known locally as proffèrli) is one of the most scenic and well preserved in Italy.

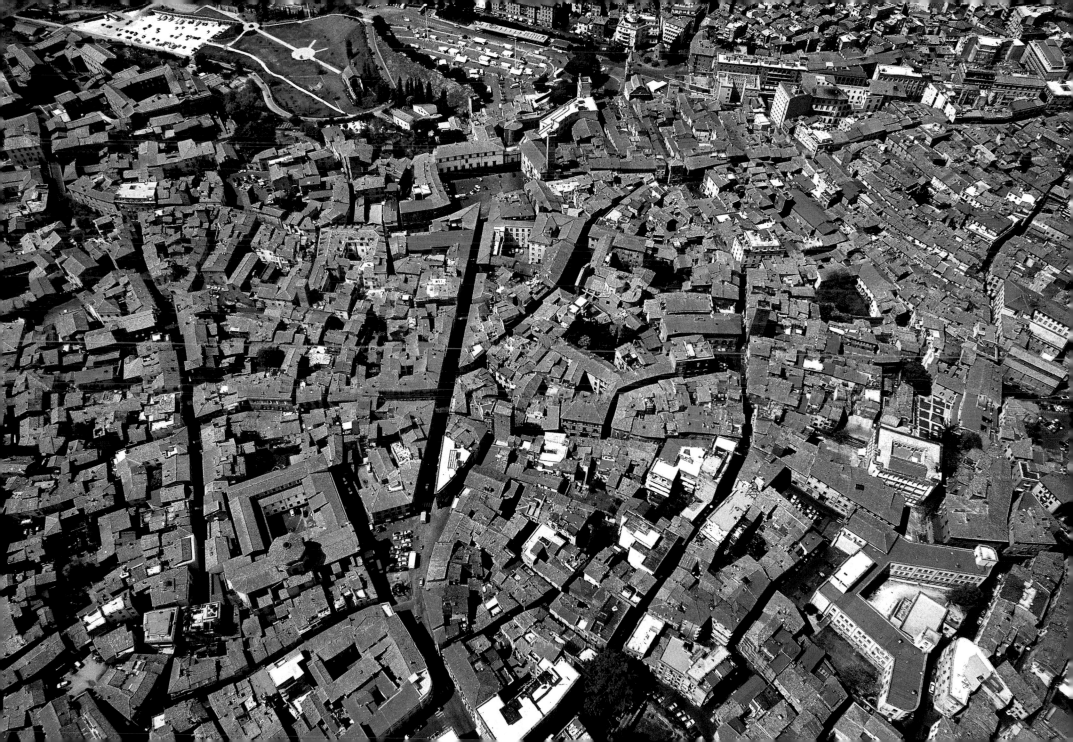

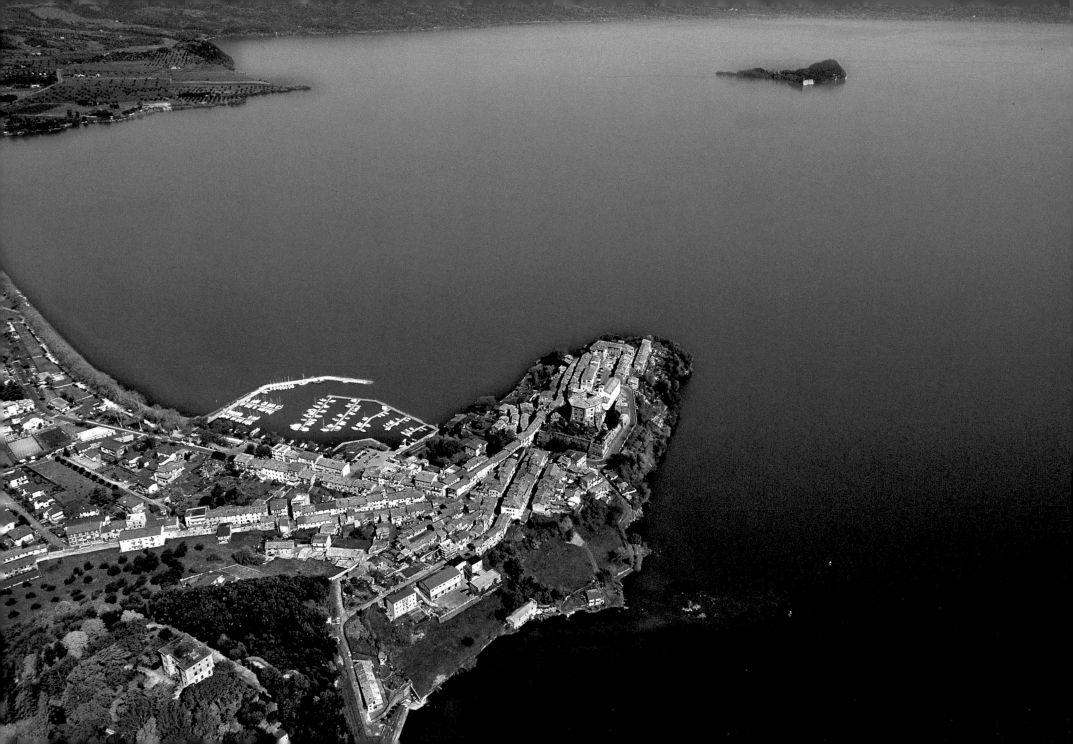

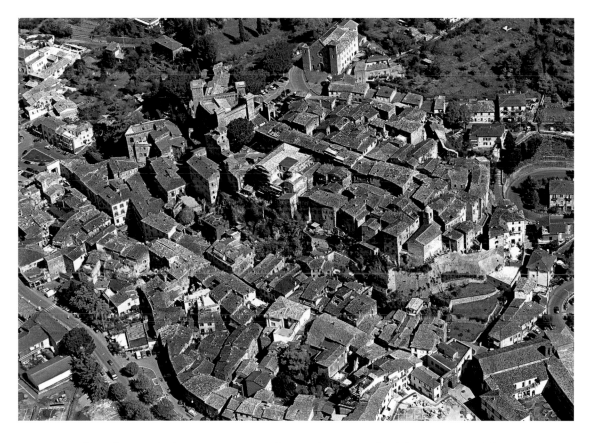

204 Capodimonte, built on a promontory that reaches into Lake Bolsena, is one of the most evocative towns in the Viterbo area, The islands of Bisentina and Martana rise from the waters of lake, which is the largest in Lazio. Farnese Castle stands in the center of Capodimonte.

205 Bolsena (Viterbo), known in ancient times as Volsinii, is one of the most important Etruscan towns in Lazio. It boasts a well-preserved medieval center guarded by the turreted Palazzo Farnese, whose current appearance is the work of Antonio da Sangallo the Younger. The village and nearby beaches are particularly popular with German tourists.

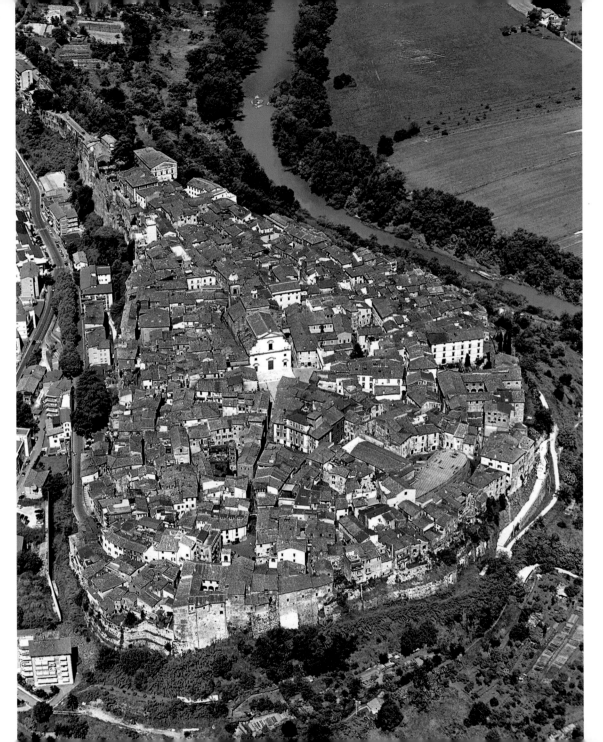

206 Orte (Viterbo) is an important railway and road hub that controls the Tiber Valley and entrance to the Flaminian Way in the direction of Terni. The white façade of the cathedral of Santa Maria Assunta is visible in the historic center, along with the nearby Romanesque church of San Silvestro.

207 Tuscania (Viterbo), known as Toscanella in ancient times, boasts medieval roofs and churches, huge Etruscan necropolises and the medieval basilicas of Santa Maria Maggiore and San Pietro. Excellent restoration work has repaired the damage caused by the 1971 earthquake.

208-209 The old town of Ronciglione (Viterbo), between Lake Vico and the Cassian Way, has a well-preserved medieval center crowned by many tuff towers. The baroque cathedral of Santi Pietro e Caterina stands alongside the castle, known as "I Torrioni."

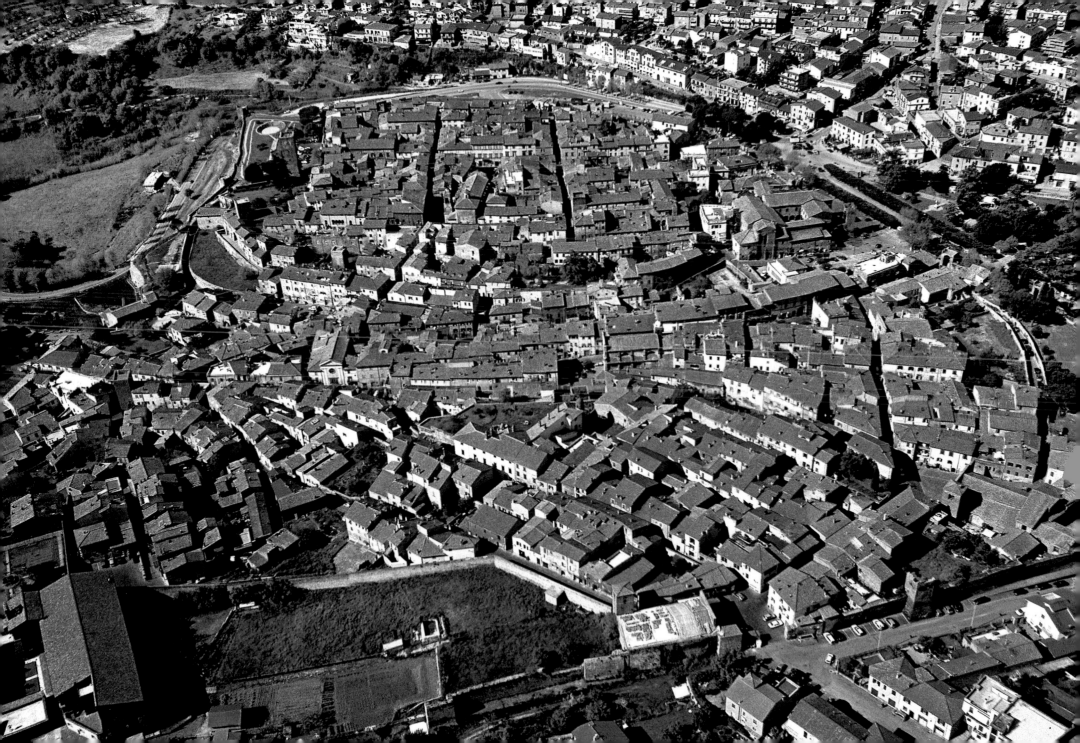

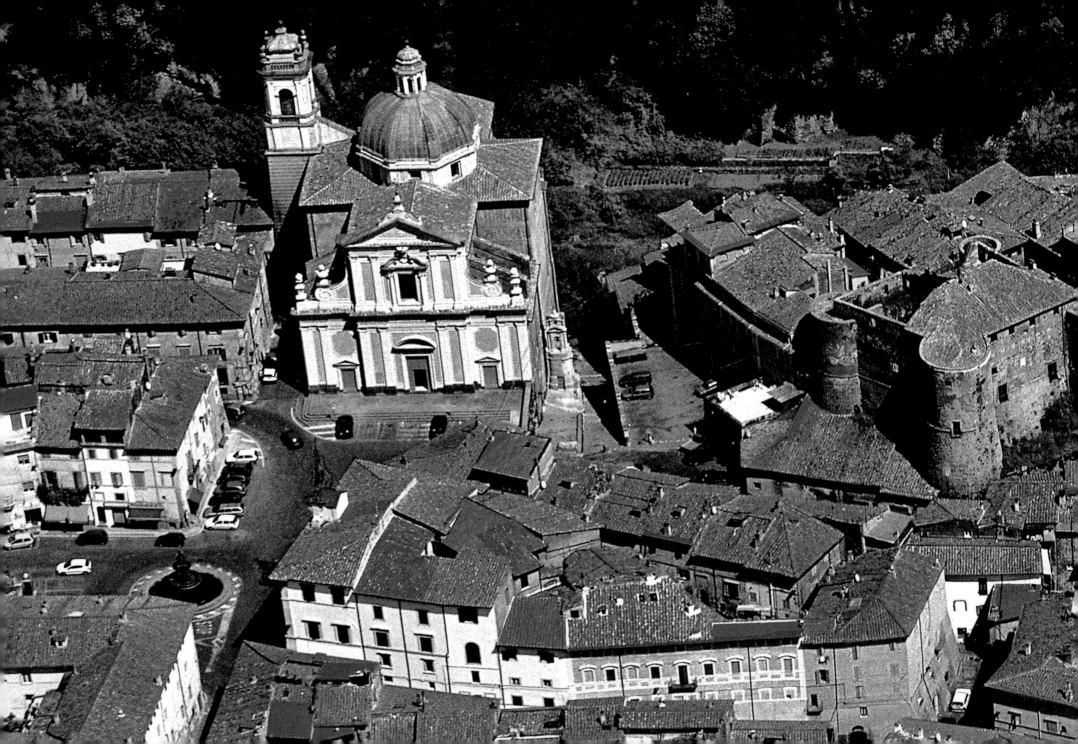

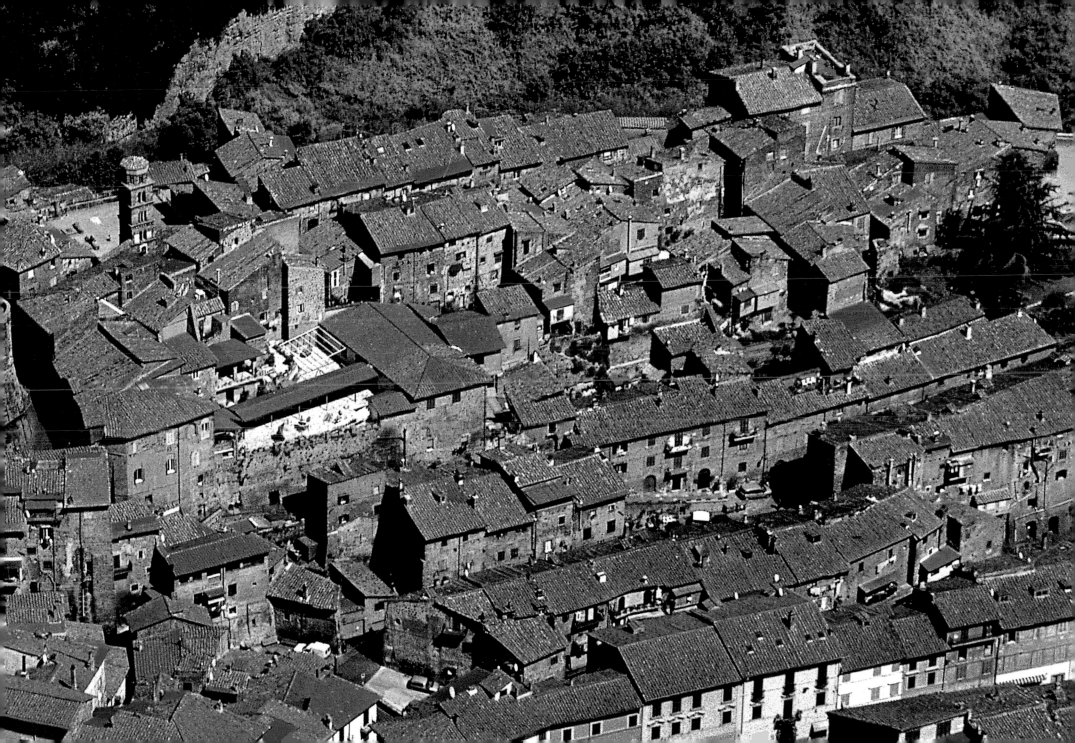

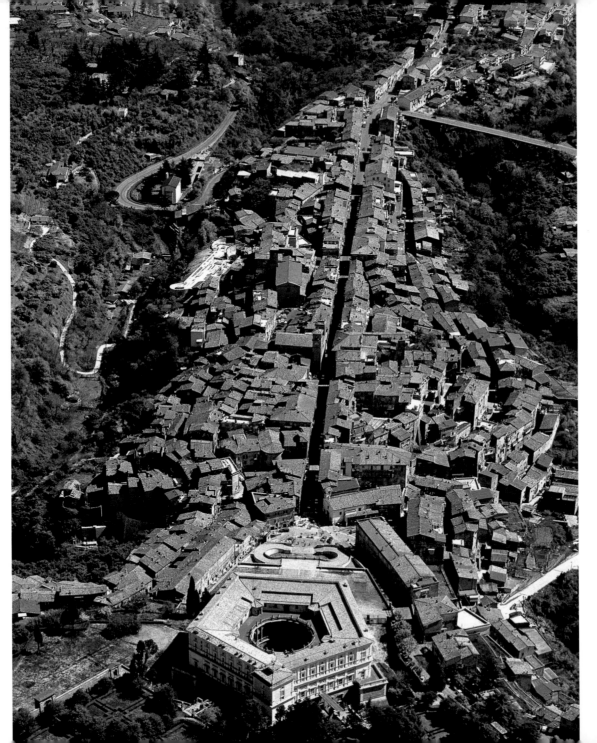

210 Picturesque Palazzo Farnese with its pentagonal plan, rises above the historic district of Caprarola (Viterbo), which also owes its fame to its proximity to Lake Vico and its huge hazel groves. The palace, designed by Vignola, is decorated with important frescoes dating from the late 16th century.

211 Following the Aurelian Way northward, Montalto di Castro (Viterbo) is the last town in Lazio before the Tuscan border. This old Maremma settlement, defended by a ring of handsome walls, lies just a few miles from the sea and the Etruscan city of Vulci.

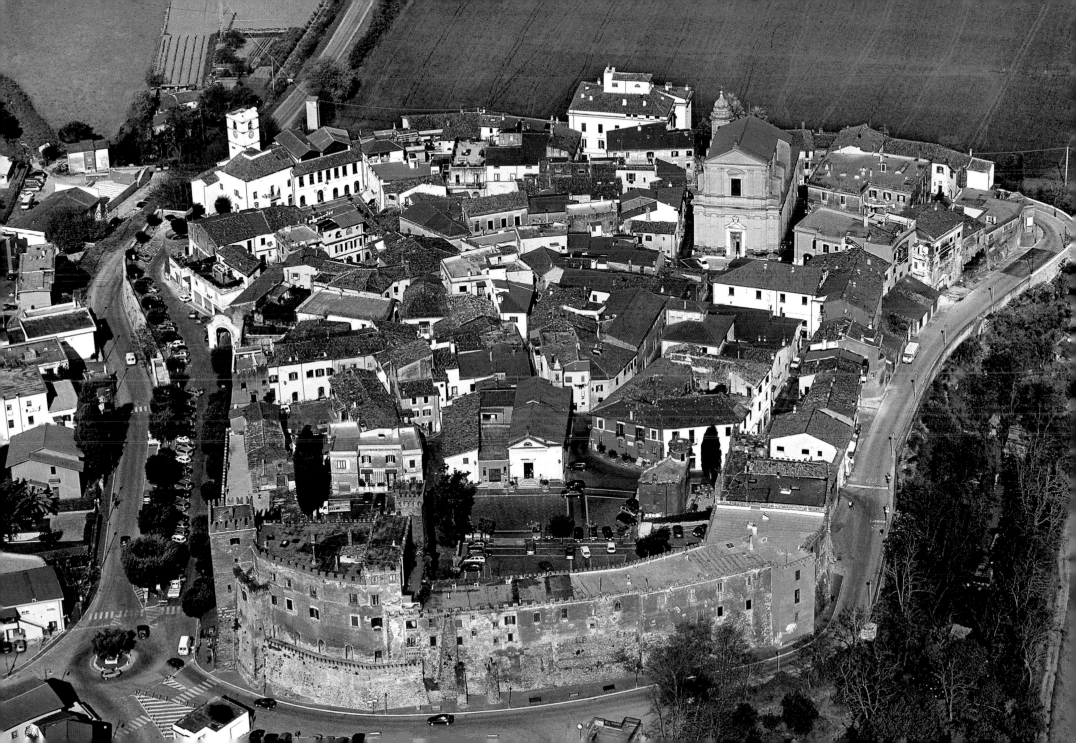

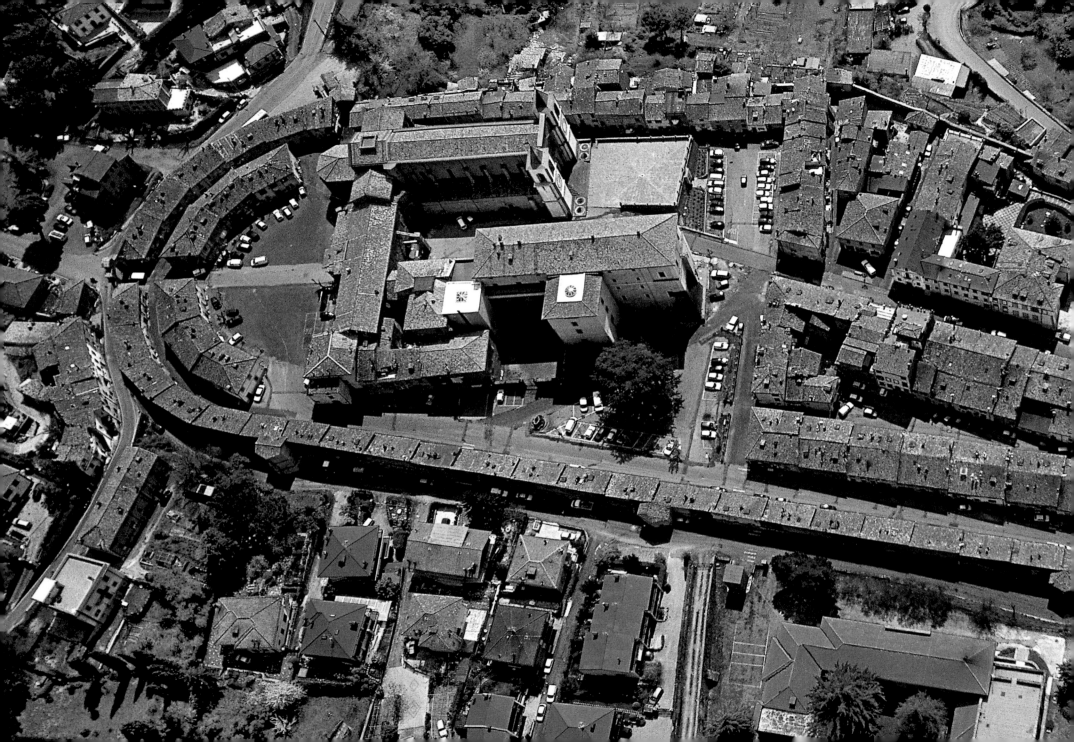

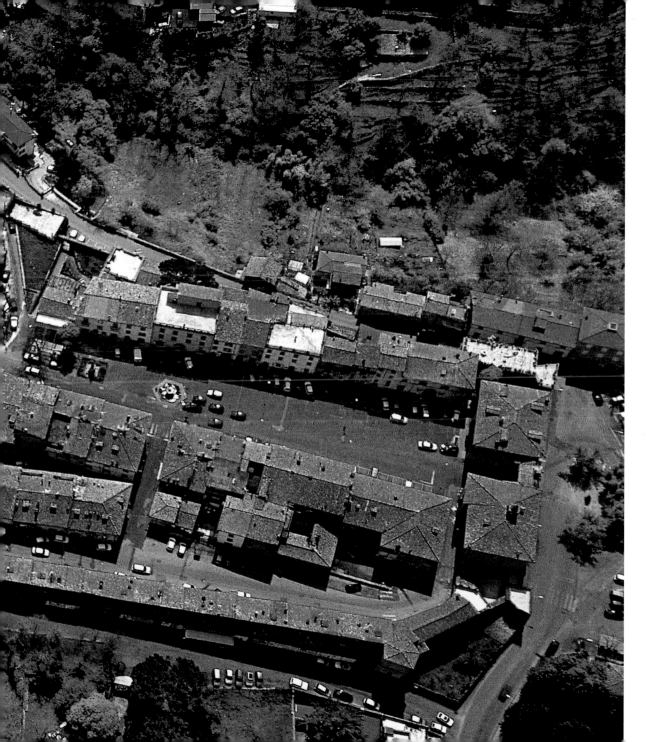

212-213 A great abbey built by the Cistercian order at the beginning of the 13th century stands in the center of San Martino al Cimino (Viterbo), between Lake Vico and Viterbo. The layout of the town was designed by Marcantonio De Rossi in the 17th century and has survived almost unaltered.

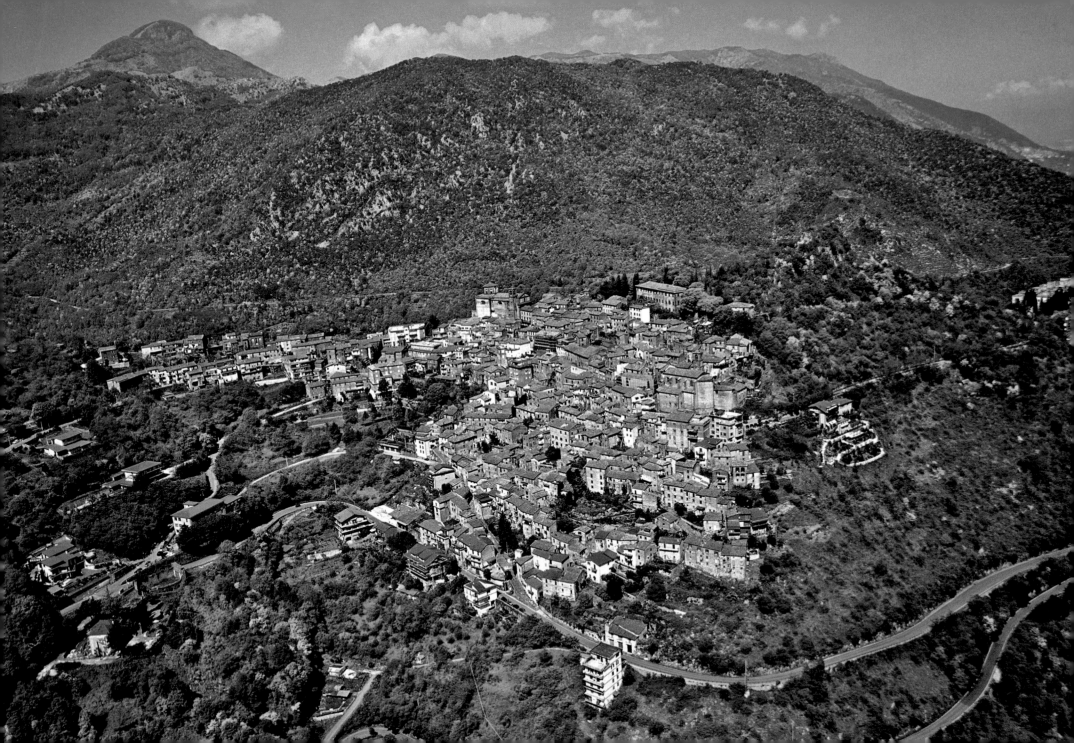

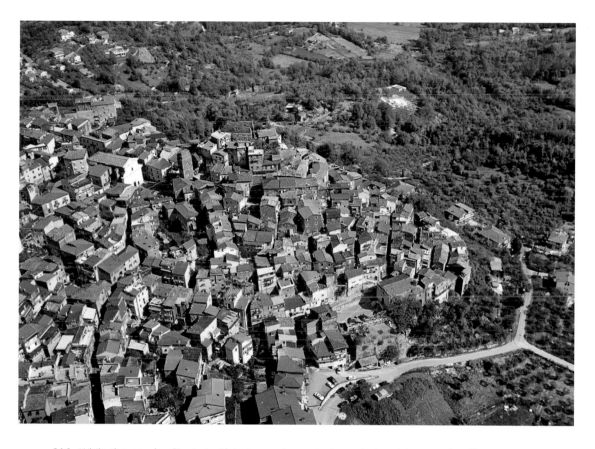

214 While the nearby Ciociaria Plain is now home to huge industrial areas, the villages on the slopes of the Lepini Mountains have survived unaltered, almost as though in a time warp. Patrica (Frosinone) is undoubtedly one of the most picturesque and lies at the beginning of the path leading up to Mt. Cacume (top left in the photograph).

215 Just a few miles from Anagni and its magnificent cathedral, Sgùrgola (Frosinone), boasts a well-preserved medieval center that belonged to the Caetani and subsequently the Colonna families. It was used as a base by the Ghibellines who plotted against Pope Boniface VIII. The town is home to several medieval churches.

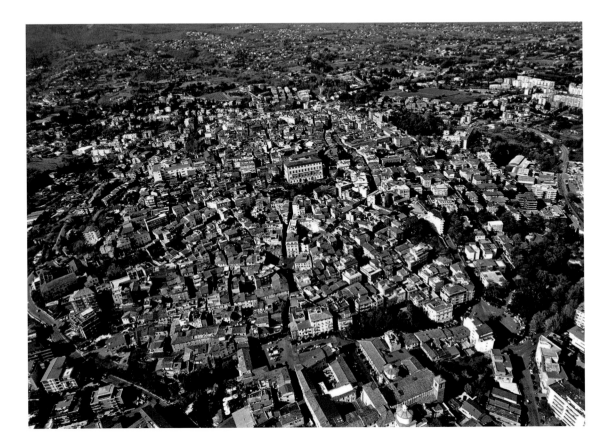

216 On the southern slopes of the Alban Hills, the old town of Velletri (Rome) owes its fame to the fact that it was the birthplace of the Gens Octavia and thus Octavian (Augustus). The town's most important monument is the cathedral of San Clemente, which was built in the 6th century and remodeled many times.

217 The village of Posta Fibreno (Frosinone), in the heart of the Comino Valley, owes its fame to the nearby lake, a deep and very clear resurgence protected by a Regional Nature Reserve, where the waters of the mountains of the National Park of Abruzzo, Lazio and Molise resurface.

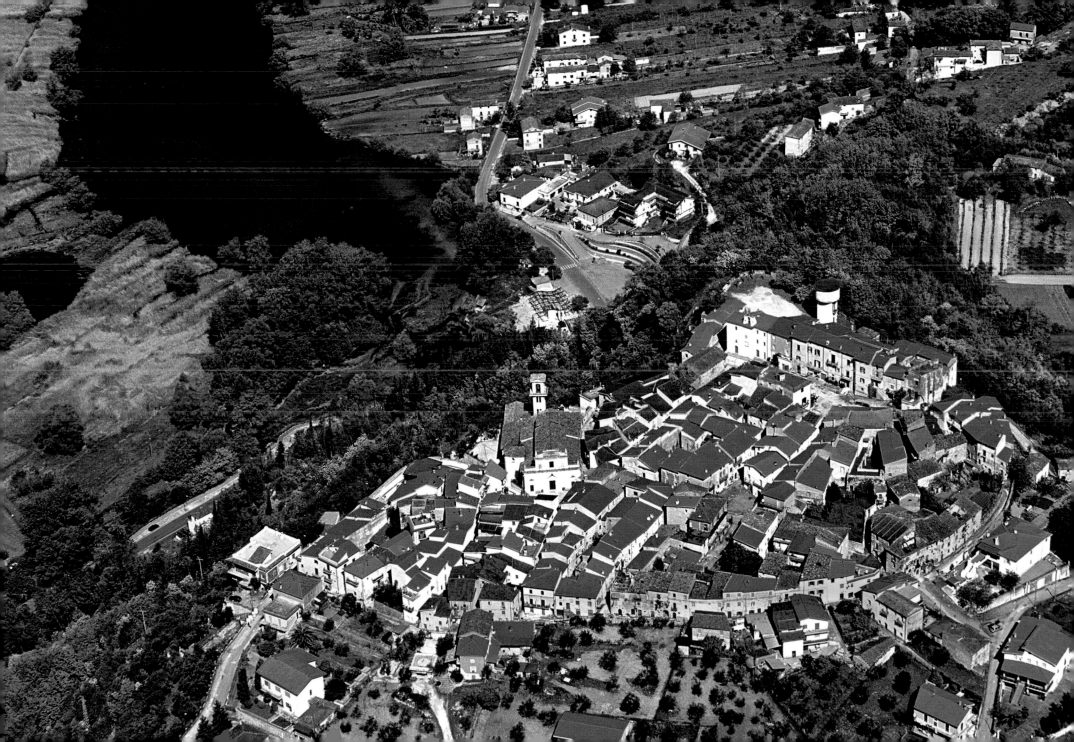

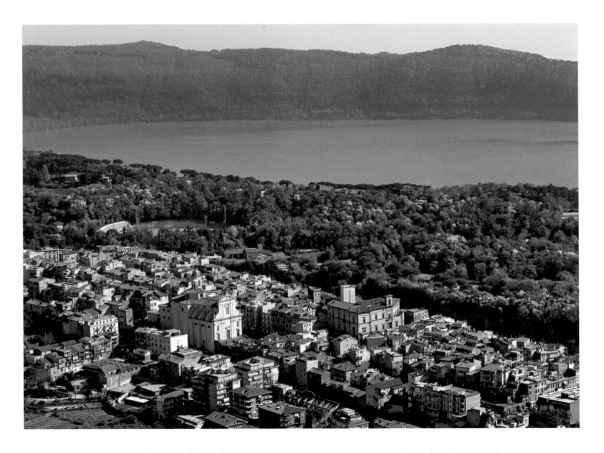

218 The town of Marino (Rome) stands on a spur of peperino rock on the slope of the crater that houses Lake Albano. The center is home to the 17th-century church of San Barnaba (left).

219 The cathedral of Anagni (Frosinone) is one of the most important examples of Romanesque art in Lazio. It was built between 1072 and 1104 in the highest part of the city, which acted as a kind of "papal capital" for many years.

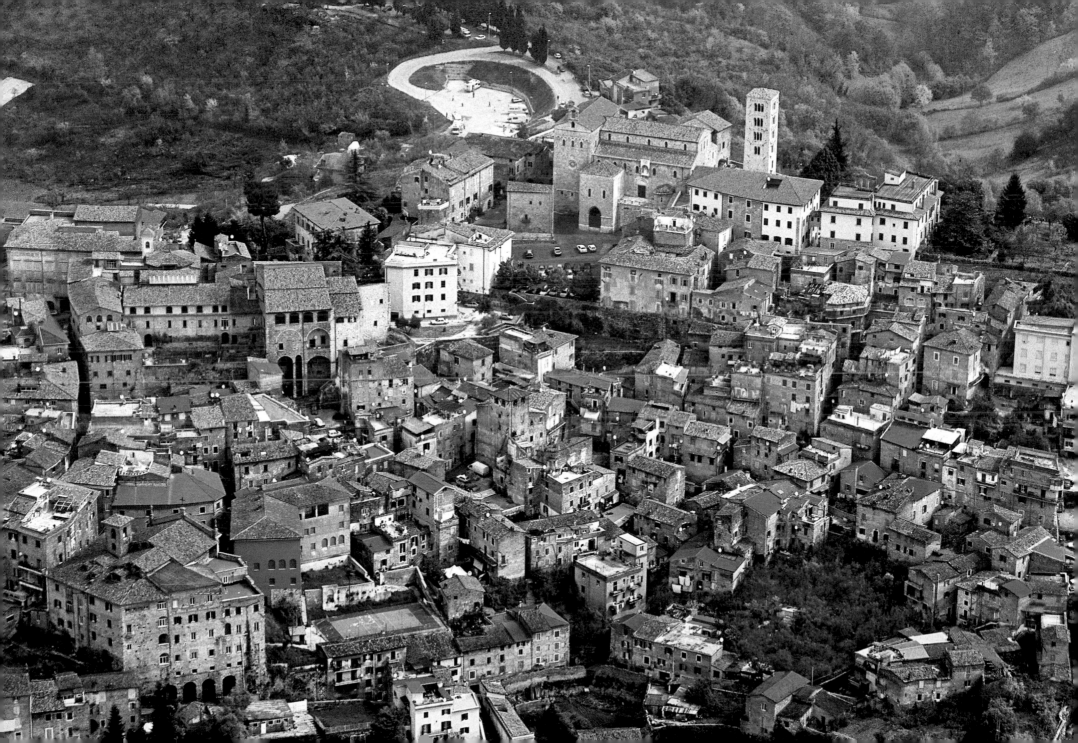

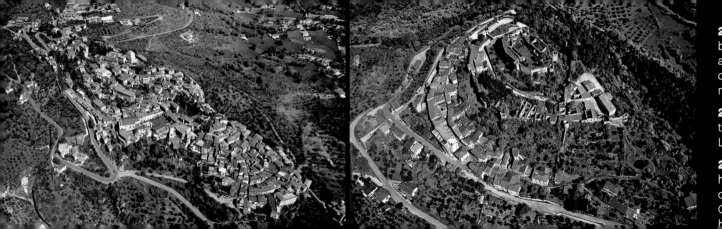

220 left The old town of Castelforte, in the huge fertile basin that separates Frosinone from Isola del Liri, Sora and Monte San Giovanni Campano (Frosinone), was one of the best-defended strongholds of the Ciociaria for many centuries.

220 right The medieval town of Vicalvi (Frosinone) on the floor of the Comino Valley, is flanked by a mighty Lombard castle built in the 12th century.

221 Arpino (Frosinone), in the Ciociaria, boasts a long history and many monuments. It is famous as the birthplace of the Roman orator Cicero. The ruins of the Italic city (now Civitavecchia), defended by the magnificent polygonal walls built by the Volsci, stand on the top of the hill.

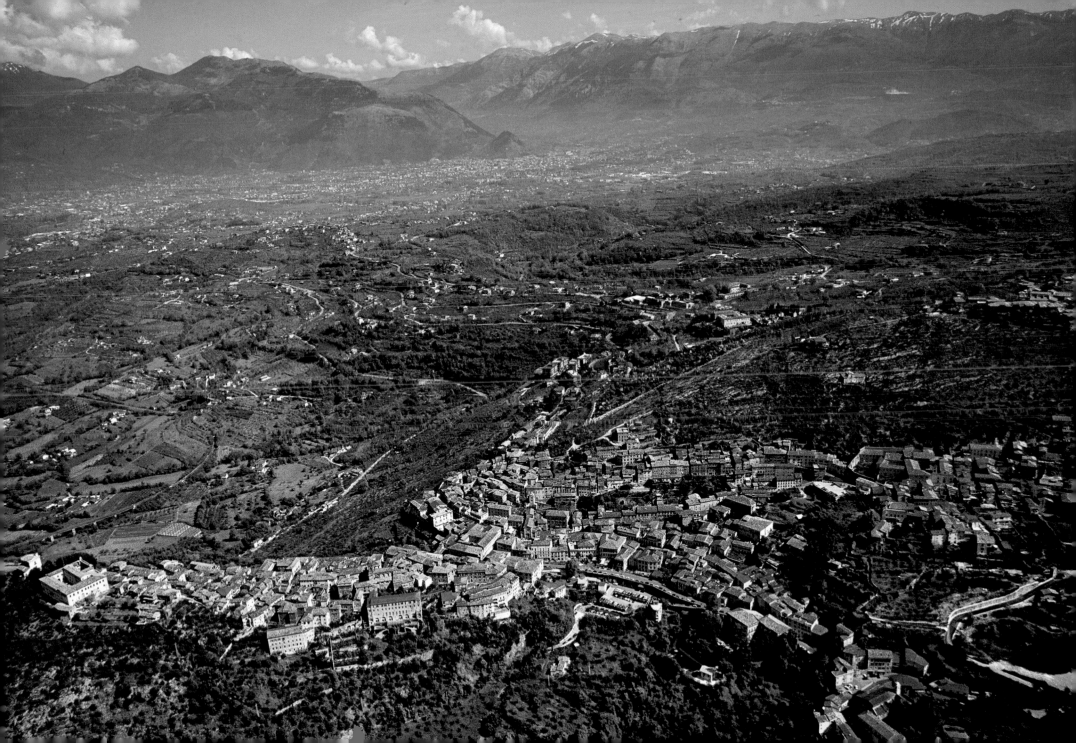

Index

222

Index

223

Credits:

Antonio Attini/Archivio White Star: page 2-3, 6-7, 8, 12 center and right, 15, 20-21 22-23, 24 right, 27, 28 left and right, 32, 33, 35, 54, 58, 70, 72-73, 86, 87, 88, 89, 90, 91, 92, 93, 94, 95, 99, 102, 103, 104, 105, 106-107, 108 left, 109, 112 left, center and right, 115, 116-117, 118, 119, 120, 121, 122, 123, 124, 125, 134 left and right, 135, 136, 137, 138, 139, 140-141, 142, 143, 144, 145, 146 left and right, 147, 148-149, 150 left and right, 151, 154 left , center and right, 157, 160-161, 162, 163, 164, 165, 166 left and right, 167, 168, 169, 170, 171, 172, 173 left and right, 174, 175, 176, 177, 178, 179, 180, 181, 182, 183, 184, 185, 190, 191, 192, 193, 194, 195, 196, 197, 198, 199, 200, 201, 202, 203, 204, 205, 206, 207, 208-209, 210, 211, 212-213, 214, 215, 216, 217, 218, 219, 220 left and right, 221

Marcello Bertinetti/Archivio White Star: page 4-5, 9, 11, 12 left, 18-19, 24 left, 25, 28 center, 31, 34, 36, 37, 38, 39, 40, 41, 42, 43, 44-45, 46, 47, 48, 49, 50, 51, 52, 53, 55, 56, 57, 59, 60-61, 62, 63, 64, 65, 66, 67, 68, 69, 71, 74, 75, 76, 77, 78, 79, 80, 81, 84, 85, 96, 97, 98, 100-101, 108 right, 111, 126, 127, 128, 129, 130, 131, 132, 133, 153, 158-159, 186, 187, 188, 189

WorldSat International Inc.: page 16

Photographs
Antonio Attini
Marcello Bertinetti

Text
Stefano Ardito

Editorial Director
Valeria Manferto De Fabianis

The Publisher would like to thank:
Emo, Francesco and Lanfabio Bientinesi of Volitalia,
Francesco Orrico, Hotel Fontana (Rome).

© 2007 White Star s.p.a.
Via Candido Sassone, 22/24
13100 Vercelli, Italy
www.whitestar.it

TRANSLATION : SARA PONTING

ISBN 978-88-544 0237-9

REPRINTS:
1 2 3 4 5 6 11 10 09 08 07

Printed in China